# PETAL

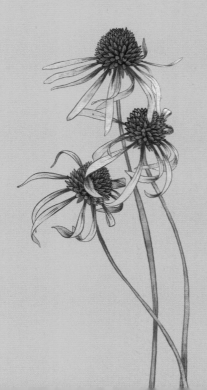

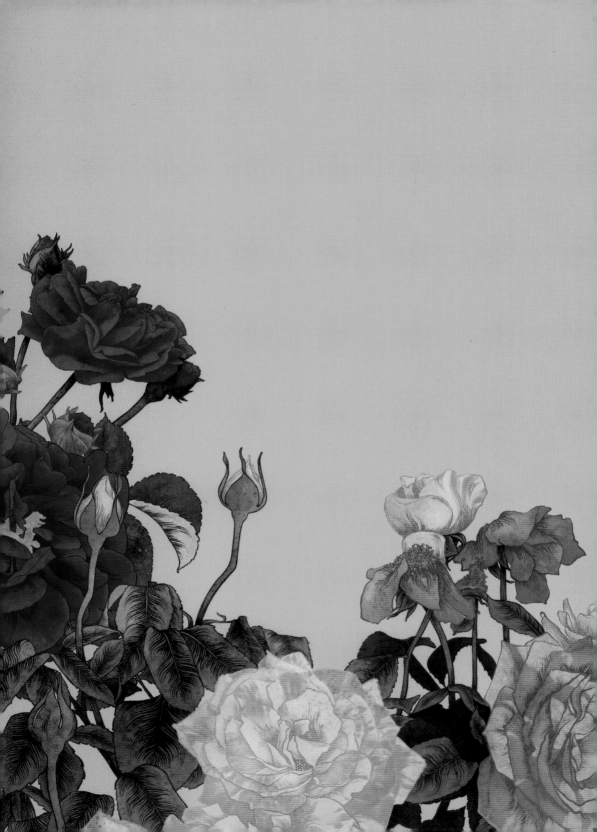

# PETAL

## THE WORLD OF FLOWERS THROUGH AN ARTIST'S EYE

### ADRIANA PICKER

*with*
Nina Rousseau

*Hardie Grant*
BOOKS

# CONTENTS

Introduction 9

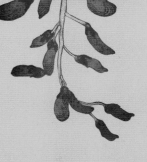

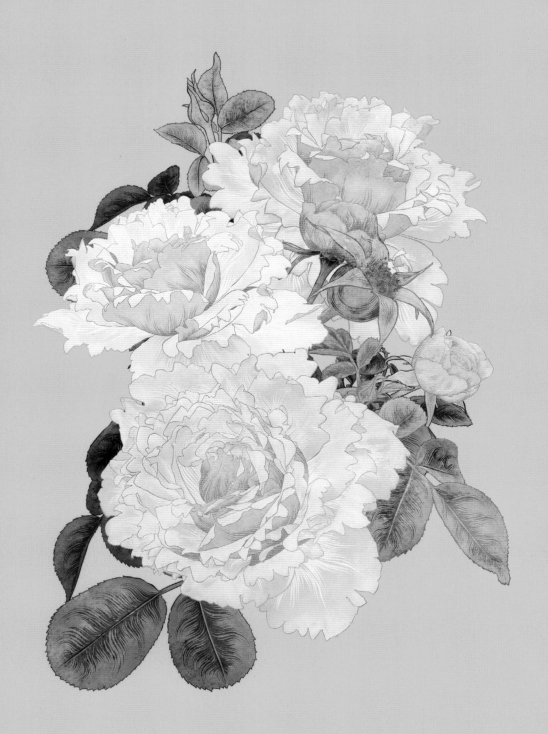

# FOREWORD
Gemma O'Brien

Shortly after we both finished art school in Sydney, I shared a house with Adriana. One spring day she returned to the house with excitement and declared she had been 'foraging'. 'What do you mean?' I asked. She ran back downstairs then re-emerged grasping an enormous bunch of plants, foliage and flowers that obscured half her body. They were fragrant and beautiful. She proceeded to joyfully list their names: magnolia leaves, crepe myrtle, various Australian natives and more. She described when they were in bloom, whether they liked sun or shade, and recounted a story or two from her childhood in the green-and-gold New South Wales countryside. I remember feeling inspired and enamoured as she divvied up bouquets in ornate vases around the house. Gathered from laneway overhangs, friendly neighbours and the overlooked corners of public parks, the flora was clearly foraged with love.

Since then, I've watched Adriana's passion for the natural world distilled into volumes of exquisite illustrations. From the Australian bush to New York City, she finds flowers everywhere she goes and reimagines them in her very own style. Armed with a wealth of botanical wisdom, a designer's eye and enviable technical ability, she gives new life to familiar forms.

Her latest compendium, *Petal*, is more than an extensive catalogue of beautiful flora; it's a contemporary take on the traditional art of botanical illustration. Adriana takes us off the page and back to the earth, reminding us of the changing colours and textures of the seasons, the scents of our favourite blooms and the natural pleasures around us. I have no doubt that this book will bring joy and inspiration to flower lovers, illustrators and foragers for years to come.

Opposite:
## SOPHIE ROCHAS
*Rosa 'Sophie Rochas'*

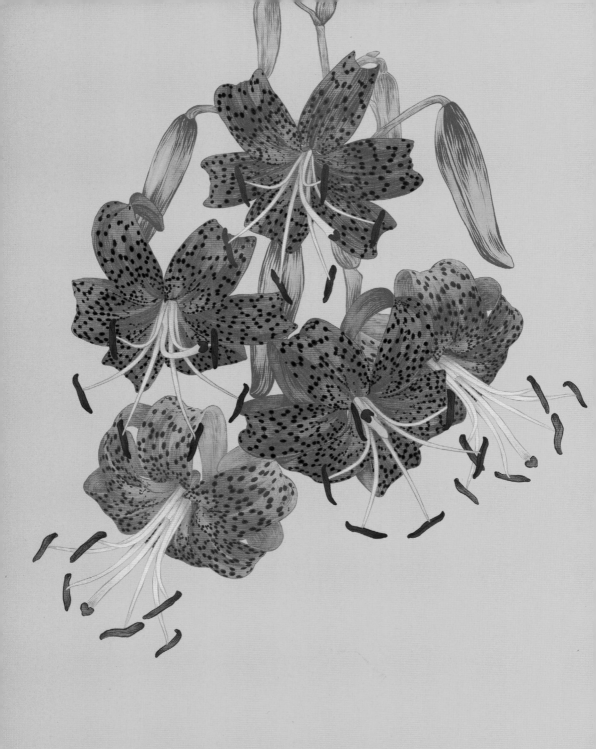

# INTRODUCTION

*When you take a flower in your hand and really look at it, it's your
world for the moment. I want to give that world to someone else.*
Georgia O'Keeffe

When I was five years old my maternal grandmother, Emma, announced to my
mother that I would be a florist.

Every time I visited Emma, on the shore of Tuggerah Lake on Australia's
central coast, we would spend hours together in her beautiful garden hunting
for blossoms, examining the whorls of a fleshy begonia leaf and inhaling the heady scent of
her heritage roses. It was our tradition, our first and most important activity directly after
my arrival for a visit, to collect a bunch of blooms for the dining table. Much to my mother's
surprise, I was also given the great honour of being able to pick any flower I chose.

Emma's garden was a fairly typical quarter-acre block with a single-storey brick veneer
house, without any real distinguishing features from its neighbours. But to me, this average
Australian backyard was a magical world of discovery. Emma had a penchant for cymbidium
orchids – ubiquitous amongst gardeners of her generation. She also had a fantastic collection
of garden roses in romantic shades of deep vermilion and delicate blush pinks, along with
sweet white crocuses and begonias with their intricately bejewelled leaves. With every visit,
there was something new to marvel at.

I did not have very long in Emma's garden; she died when I was seven and my
grandfather sold the house. On the day of Emma's funeral, with the entire family gathered
at Tuggerah Lake, her roses were in full, glorious bloom, and I collected a huge bunch for
the dining table. My aunt Margo made me point out each rosebush I had picked from so
that she could move them to her own garden in memory of her mother.

My botanical education continued after Emma's death, furthered by my mother, Sally,
also an avid gardener. Our family lived in the wonderland that is Australia's Blue Mountains,
a haven for flower-power hippies in the mid-nineties. We were immersed in nature, running
wild in the bushland right next to our house. On the walks we would take through the
national parks, Mum taught me to identify plants with their botanical names. I was in love
with all the banksias and their mesmerising Latin titles: *Banksia serrata*, *Banksia integrifolia*,
*Banksia grandiflora*. Mum taught me to pick mountain devil (*Lambertia formosa*) and suck
the sweet sap from the base.

Among the flowers of the Blue Mountains my already vivid imagination flourished, and
I began to draw in earnest.

Throughout my childhood and teenage years I explored many artistic mediums, always
happiest when I was making. At twelve I discovered a great passion for sculpting life-sized

Opposite:
## TIGER LILY
*Lilium lancifolium*

Alice finds a talking tiger lily in Lewis Carroll's nineteenth-century
classic about her adventures in Wonderland.

busts out of clay. Not long after this I threw myself into oil painting, enthralled by the rich colours, intoxicating smell and long history of the medium. My very tolerant mother let me paint for hours inside our house, ignoring the mess I was making of her carpets.

After school, I studied design and started working in costume departments on studio films, but between shoots I returned to my first love: pen on paper. And for some reason, it was when I started drawing plants again (ignoring all the commercial illustration trends I saw at the time) that my career as an illustrator took off. My floral images now come to life digitally, which gives me the entire colour spectrum at my fingertips – and the freedom to create, wherever I am in the world.

My life is still punctuated by flowers. I spend my days observing their form, shape and shades, and drawing them in minute detail. On my travels I seek out flowers; a morning walk becomes an opportunity to search for a new bloom for my next work. It could be a brilliant flush of heady lilac in the early Brooklyn spring, or a spindly stalk holding up the great spreading head of Queen Anne's lace from the gravelly side of the road. I spend countless hand-numbing, back-bending hours on each botanical artwork and I have never yet, not once, tired of my muse. Nature continues to delight and surprise – and I am perpetually under her spell.

Flowers unfurl their petals, some for mere hours, to attract not only pollinators – birds, beetles, bees, perhaps a bat – but also humans. Early plant hunters endured extreme weather, disease and near death while travelling to remote lands in search of botanical treasures, returning with specimens that breeders turned into never-before-seen hybrids. One of the greatest speculative bubbles in history, the Dutch tulipmania, emerged from the obsession of botanical collectors. Cut flowers have so entirely seduced us that we now buy some ten million a day worldwide.

This book is my love letter to these ephemeral jewels of nature: a celebration of the floral world. Within these pages lies a collection that spans priceless hothouse gems and unapologetic roadside survivors. The world of flowering plants (otherwise known as angiosperms) is so vast, varied and alluring that narrowing down the selection has been an excruciating process. I want this book to not only highlight our most loved blooms, but also to shine new light on those plant families considered unfashionable or not highly valued. The humble geranium, for example, has long been a favourite of mine; anything that boasts a variegated leaf, with its painterly stripes or swirls and contrast of colours, catches my breath and sets my heart aflutter. Even something as ubiquitous as a corner-store tulip swaddled in plastic can still bring brightness to a kitchen table. Through this book, I want to share my vast passion for flowers, with the hope the viewer can gaze with a fresh lens, perhaps inspiring exploration of a plant that was previously off the radar.

Flowers for me are still so strongly linked to family, in particular my grandmother and mother. Flowers have become the vessels of my fondest memories, connections to the places where I find the most joy and reminders of the people I most cherish. No wonder flowers have been a constant and enduring love in my life. So many years later, the flowers I first encountered in Emma's garden are my favourites to draw. I think she would be so very thrilled if she could see the work I do today, as a florist of sorts, certainly a collector and cataloguer of flowers. She prophesied correctly. This book is dedicated to her.

Opposite:
## HARLEQUIN
## BIGLEAF HYDRANGEA
*Hydrangea macrophylla* 'Harlequin'

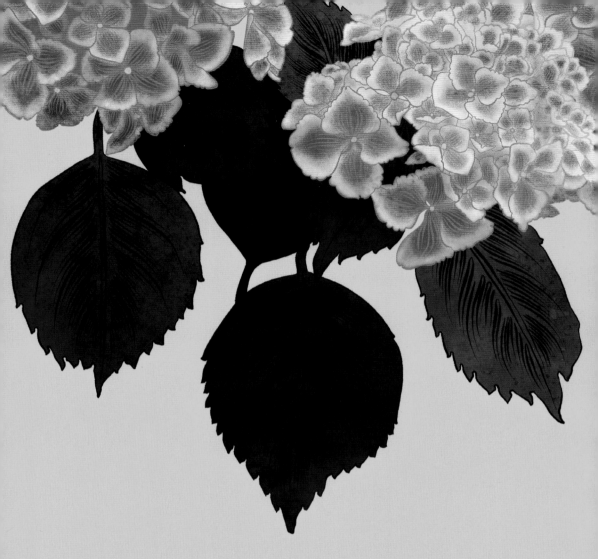

## A NOTE ON NOMENCLATURE

Scientific names (or Latin names) are a useful classification tool for identification within plant families. You may know more plants by their common names, which can be different depending on where you are in the world – the scientific name acts as a 'universal language'. As we'll discover, plant names are their own source of wonder, but sometimes they are also downright confusing. For example *Datura metel* 'Golden Queen' and *Datura metel* 'Fastuosa' are different cultivars of the same species of nightshade (the quote marks designate cultivars), but they share the common name devil's trumpet. When there's a '×' in a plant name, such as the geranium *Pelargonium × hortorum*, it means it has been bred as a hybrid of the two varieties. And sometimes you won't see a separate scientific name, because the common and scientific names for that plant are one and the same.

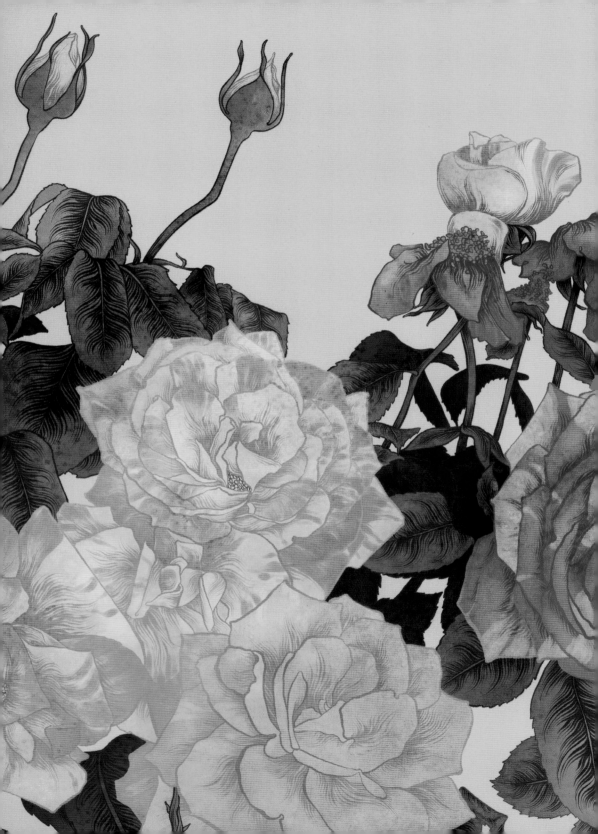

# ROSE

ROSACEAE

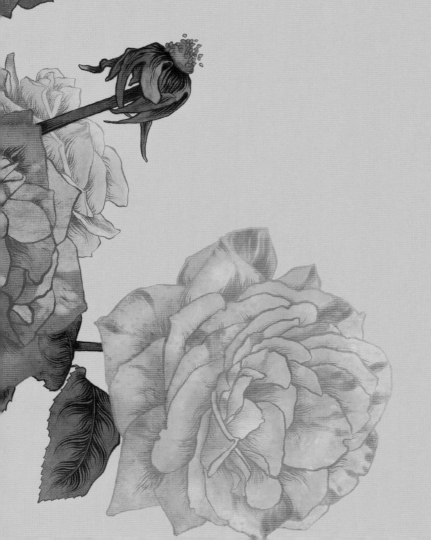

Wild and wanton, fragrant and heady, roses have entwined themselves in history for millennia. Painted, eaten and inked on our skins, they can be a gift for an adored lover, distilled in a spritz of perfume or found in the precious jars of an apothecary's treasures.

Hailing from China, the Mediterranean and the Middle East, Rosaceae is a family of productive ancestors, a giver of sustenance to the Old and New worlds. There's the prehistoric pear (*Pyrus communis*), the unruly blackberry (*Rubus fruticosus*), and the famous white mulberry (*Morus alba*), its leaves fed to silkworms, giving ancient trade route the Silk Road its name. Wild apple (*Malus sieversii*) forms untamed orchards in the cool mountains of Kazakhstan, the seeds spread by birds and bears, while proud, showy ornamentals include the Japanese cherry tree (*Prunus serrulata*) and crabapple (*Malus sylvestris*), its gnarly branches revered by wood-turners.

## IN THE FIFTEENTH CENTURY, ROSEWATER WAS USED AS BARTER AND ROYALTY CONSIDERED IT LEGAL TENDER.

In medieval Europe, rose gardens were as important as food crops; the oil from the petals was prized for its medicinal properties. Therapeutic plots were full of hardy, prolific bloomers, including albas, damask and the apothecary's rose (*Rosa gallica*) – one of the oldest cultivars available today, grown by Persians in the twelfth century. Astringent petals were used for washing skin and healing bruises, while the berry-like fruit of dog rose (*Rosa canina*) was brewed into a vitamin C–packed rosehip tea. Rose oil was an all-rounder, given to improve digestion and depression, ease premenstrual symptoms and boost libidos.

One lover of roses was Empress Josephine, first wife of Napoleon Bonaparte. One of the world's great growers, she collected and bred roses on a grand scale at Chateau de Malmaison. Plants came via many sources, including Napoleon's warships, and Sir Joseph Banks often sent her specimens when he was director at Royal Botanic Gardens, Kew. She was the first to write a guide on rose cultivation and her famous garden was a fragrant feast of more than 200 varieties.

Josephine's official artist, botanical illustrator Pierre-Joseph Redouté, brilliantly documented the collection. But, more than that, Redouté and earlier fifteenth-century illustrators spawned a new genre of botanical art, creating elegant, detailed, scientifically accurate drawings used as references for years to come. Images of roses were painted by European masters and French impressionists, their canvases rich in floral symbolism. White roses represented the chastity of Virgin Mary, dark red the blood spilled by Jesus on the cross.

Roses have been laden with meaning throughout the centuries. British pre-Raphaelites used them to send messages – red for love, yellow for friendship, and pink for a new romance or to keep an affair secret. Roses have long symbolised desire: Cleopatra's bedroom was covered with a thick layer of rose petals when she invited Marc Antony in for a night of lust. And ancient Romans spoke of confidences and deals in rooms decorated with wild roses; words spoken *sub rosa* – 'under the rose' – were considered top secret.

Maybe Shakespeare had it right? 'Of all flowers, methinks a rose is best.'

Previous:
### 'ALFRED SISLEY' ROSE
*Rosa Delbard 'Alfred Sisley'*

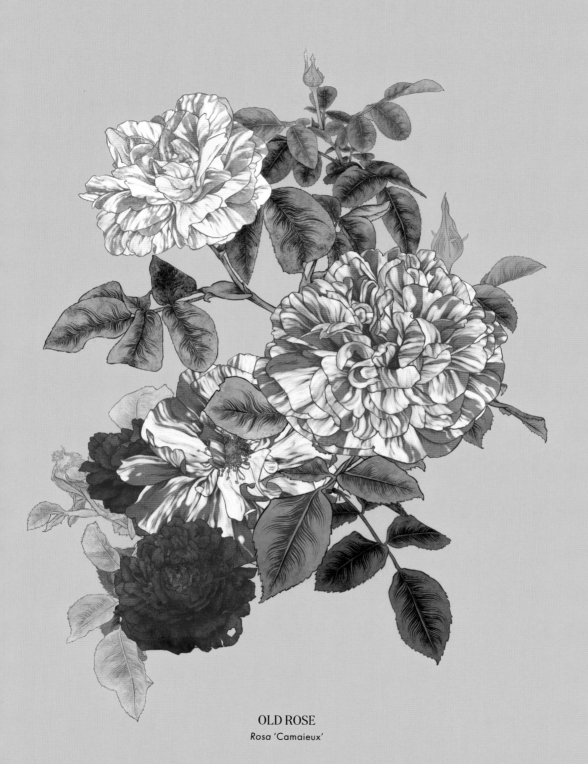

**OLD ROSE**

*Rosa 'Camaieux'*

15

# APOTHECARY'S ROSE
*Rosa 'Gallica'*

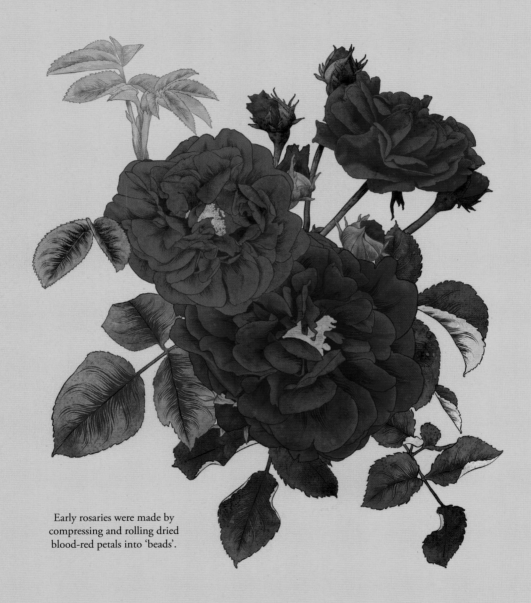

Early rosaries were made by
compressing and rolling dried
blood-red petals into 'beads'.

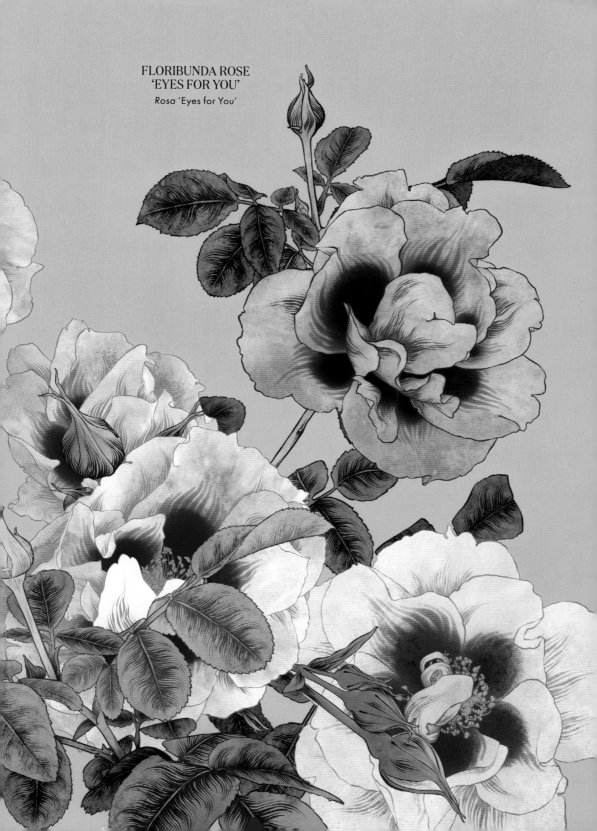

**FLORIBUNDA ROSE
'EYES FOR YOU'**

*Rosa 'Eyes for You'*

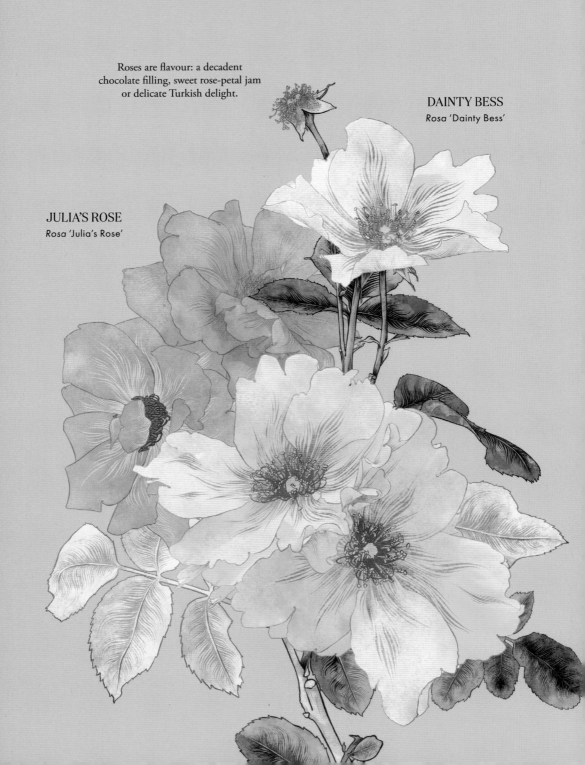

Roses are flavour: a decadent
chocolate filling, sweet rose-petal jam
or delicate Turkish delight.

DAINTY BESS
*Rosa 'Dainty Bess'*

JULIA'S ROSE
*Rosa 'Julia's Rose'*

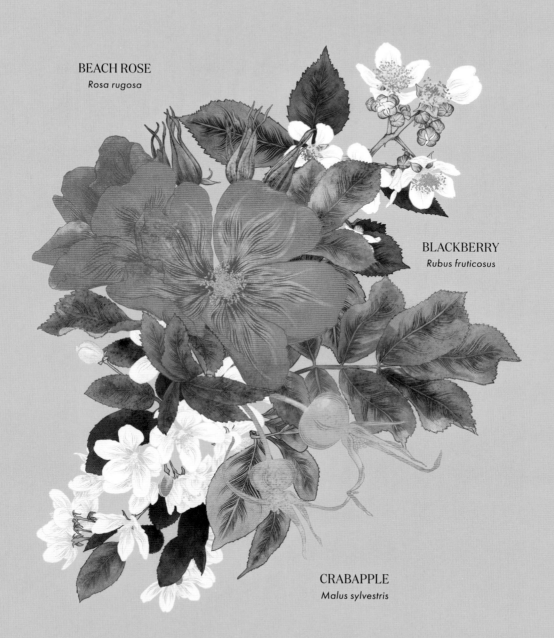

**BEACH ROSE**
*Rosa rugosa*

**BLACKBERRY**
*Rubus fruticosus*

**CRABAPPLE**
*Malus sylvestris*

**BLUEBERRY HILL**
*Rosa* 'Blueberry Hill'

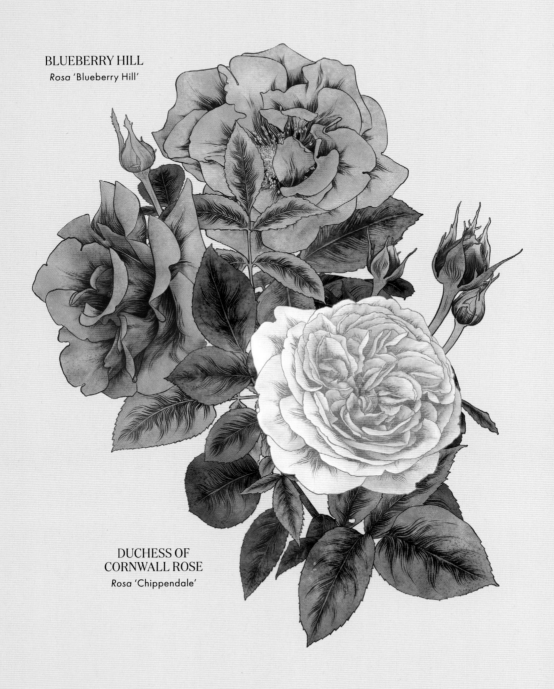

**DUCHESS OF
CORNWALL ROSE**
*Rosa* 'Chippendale'

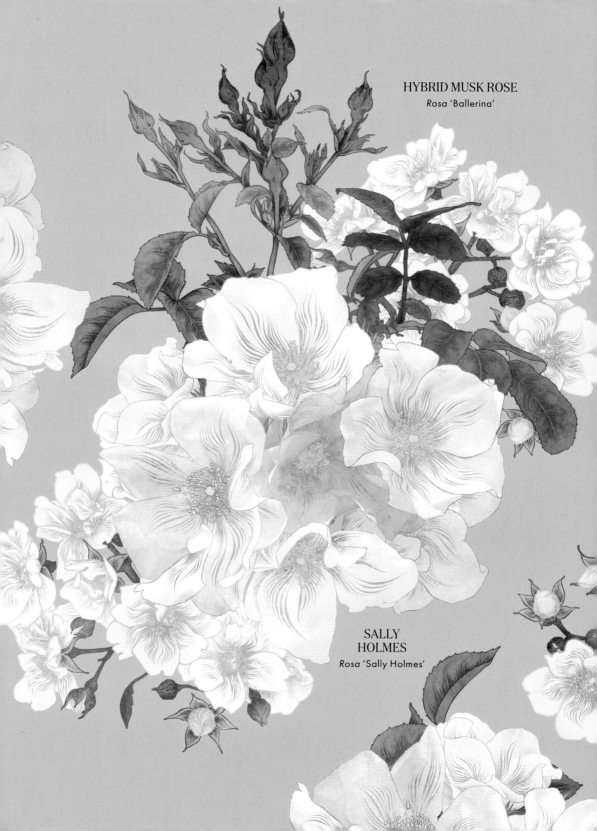

HYBRID MUSK ROSE
*Rosa 'Ballerina'*

SALLY
HOLMES
*Rosa 'Sally Holmes'*

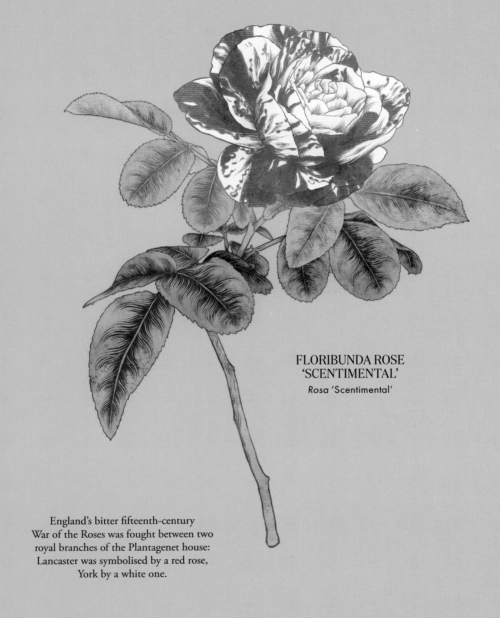

**FLORIBUNDA ROSE
'SCENTIMENTAL'**

*Rosa 'Scentimental'*

England's bitter fifteenth-century
War of the Roses was fought between two
royal branches of the Plantagenet house:
Lancaster was symbolised by a red rose,
York by a white one.

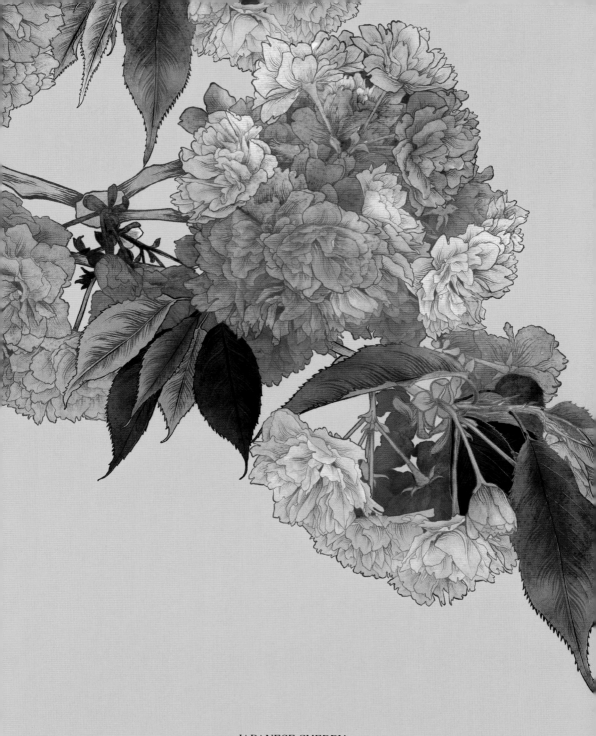

JAPANESE CHERRY

*Prunus serrulata 'Kanzan'*

# LEGUME

LEGUMINOSAE

You won't find this family in Antarctica, but you will find Leguminosae everywhere else. A family of old-timers, with acacias growing in Gondwanaland 140 million years ago, this is a huge and abundant group with more than 23,000 species of giant tropical trees, food crops, shrubs of all sizes, and lush, hanging, vigorous vines.

Legumes are nitrogen fixers, a primitive adaptation from when the atmosphere lacked oxygen. Rhizobia bacteria grow on the roots, converting nitrogen from the air to be used by the plant. The seeds of the strap wattle (*Acacia holosericea*), eaten by Indigenous Australians for centuries, are rich in nitrogen and can be cooked like lentils. Meanwhile Europeans have been munching on broad beans (*Vicia faba*) since the sixth millennium BCE.

A close cousin of the kidney bean, but oh-so glamorous, is the showstopper jade vine (*Strongylodon macrobotrys*). Curling and climbing in the tropical jungles and steamy ravines of the Philippines, its stems are up to 18 metres (60 feet) long, and its exquisite aquamarine flowers hang in big showy clusters. As twilight falls, bats are enticed by the luminous petals and swing upside-down to drink the nectar, their heads brushing the pollen and transferring it to other plants.

> **THERE'S FOSSILISED EVIDENCE OF LEGUMINOSAE FROM ABOUT 56 MILLION YEARS AGO.**

More common but equally magnificent is Chinese wisteria (*Wisteria sinensis*), a powerfully vigorous, beautiful and fragrant beast of a vine, with bean-like pods hanging from bare branches in winter and purple clusters of flowerheads forming enchanting outdoor arbours.

In Australia's arid inland heart, Sturt's desert pea (*Swainsona formosa*) is a striking wildflower with scarlet petals and a glossy black eye, forming a vivid carpet against the ochre-red dirt. For Aboriginal people, it's the flower of mourning: 'the flower of blood', symbolising the invasion of their land.

On the Mediterranean isle of Sicily, sweet pea (*Lathyrus odoratus*) changed the course of history. A self-pollinator, its genetic information complete, one sweet pea can reproduce itself exactly. A 'camel's-hair brush' or 'rabbit's tail affixed to a stick' were suggested for dusting pollen from one plant to another, and the subsequent cross-pollination from growers and gardeners in the eighteenth century created a floral sensation. Experimentation with the sweet pea led to research into its cousin, the edible pea (*Pisum sativum*), and when Gregor Mendel noticed its traits were being inherited, it was a massive scientific breakthrough, unlocking genetics and DNA and giving fellow scientists including Charles Darwin renewed focus. It also showed the sweet pea was way more than just a pretty petal.

Previous:
## LUPINE 'GALLERY BLUE'
*Lupinus polyphyllus*

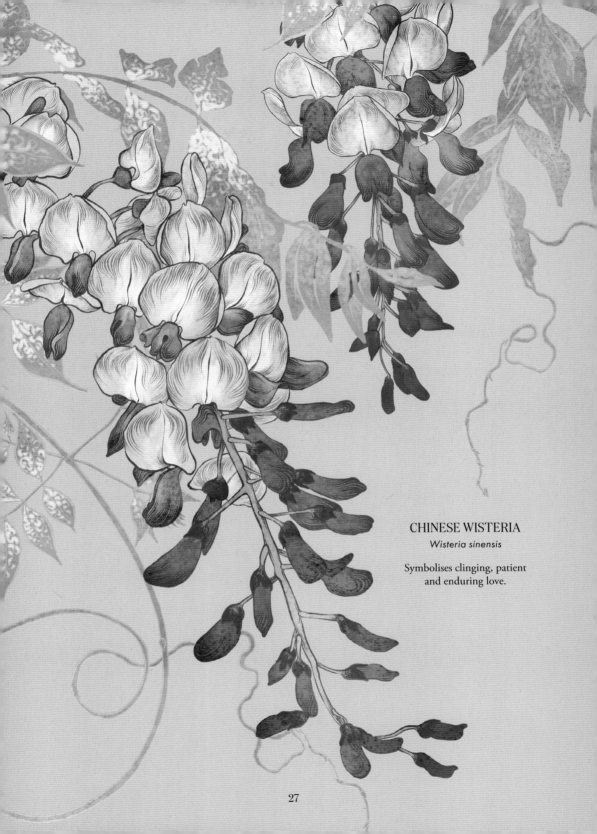

**CHINESE WISTERIA**

*Wisteria sinensis*

Symbolises clinging, patient
and enduring love.

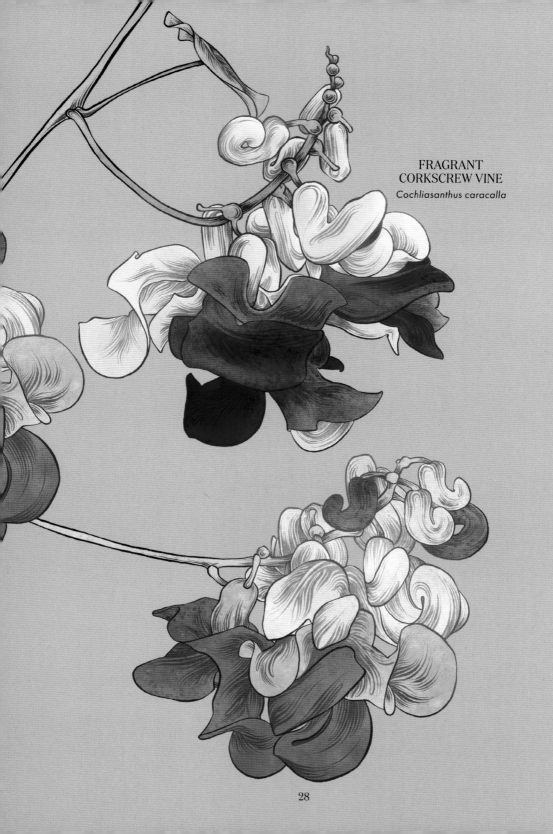

FRAGRANT
CORKSCREW VINE
*Cochliasanthus caracalla*

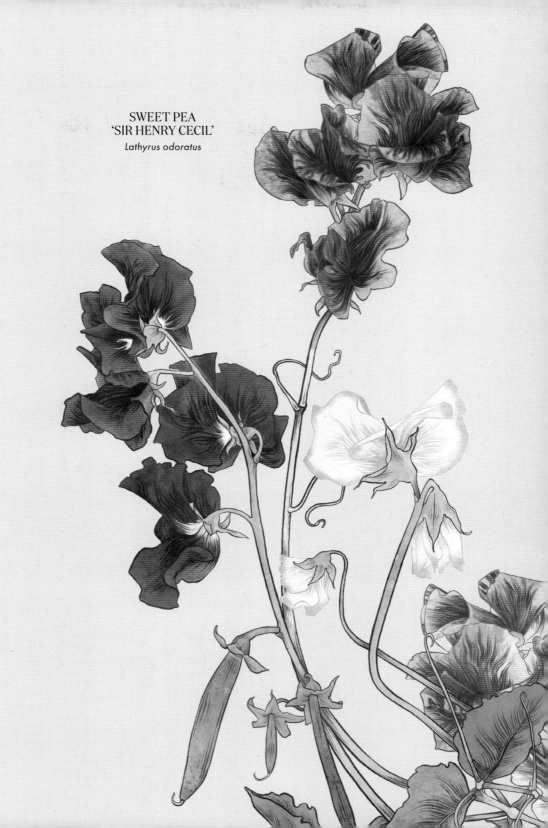

SWEET PEA
'SIR HENRY CECIL'
*Lathyrus odoratus*

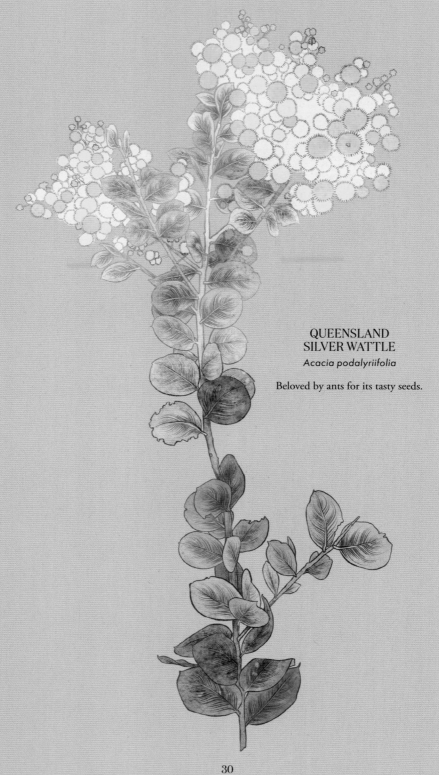

QUEENSLAND
SILVER WATTLE
*Acacia podalyriifolia*

Beloved by ants for its tasty seeds.

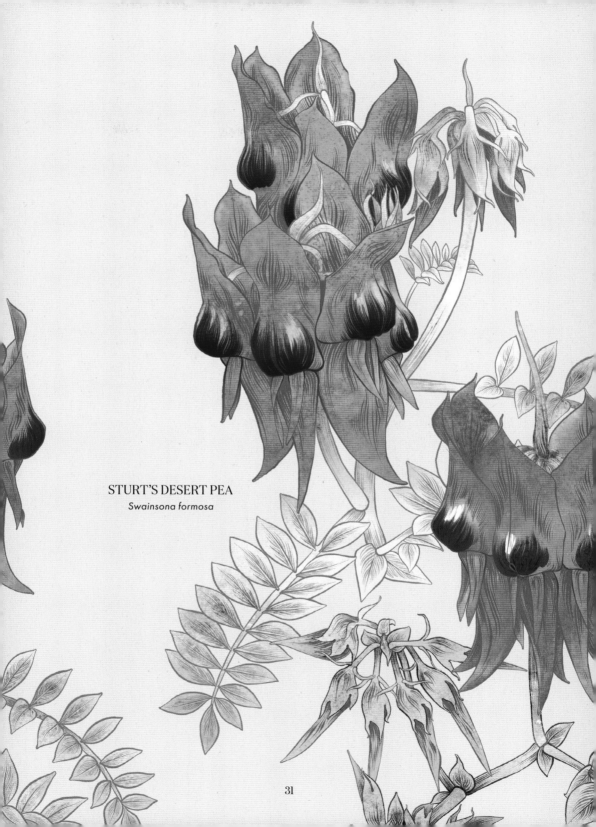

STURT'S DESERT PEA
*Swainsona formosa*

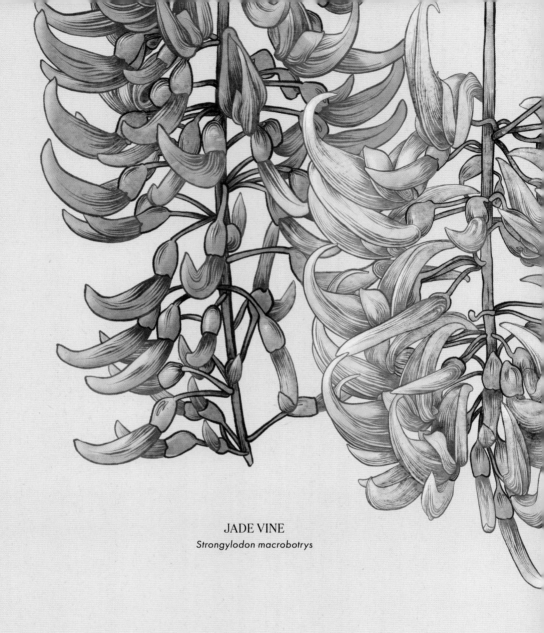

JADE VINE
*Strongylodon macrobotrys*

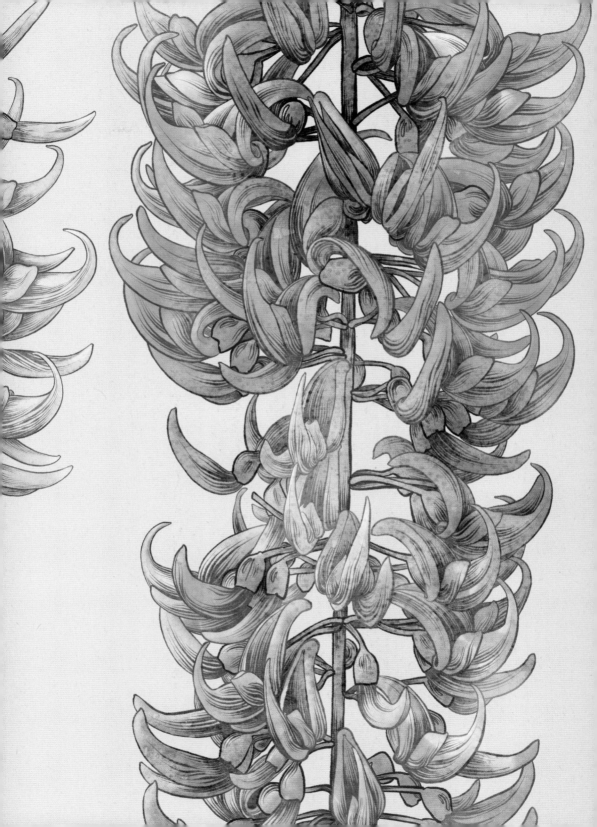

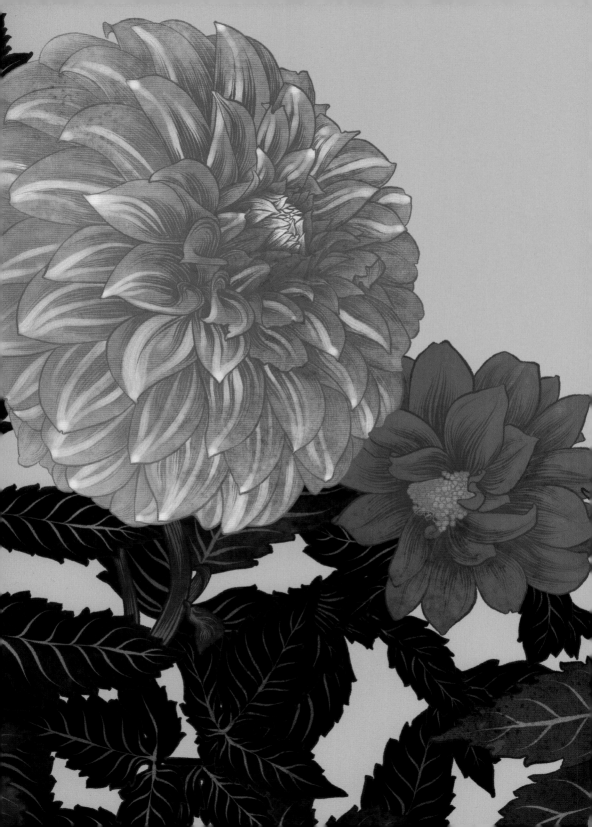

# DAISY

ASTERACEAE

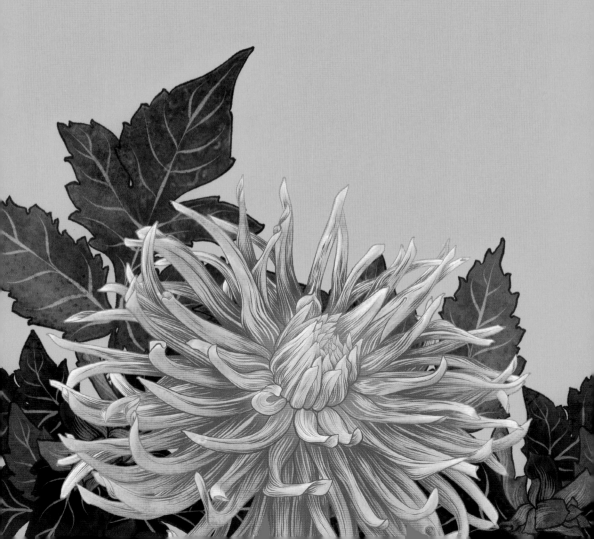

Sunny and bold, friendly and bright, Asteraceae is a hardy, can-do family adding colour and cheer with its open-faced flowers and petal haloes that splay like rays.

'Mum' – or 'chrysanth', as she's affectionately known – is the matriarch, leading the beaming dahlias and zinnias, the medicinal heroes of yarrow and echinacea, along with hundreds more extended relatives. They're a big bunch, one of the largest plant families in the world, with more than 23,000 species, and they've been around for centuries.

In China, native spider mum (*Chrysanthemum morifolium*) has bloomed since 500 BC, valued by eastern doctors and herbalists as an ingredient in the quest to defy ageing. The flowers were used to make sweet healing tea, the leaves eaten as steamed greens, and the petals added to a bowl of snake soup to give it zing. But it wasn't until the fifth century that the Chinese began to prize the humble, hardy 'mum' for its bold, warm hues (yellows and reds, purples and pinks), planting chrysanthemums in gardens near Buddhist shrines to form low herbaceous borders.

# CHRYSANTHEMUMS MAKE THE BLOOD FLOW AND THE CHI SING, HELPING THE BODY ELIMINATE TOXINS.

On the mountainous peaks of Mexico, Guatemala and Colombia, the bell tree dahlia (*Dahlia imperialis*) grew wild and free, reaching 10 metres (32 feet). Aztecs and Maya cooked the sweet tuberous roots like potatoes, ate the dark green leaves, and used the bamboo-like stems for carrying water when travelling. Another mountain-dweller, *Barnadesia spinosa* has spiky spines that stopped it being eaten by llamas on Andean peaks.

After botanists travelling with the Spanish conquistadors at the end of the eighteenth century sent bulbs home, Europeans began a long-lasting love affair with the dahlia, breeding single, double, pompom and cactus cultivars, with flowerheads as tiny as coins or as big as frisbees. Dahlias and chrysanthemums held great currency during the florilegia craze in nineteenth-century Europe, their prized colours spanning flame red to canary yellow to bright orange. Stunning modern-day hybrids include dahlia 'The Phantom', with its pretty petal skirt, and dahlia 'Pink Giraffe', a double orchid with mottled pink petals that curl inwards.

Delicate-looking yarrow (*Achillea millefolium*), the medicinal wonder weed that rambles along roadsides, has been used for centuries to cure a range of ills, stemming the flow of blood and healing wounds on the battlefields of yesteryear. It's also a hardy and ornamental garden perennial.

Echinacea, growing wild on American prairies, was used by Native Americans to boost immunity and cure infections, and modern coneflower hybrids, such as echinacea 'Supreme Flamingo' and echinacea 'Amazing Dream', are beautiful and bright.

Peel and reveal to discover the edible heart of the globe artichoke (*Cynara scolymus*), chock-full of antioxidants. And, while not actually edible, the velvety wine-red flowers of chocolate cosmos (*Cosmos atrosanguineus*) do at least smell like everyone's favourite treat.

Previous:
*DAHLIA* 'STAR ELITE',
*DAHLIA DAHLINOVA* 'CAROLINA BURGUNDY'
AND *DAHLIA* 'ISLANDER'

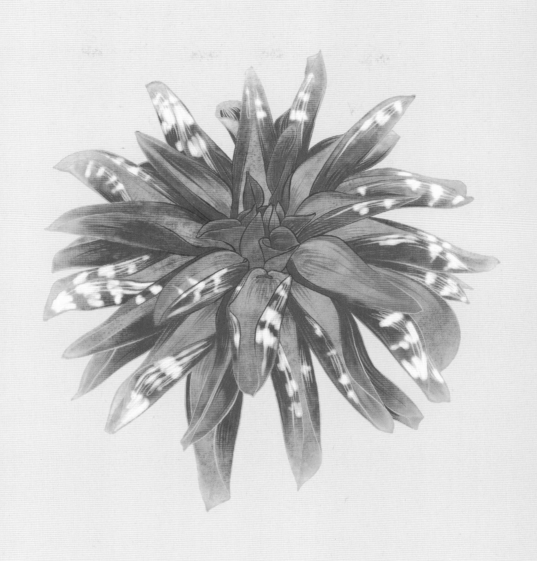

*DAHLIA*
'PINK GIRAFFE'

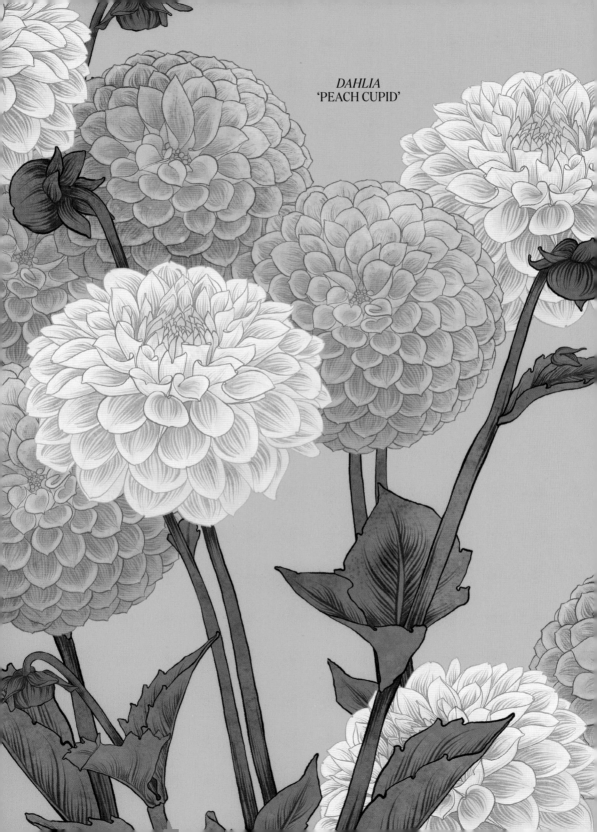

*DAHLIA*
'PEACH CUPID'

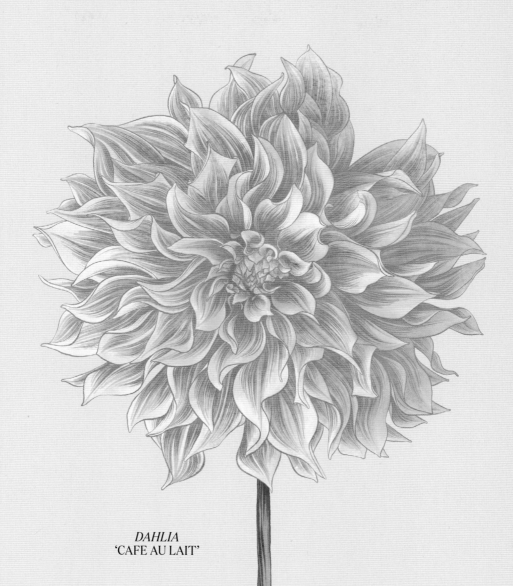

*DAHLIA*
'CAFE AU LAIT'

There are many impressive dahlia
displays in Seattle; they're the
city's official flower.

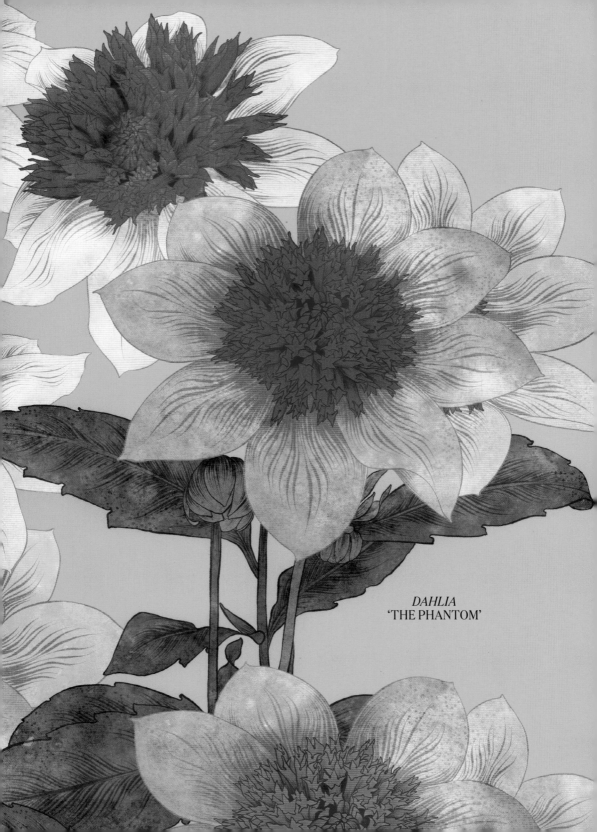

*DAHLIA*
'THE PHANTOM'

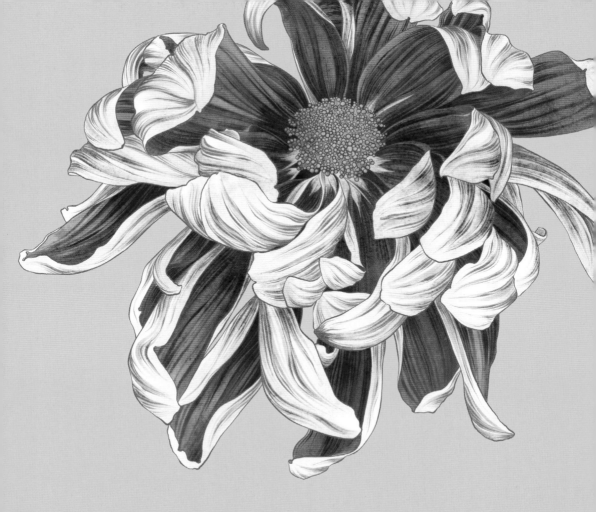

## FLORIST'S DAISY

*Chrysanthemum morifolium*

Chrysanthemums, along with cherry blossoms,
have long been revered in Japanese tattoo art.

In the language of flowers, chrysanthemums represent optimism and joy.

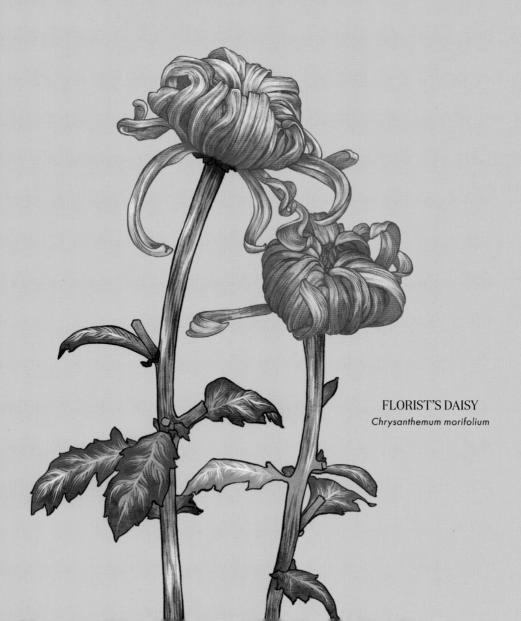

FLORIST'S DAISY

*Chrysanthemum morifolium*

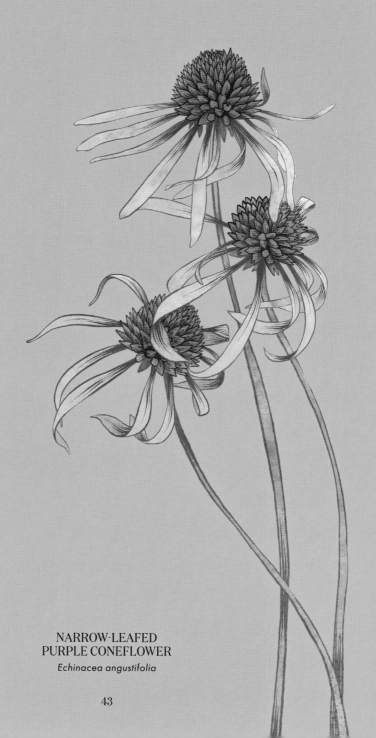

NARROW-LEAFED
PURPLE CONEFLOWER

*Echinacea angustifolia*

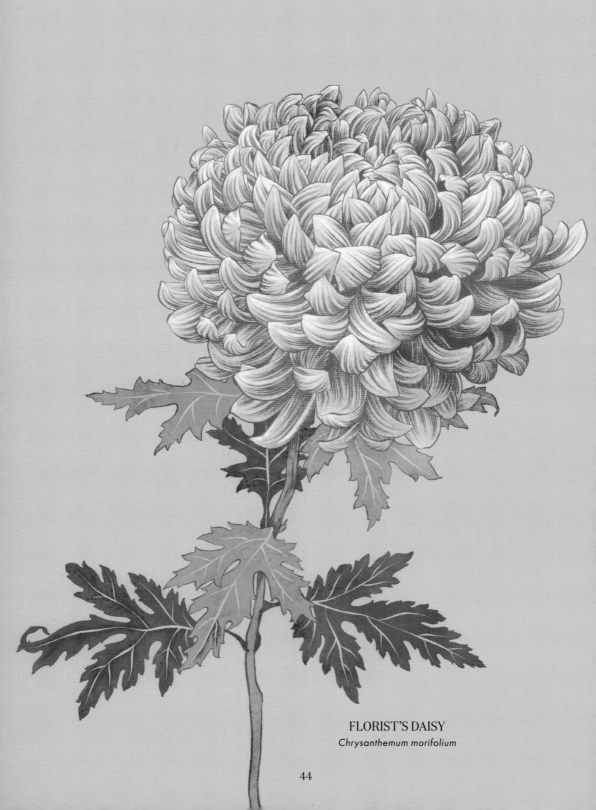

FLORIST'S DAISY

*Chrysanthemum morifolium*

# FLORIST'S DAISY

*Chrysanthemum morifolium*

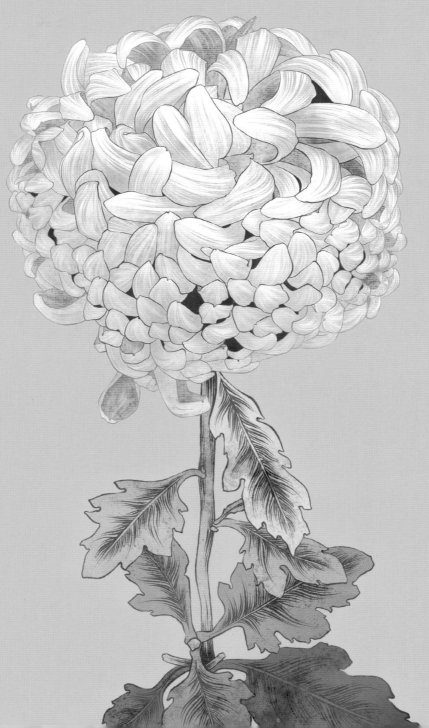

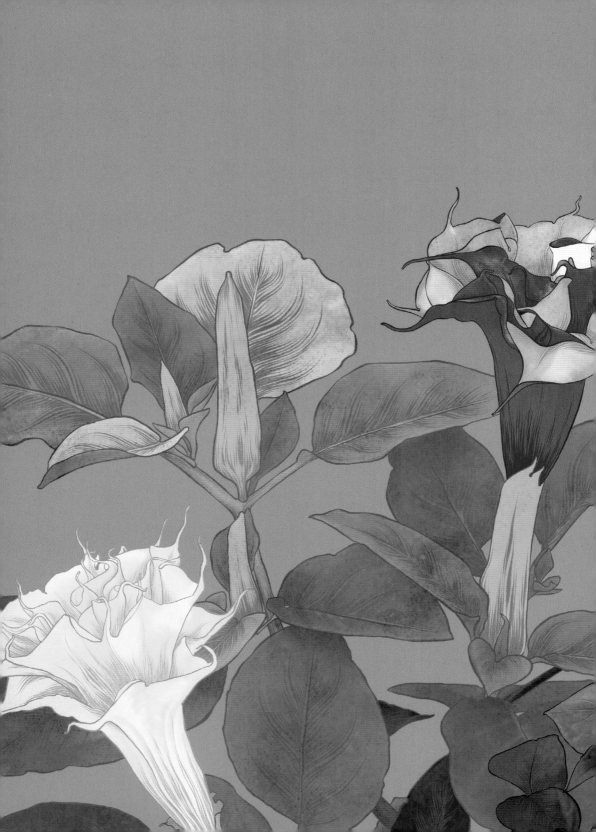

# NIGHTSHADE

SOLANACEAE

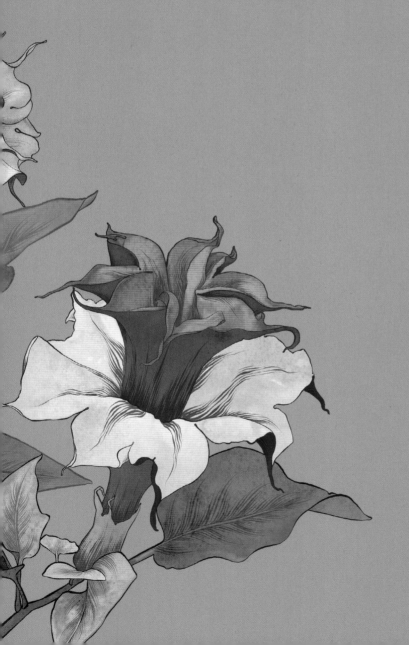

Nightshades tell the story of good versus evil better than any fairytale.

This group of plants is full of devilish characters, but datura is the most malevolent crew, with the power to cause death, psychosis and delirium. Those in possession of datura's narcotic, poison-packed seeds hold the power to inflict great harm or great healing. Used well, these potent plants can halt chronic asthma attacks, act as an anaesthetic, treat motion sickness, reduce inflammation and soothe arthritis. Used badly, and victims fall into intense states of confusion, losing memory and free will, making them vulnerable to robberies, kidnappings and sexual assault.

Growing wild on the river flats and fertile soils of Central America, there are nine species of datura, including devil's trumpet (*Datura metel*) and thornapple or jimson weed (*Datura stramonium*). These highly aromatic and sticky plants have trumpet-like flowers that open and release their scent at twilight, when the bats and night creatures roam.

**THE MAYA AND INCAS BELIEVED THE AROMA OF PETUNIAS HELPED WARD OFF DEMONS FROM THE UNDERWORLD.**

A close relation is brugmansia, including angel's trumpet (*Brugmansia suaveolens*), a scrubby tree with pendulous bell-like flowers. It once thrived in the volcanic Andean soils of Colombia and Peru but is now extinct in the wild.

All datura, brugmansia and many other Solanaceae, such as deadly nightshade (*Atropa belladonna*), are loaded with tropane alkaloids – poisonous chemicals concentrated in the seeds and leaves, a plant defence adaptation. These tropane alkaloids – atropine, hyoscyamine and scopolamine – have psychoactive properties used for centuries by witches and wizards practising black magic, Hindus worshipping Shiva in religious rituals, and South American shamans contacting ancestors in the spirit world or medicating 'bad' children to make them more compliant.

The name 'jimson weed', commonly used for datura in the United States, is a contraction of 'Jamestown', a garrison town in Virginia. English soldiers stationed there in 1676 ran out of food, so they cooked up a thornapple stew and spent the next eleven days tripping, delirious and naked and with terrible diarrhoea.

Ladies of yesteryear used belladonna to dilate their pupils, believing it made them more desirable to potential suitors. Scopolamine was used as truth serum in World War II and given to women during childbirth partially to ease the pain, but also to induce amnesia.

And of course, that lucrative leaf tobacco (the bad uncle of the family) contains the addictive alkaloid nicotine. Petunias look similar to tobacco, and in Tupi-Guarani languages, spoken by indigenous people of South America, 'petun' translates to 'tobacco'.

But Solanaceae isn't all devil's work. Other family members such as potato, eggplant, tomato and chilli are heroes, full of nutrients and antioxidants, their introduction from the 'New World' forever changing the way we cook and eat.

Solanaceae has some of darkest plants in its family, while others are full of hope and positivity. Careful how you go.

Previous:

**DEVIL'S TRUMPET**

*Datura metel 'Golden Queen' and Datura metel 'Fastuosa'*

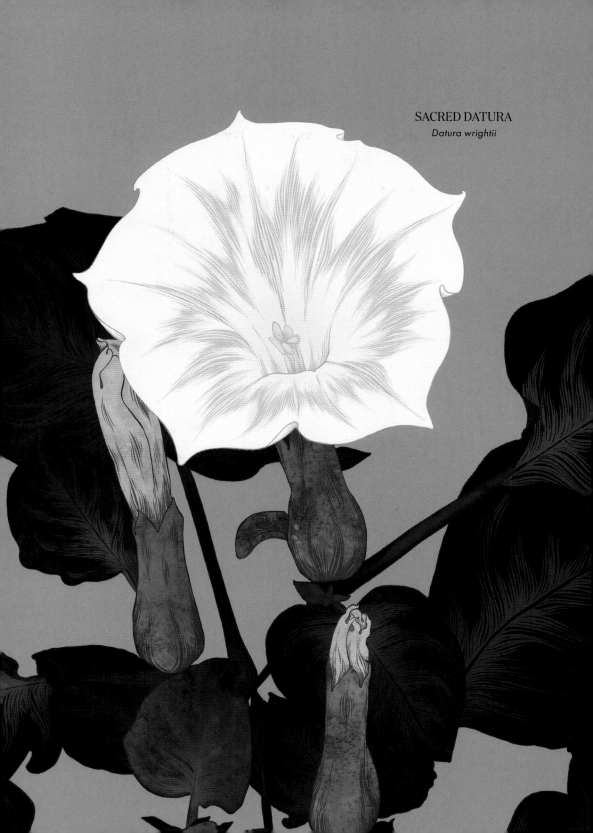

SACRED DATURA
*Datura wrightii*

# GOLDEN CHALICE VINE
*Solandra maxima*

Bats love these giant, cup-shaped yellow flowers,
which emit a heady fragrance at night.

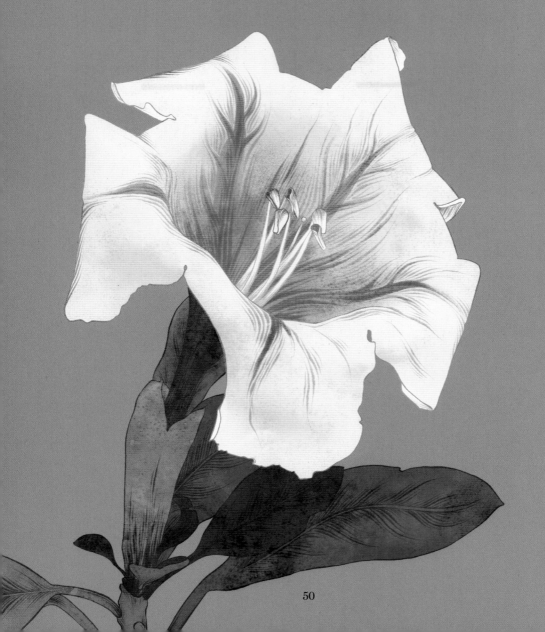

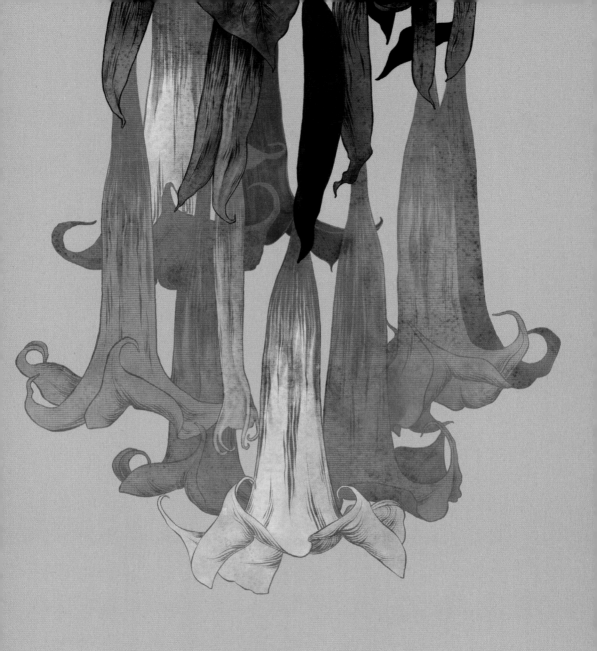

ANGEL'S TRUMPET

*Brugmansia suaveolens*

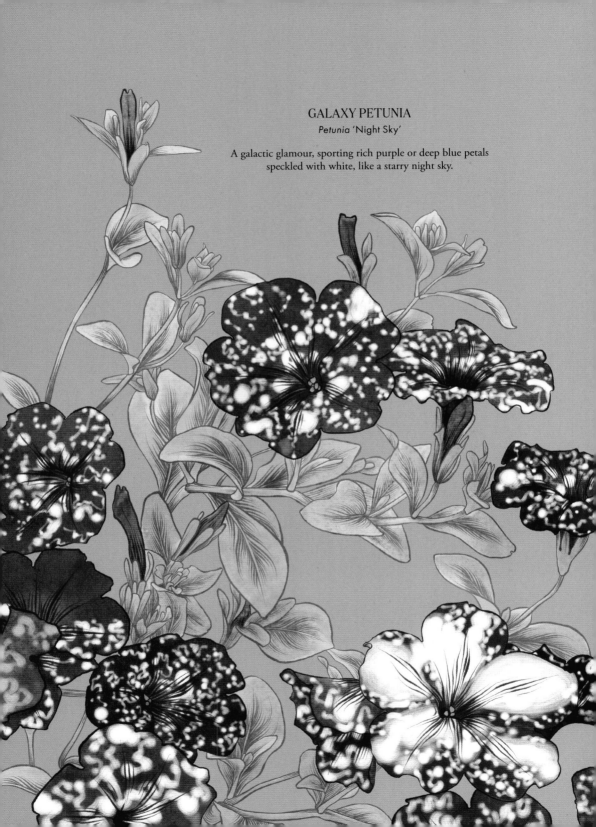

# GALAXY PETUNIA
*Petunia 'Night Sky'*

A galactic glamour, sporting rich purple or deep blue petals
speckled with white, like a starry night sky.

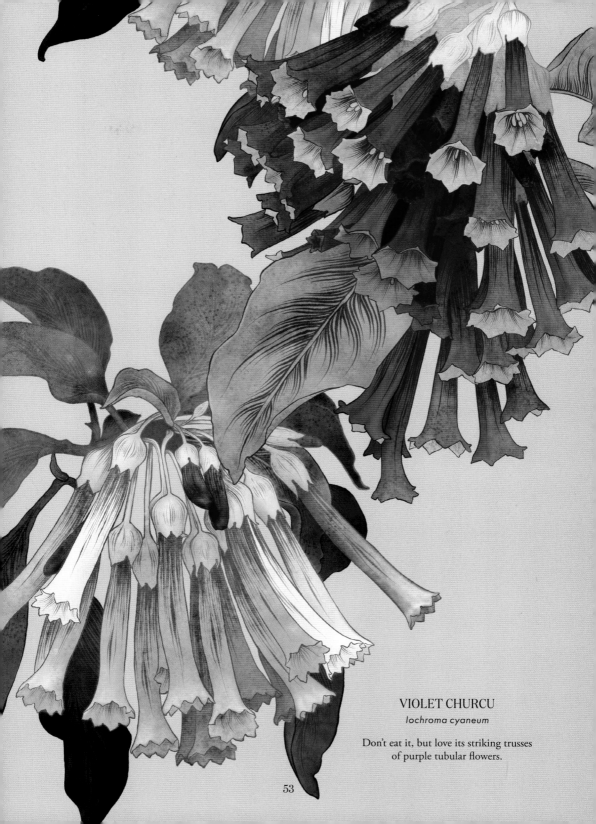

**VIOLET CHURCU**

*Iochroma cyaneum*

Don't eat it, but love its striking trusses
of purple tubular flowers.

53

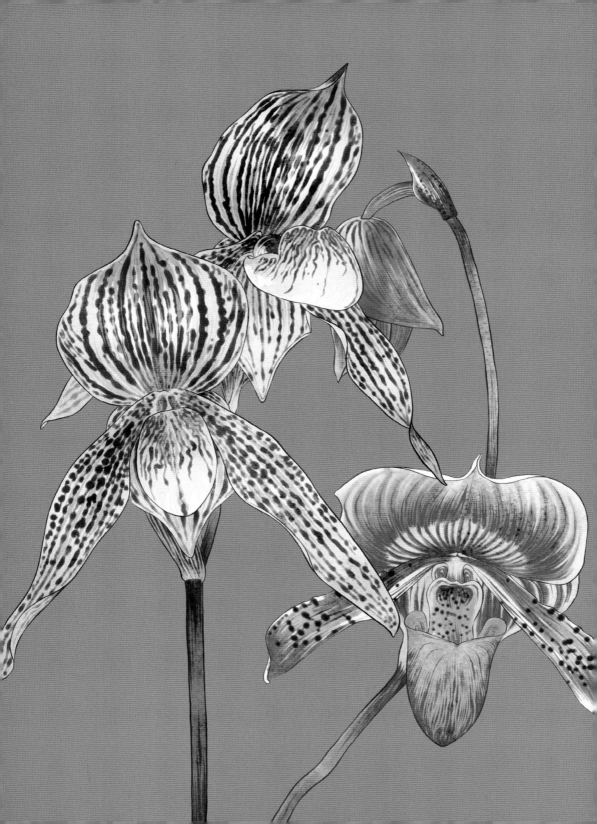

# ORCHID

ORCHIDACEAE

O rchids have been here since dinosaurs stomped the earth, since Confucius bestowed his wisdom on the world, since obsessed plant hunters searched for the rarest of the rare. They are the biggest family of flowering plants.

Pick a continent – any except Antarctica – and find an orchid. With 26,000-plus species and more than 100,000 cultivars, these protean plants are a family of biodiverse survivors, colonising deserts, swamps, cloud forests and bamboo woods, adapting and thriving in obscure ecological environments. They can be terrestrial, forming chunky underground tubers; subterranean, uniquely able to bloom underground; epiphytic, with aerial roots sucking nutrients and water through the air; or saprophytic, feeding off dead organic matter. Some orchids smell rank, others aromatically sublime. Some are breathtaking, others resemble slime.

## NIGHT-FLOWERING ORCHID (*BULBOPHYLLUM NOCTURNUM*) FROM PAPUA NEW GUINEA FLOWERS FOR ONE NIGHT ONLY.

This diverse group of plants is full of surprises. Orchid flowers have a zygomorphic structure, a pleasing bilateral symmetry, like that of a face. But the plant etymology points to another part of the body: 'orchis' is the Greek word for testicles. Early English common names for the orchid included 'dogstones' and 'hares' bollocks'.

Conversely, in China and Japan, orchids symbolise refinement and grace. Capturing the mystique of an orchid on canvas was considered a great skill in eighteenth-century China, where the flowers were also thought to ward off evil spirits – instructional art manuals suggested a touch as 'light as a dragonfly' and swift brushstrokes to mimic 'the tail of a soaring phoenix'.

Later, in the second half of the nineteenth century, orchidelirium swept Europe. Plant hunters were dispatched to find lost orchid specimens in the woods of Central America or unknown cattleya in Brazil. In the swampy forests of Florida, they searched for the endangered ghost orchid (*Dendrophylax lindenii*), a spooky, leafless plant also called white frog orchid because its dangly appendages resemble a ghoulish jumping amphibian. It can be pollinated only by the giant sphinx moth, whose proboscis is long enough to reach the nectar at the bottom of the plant's long spur.

Another noteworthy orchid is vanilla (*Vanilla planifolia*), first introduced to Spanish explorers by the Aztec ruler Montezuma in the sixteenth century. Montezuma's favourite drink was *chocolatl*, a frothy, bitter brew of ground cacao, vanilla and annatto (chilli), thought to be an aphrodisiac. Vanilla was also used to flavour rum and create spicy, exotic perfumes, and it's still a high-value food crop today.

Yet, despite orchids' ability to survive for millennia, some species are now being over-collected to the point of extinction, including wild terrestrial orchids in Turkey and East Africa, and dendrobium orchids, used in eastern medicine. One of England's last remaining lady's slipper orchids (*Cypripedium calceolus*) was put under armed guard in 2010 to protect it from thieves. Unscrupulous collectors will pay thousands for specimens on the black market, endangering these precious plants that hold our histories in their petals.

Previous:

## SLIPPER ORCHID

*Paphiopedilum Saint Swithin (Philippinense × rothschildianum)*
*and Paphiopedilum hsinying rubyweb*

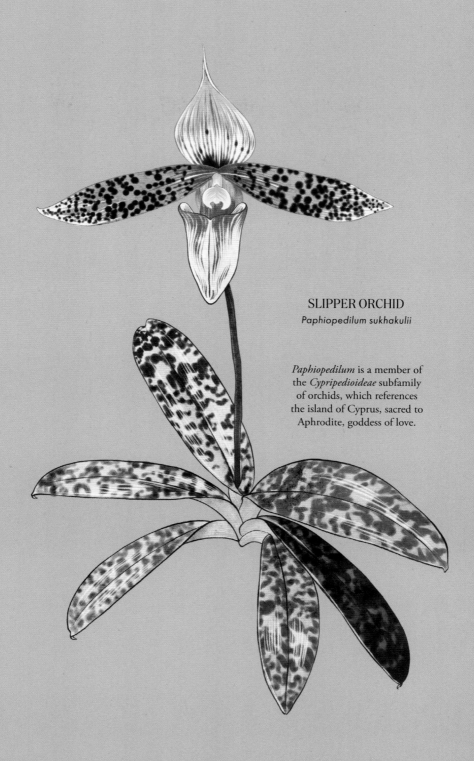

SLIPPER ORCHID

*Paphiopedilum sukhakulii*

*Paphiopedilum* is a member of
the *Cypripedioideae* subfamily
of orchids, which references
the island of Cyprus, sacred to
Aphrodite, goddess of love.

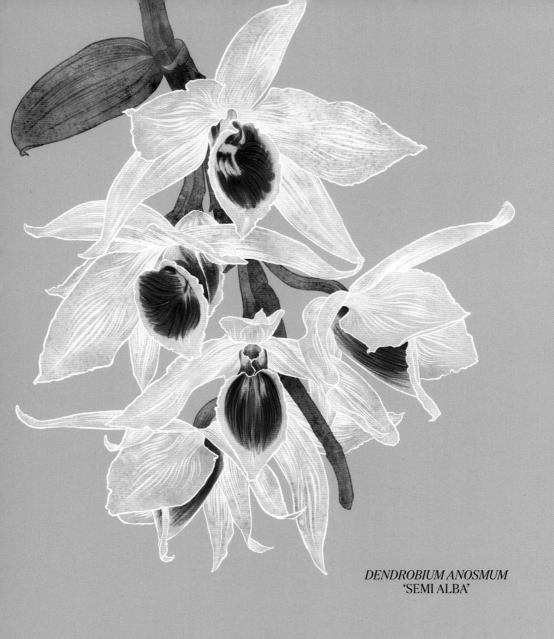

*DENDROBIUM ANOSMUM*
'SEMI ALBA'

Orchids evolved during the Cretaceous period over 100 million
years ago, when small dinosaurs may have been pollinators.

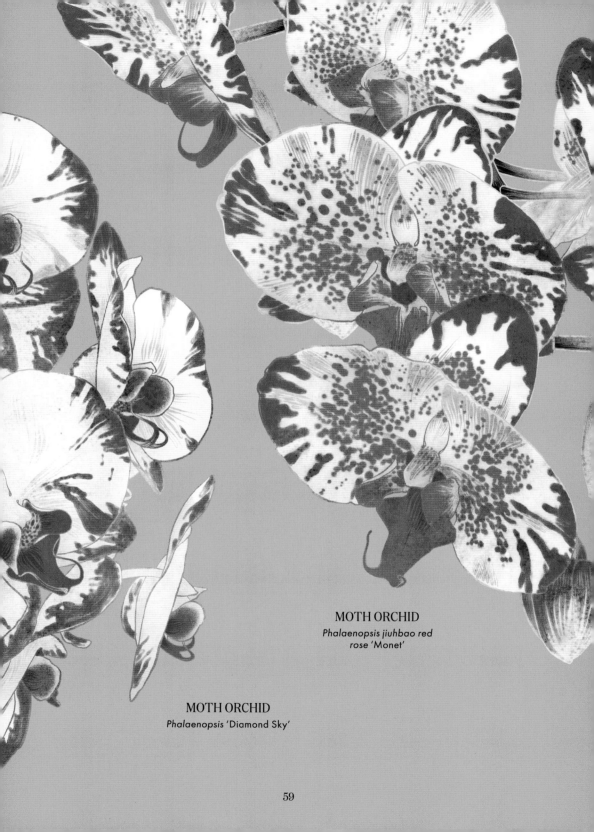

**MOTH ORCHID**
*Phalaenopsis jiuhbao red
rose 'Monet'*

**MOTH ORCHID**
*Phalaenopsis 'Diamond Sky'*

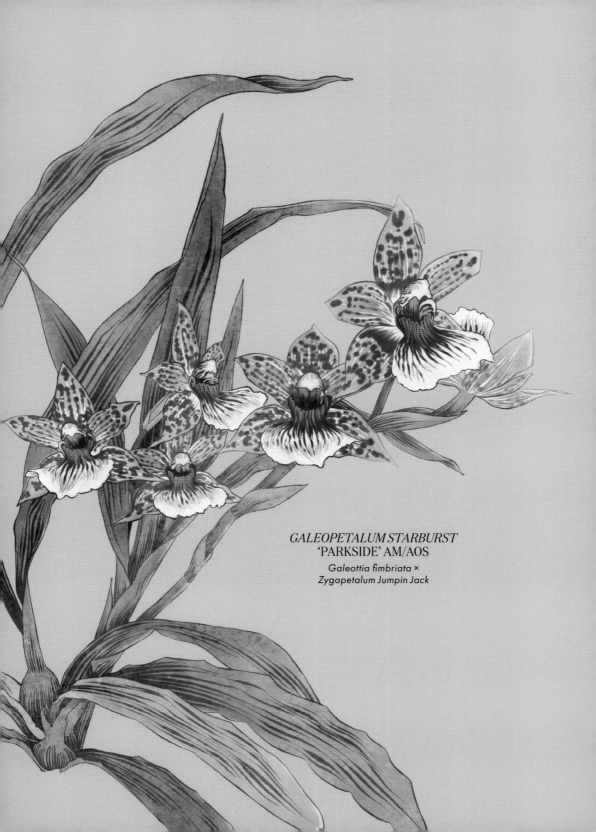

*GALEOPETALUM STARBURST*
'PARKSIDE' AM/AOS

*Galeottia fimbriata* ×
*Zygopetalum Jumpin Jack*

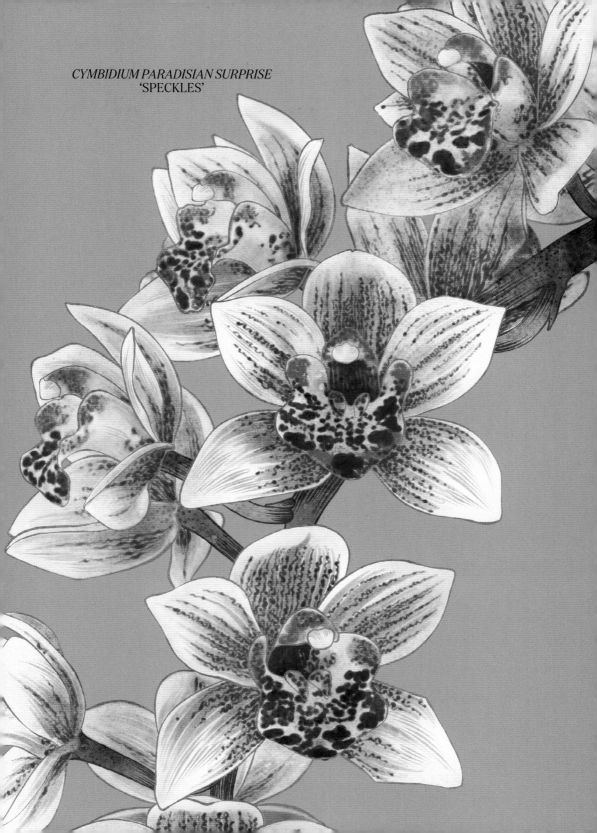

CYMBIDIUM PARADISIAN SURPRISE
'SPECKLES'

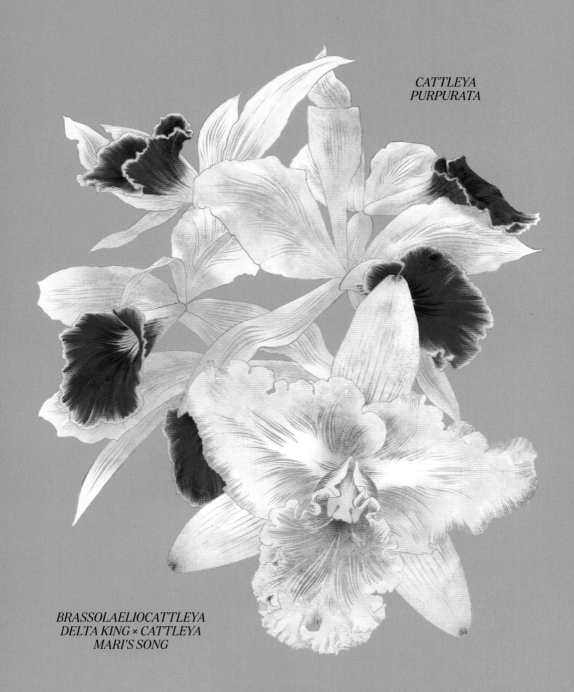

*CATTLEYA
PURPURATA*

*BRASSOLAELIOCATTLEYA
DELTA KING × CATTLEYA
MARI'S SONG*

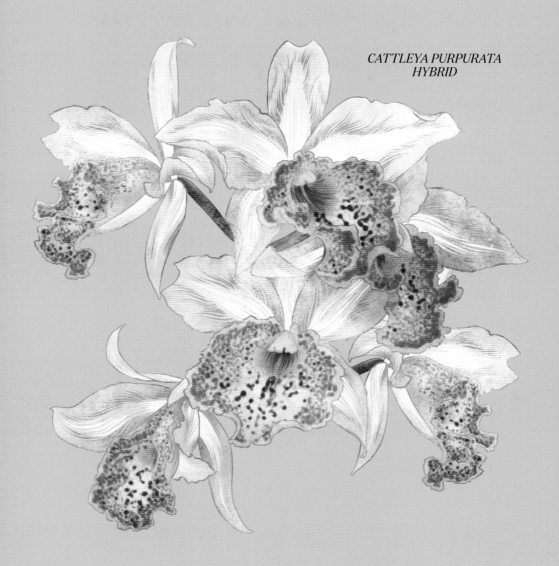

*CATTLEYA PURPURATA HYBRID*

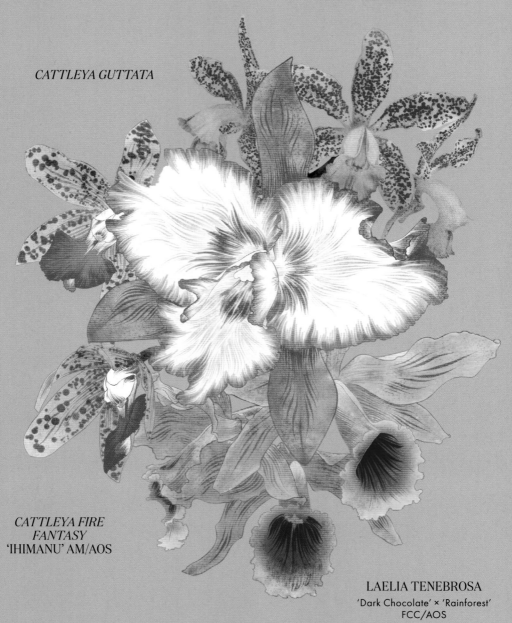

CATTLEYA FORT MOTTE
'LEOPARD'

CATTLEYA GUTTATA

CATTLEYA FIRE
FANTASY
'IHIMANU' AM/AOS

LAELIA TENEBROSA
'Dark Chocolate' × 'Rainforest'
FCC/AOS

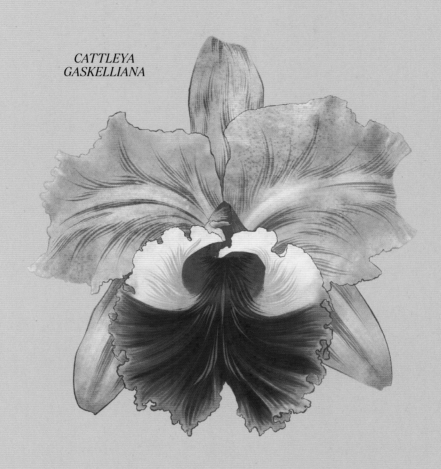

CATTLEYA
GASKELLIANA

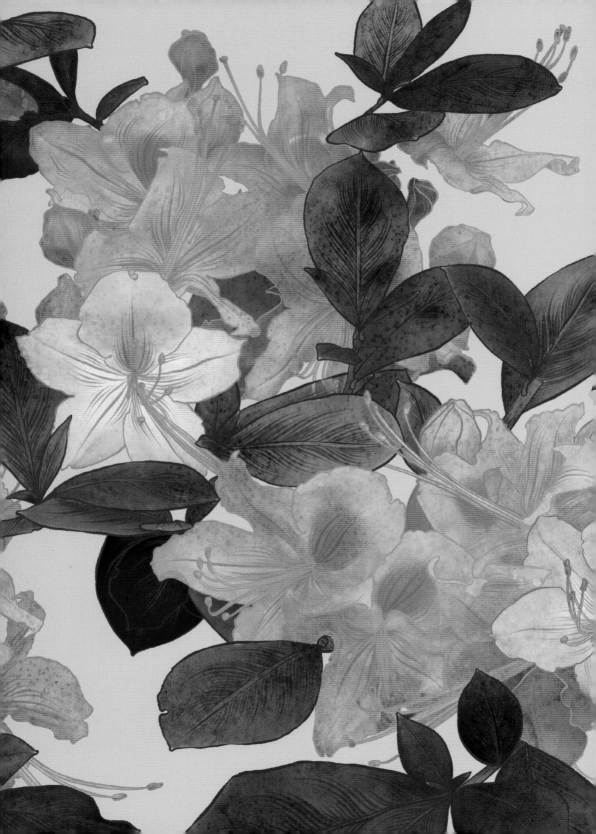

# HEATH

ERICACEAE

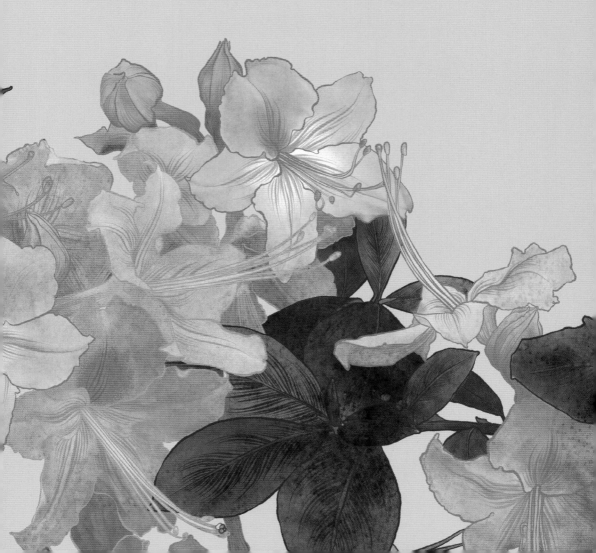

In the remote region of the Eastern Himalaya, nineteenth-century plant hunters searched for novel species of rhododendrons and azaleas – the cool-climate, rain-loving bloomers of the Ericaceae family.

Rhododendrons and azaleas had been grown in European gardens for years, introduced in the sixteenth century from their native China, the Mediterranean and the Appalachian Mountains, but zealous collectors and botanists were desperate for new species. They funded expeditions for horticultural hunters to journey to the 'azalea cradle': a heartland for the plants on the low-altitude peaks and snowy kingdoms of Yunnan, Sikkim, Tibet and Sichuan.

Some of the first westerners granted access to these lands, the plant hunters travelled and camped for months, even years, battling isolation and freezing conditions, but returned to Europe with thousands of novel specimens. Rhododendromania swept the continent. Collectors were intrigued and inspired by the evergreen trees and shrubs, with their glossy green leaves and voluptuous blooms of hot pinks, reds and oranges, that had thrived among thick carpets of snow.

**VICTORIAN-ERA GARDENERS SPENT COLLECTIVE MILLIONS ACQUIRING SEEDS OF THESE CULT NEW AND EXOTIC BEAUTIES.**

But rhododendrons, meaning 'rose tree', should have come with a cautionary note, for their ability to flourish in alpine and coastal climes, along with the humid jungles of Borneo, mean they are survivors, able to out-compete most natives.

Obsession turned to anger as newspapers described rhododendrons as 'ruthless triffids', strangling the wildflowers and woodlands of Snowdonia. *Rhododendron ponticum* was the main culprit, colonising native habitats and repelling wildlife with its toxic leaves. It's still a major environmental problem in some countries to this day.

But not all Ericaceae are destroyers. There's *Rhododendron kesangiae*, which grows far above sea level, a celebrated tree in its native Bhutan symbolising beauty and purity, with rose-pink flowers that fade to purple. And in Scotland's north-west Highlands grows a world first: a magical rhododendron thought to be coloured by the spectrum of light bouncing off rainbows. *Rhododendron macabeanum* 'Flora Pi Lo' has multicoloured flowers – dusky pinks, yellows and white – all on the same plant. It's at Inverewe Garden in the tiny village of Poolewe where high rainfall, acidic soil and the effects of the Gulf Stream create a rare microclimate. The garden's head horticulturalist is convinced a season with an unusually high number of rainbows, including triple rainbows, is the reason for the hybrid's distinctive blooms.

Rhododendrons and azaleas have made themselves at home in gardens around the globe, and while they might no longer be exotic, they're still magnificent, their blooms telling tales of exploration, history and high glamour.

Previous:
*RHODODENDRON* 'GARDEN RAINBOW'

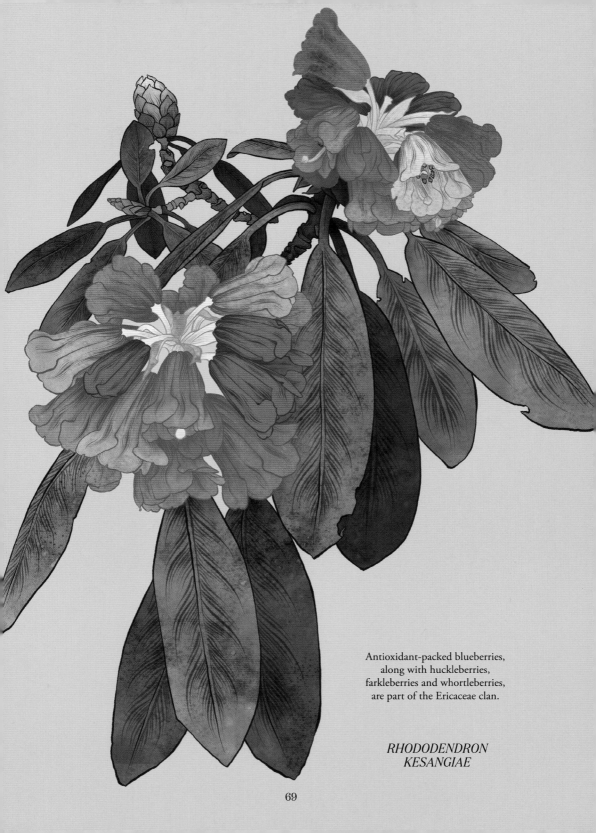

Antioxidant-packed blueberries,
along with huckleberries,
farkleberries and whortleberries,
are part of the Ericaceae clan.

*RHODODENDRON*
*KESANGIAE*

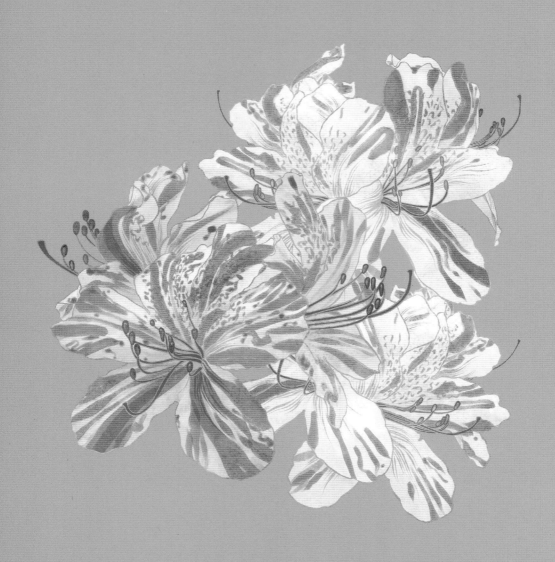

GLENN DALE AZALEA 'CINDERELLA'

*Rhododendron hybrida Glenn Dale*

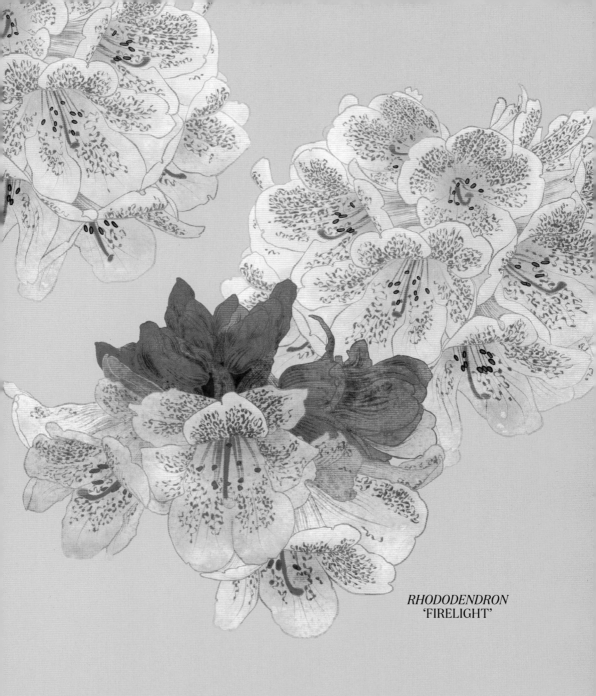

*RHODODENDRON*
'FIRELIGHT'

Pastel-coloured rhododendrons often have strong, spicy fragrances
to attract insects, whereas more flamboyant rhododendrons use
their showy colours to lure pollinators.

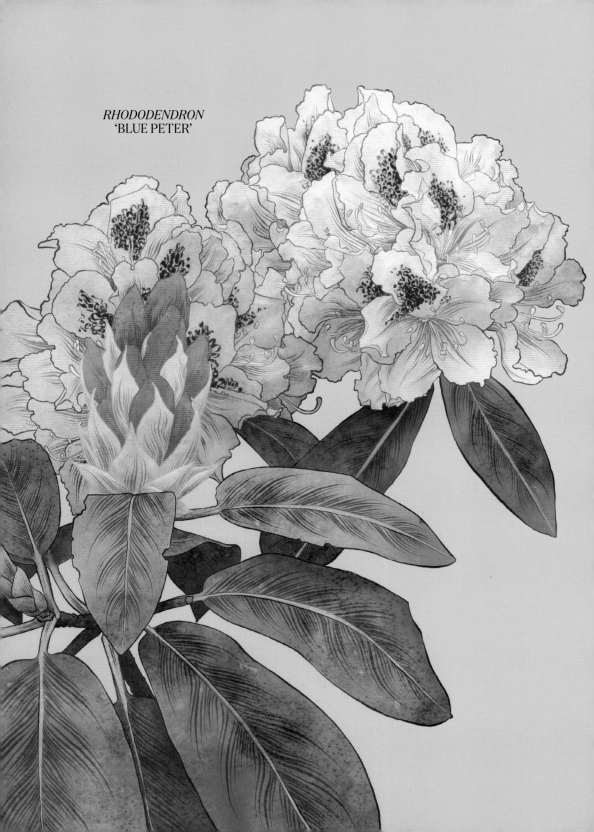

RHODODENDRON
'BLUE PETER'

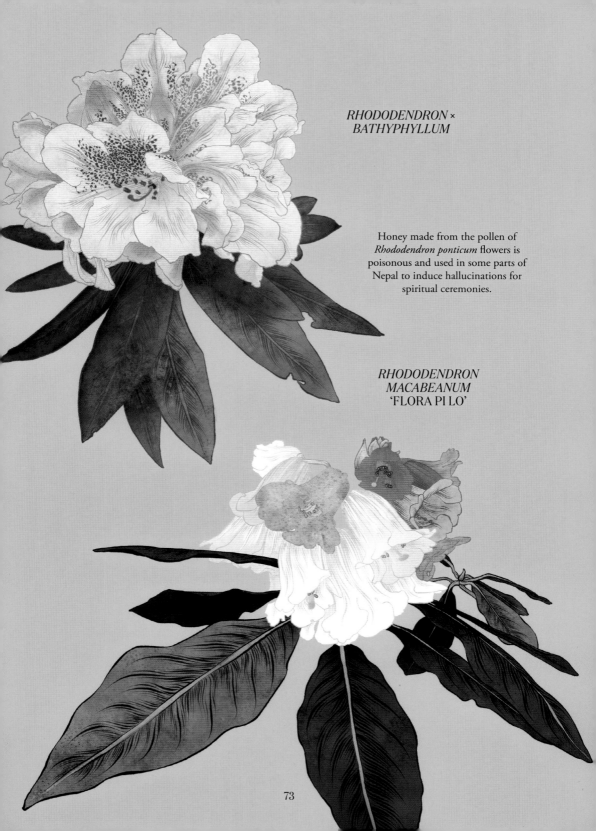

*RHODODENDRON ×*
*BATHYPHYLLUM*

Honey made from the pollen of
*Rhododendron ponticum* flowers is
poisonous and used in some parts of
Nepal to induce hallucinations for
spiritual ceremonies.

*RHODODENDRON*
*MACABEANUM*
'FLORA PI LO'

73

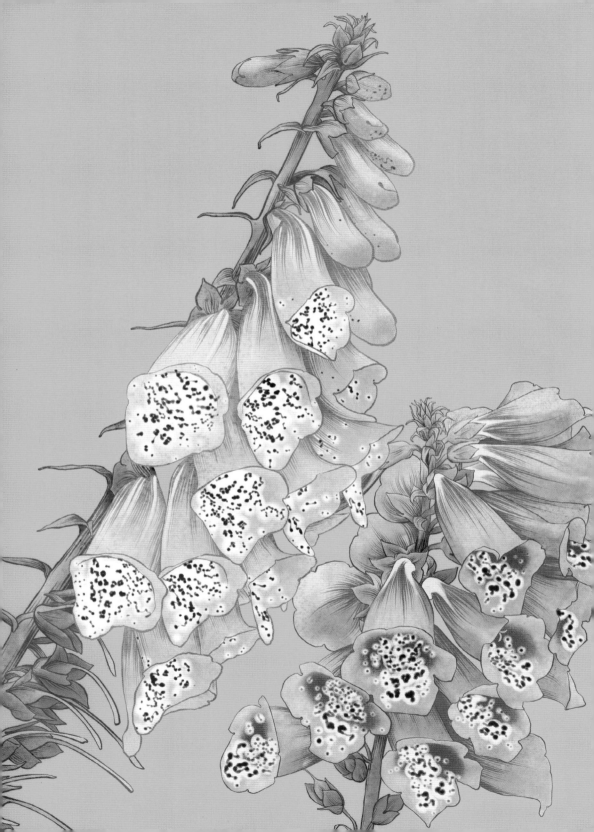

# PLANTAIN

PLANTAGINACEAE

I t can raise the dead and it can kill the living' warns the ancient adage about the potent, poisonous common foxglove (*Digitalis purpurea*), as strikingly beautiful as it is lethal. Used for centuries as a heart remedy, this powerful plant is linked to faeries and witchcraft, midwifery and medicine.

Native to Western Europe, foxgloves thrive in open woodlands and meadows, and on cliffs and slopes by the sea. Their tall, upright spires have small, thimble-shaped flowers that look like tiny bells, or the fingers of a small glove to fit a fox's paw. In European folklore, foxglove is a sacred flower used by witches to commune with the faeries or to help break enchantments. Legend tells of bad faeries giving the blossoms to foxes to help muffle their steps, or teaching foxes to 'ring' the tubular flowers, sounding a warning hunters were on the way. Planting foxgloves in the garden was a welcome invitation to faeries, but bringing them inside as cut flowers was an invitation to the devil.

**WELSH LORE SUGGESTS FOXGLOVES BOW AND BEND NOT BECAUSE OF THE WIND BUT IN RECOGNITION OF PASSING FAERIES AND SPIRITUAL BEINGS.**

In the wild, foxglove's flowers are purple with prettily speckled throats, but modern-day foxglove can be white, bright yellow, cerise or a warm chocolatey brown, such as the small-flowered foxglove (*Digitalis parviflora*). They are profuse bloomers, their jam-packed seedpods loved by hummingbirds, and bees will climb right inside the flower to collect pollen.

Foxglove is sometimes called 'witches' gloves' or 'granny's gloves' and has long been associated with women's magic, its remedial powers used by folk herbalists and medicine women. But it was the English botanist and doctor William Withering that documented foxglove as the world's original cardiac medicine in 1875. He used extracts (for the science lovers: cardiac glycosides called digoxin and digitoxin) from the plant's leaves to cure dropsy, a build-up of excess fluid in the body, usually due to congestive heart failure. Digitalis is still the active compound in modern-day drugs prescribed for heart complaints.

Further medical legend involves van Gogh, who may have been prescribed digitalis by his physician, Dr Gachet, to (ineffectually) treat his epilepsy. High concentrations of digoxin can have the side effect of xanthopsia, a colour vision deficiency where everything seems tinged with yellow, and lights look splayed with haloes; it can also cause unequal-sized pupils. Art historians have pondered van Gogh's portraits of Dr Gachet (both with a foxglove) and van Gogh's differently sized pupils in self-portraits, positing that digitalis could explain his 'yellow period' and haloes in the sky of *Starry Night*.

Ever the centre of a good story, foxglove has been used as a murder weapon in fictional tales from Agatha Christie's 1938 novel *Appointment with Death* to the cult TV crime show *CSI*.

Previous:

COMMON FOXGLOVE

*Digitalis purpurea*

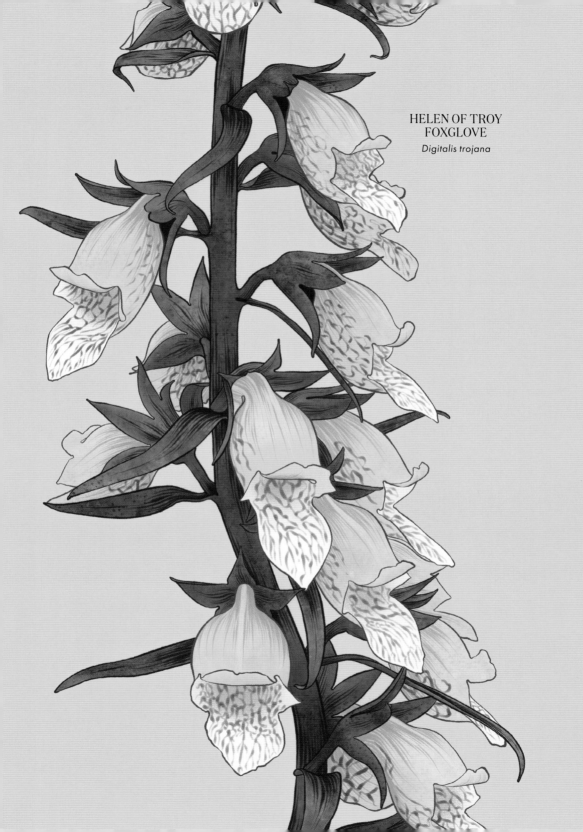

HELEN OF TROY
FOXGLOVE
*Digitalis trojana*

Roman mythology tells of Flora, the goddess of flowers and
fertility, touching Juno on her breasts and belly with a foxglove;
later, Juno conceived, giving birth to Mars.

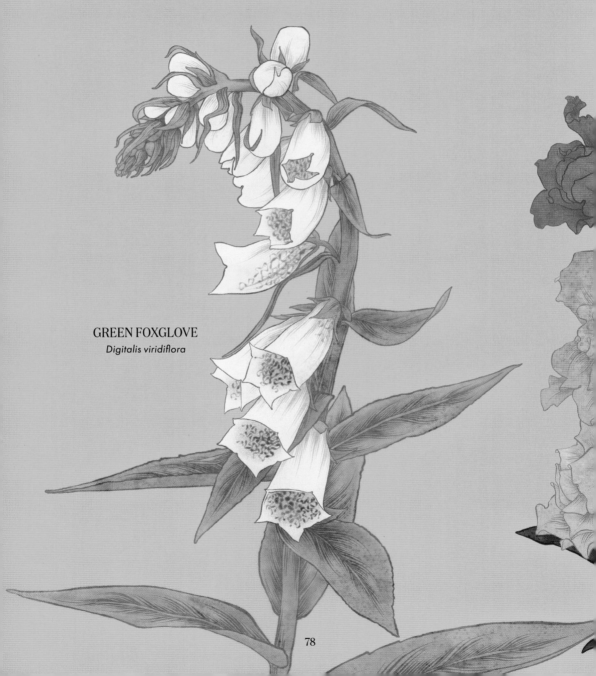

## GREEN FOXGLOVE
*Digitalis viridiflora*

SNAPDRAGON 'MADAME
BUTTERFLY' BRONZE

*Antirrhinum majus 'Madame Butterfly'*

SNAPDRAGON
'APPLE BLOSSOM'

*Antirrhinum majus 'Apple Blossom'*

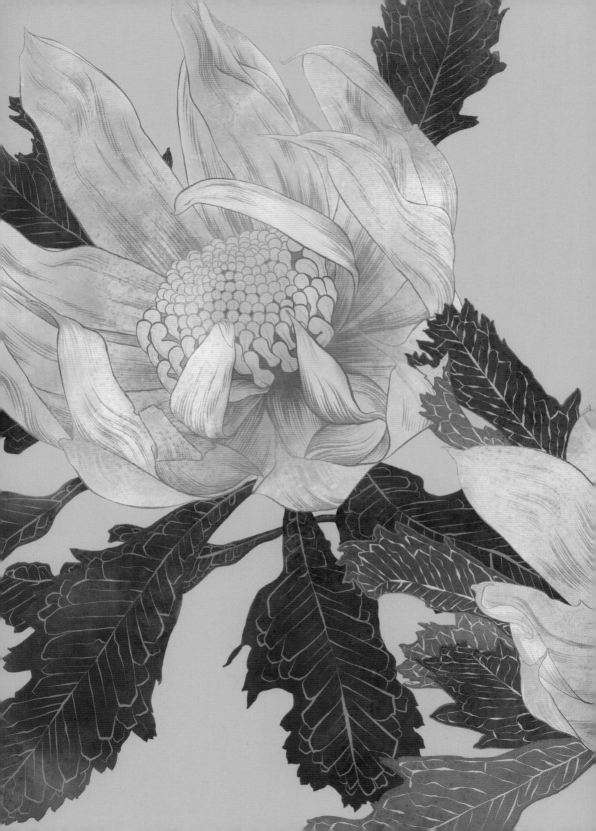

# PROTEA

PROTEACEAE

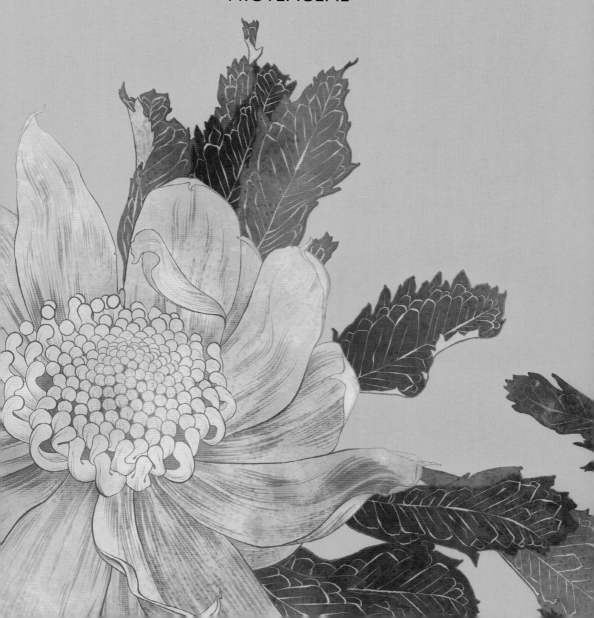

Proteaceae are some of the world's oldest flowering plants, an archaic family holding mysteries in their velvety bracts and tough, leathery leaves. They formed 180 million years ago on the ancient supercontinent of Gondwanaland, where rainforests grew and dinosaurs roamed. During the Jurassic period, the supercontinent began to separate, slowly drifting to form the world's landmasses as we know them today. Proteas and leucadendrons hitched a ride to South Africa, while Australia kept the lion's share of waratahs, banksias, hakeas and grevilleas. Lightweight, aerodynamic seeds blew across the Atlantic and Indian oceans, creating a wider spread of species, all sharing the same ancestral information despite living continents apart.

Ancient Greeks named Proteaceae after the sea god and shape-shifter Proteus, son of Poseidon, because of the family's vast variety of sizes, textures and shapes. King protea (*Protea cynaroides*) is a fine example, a magnificent, vigorous beauty with giant crown-shaped flowerheads that bloom deep crimson, dusky pink or yellowy white. A single shrub may produce only six flowers – colourful beacons in the silvery, grey-green bush of South Africa's biodiverse Cape Floristic Region. Another Cape local is the nectar-rich sugar bush (*Protea repens*), a long-known source of sustenance and used medicinally as cough medicine since the nineteenth century. Nectar is collected by shaking the flowerheads, then boiled to make 'bossiestroop' (bush syrup).

**RICH IN NECTAR, THIS FAMILY IS POLLINATED BY HONEYEATERS, BEETLES, BEES AND POSSUMS, ALL HUNTING FOR SWEET SYRUP.**

Across the Indian Ocean, another Proteaceae rich in nectar grows in the sandstone soils around Sydney: mountain devil (*Lambertia formosa*). Children have long loved to pull the red flower apart and suck the sweet liquid from its little tubes. The clear honey-like syrup of the mountain devil was a source of food for Indigenous Australian people, and provided sustenance for escaped convicts during European colonisation. The crunchy and nutritious macadamia nut (*Macadamia integrifolia*) is also native to Australia, but some of the biggest commercial orchards are located in Hawaii and South Africa.

The New South Wales waratah (*Telopea speciosissima*), with its bright-red, symmetrical flowerheads, is used ceremoniously in Indigenous rituals. One Dreamtime legend tells of a woman cloaked in wallaby fur, the pelts decorated with feathers from the gang-gang cockatoo. When her lover failed to return from battle she was broken-hearted, dying of grief, and it was there the first waratah grew.

Waratah habitats are often completely destroyed by bushfires in summer but this clever plant has adapted to regenerate from a lignotuber, an underground bunker stocked with buds and food. Proteaceae roots are able to access nutrients from poor sandy soils developed long ago, giving them the power to survive drought and tough terrain. This hardy, resilient family is not just strikingly beautiful – it's a strong symbol for the harsh landscapes it inhabits.

Previous:

WARATAH

*Telopea speciosissima 'Pink Passion'*

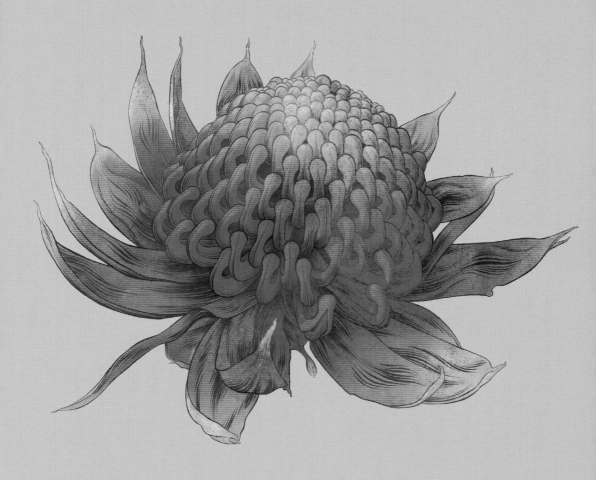

## WARATAH
*Telopea speciosissima*

Australian artist Margaret Preston is famous for her
beautiful hand-coloured woodcuts of waratahs.

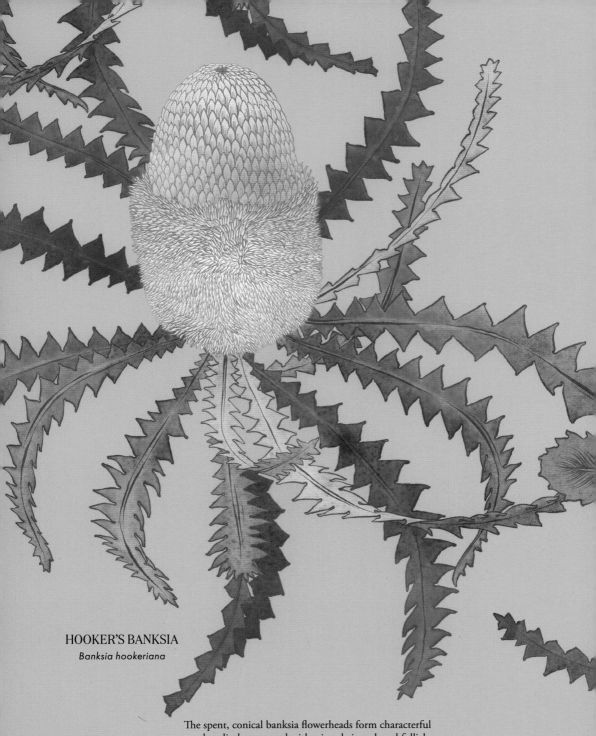

## HOOKER'S BANKSIA
*Banksia hookeriana*

The spent, conical banksia flowerheads form characterful
woody cylinders covered with wispy hair and seed follicles
like multiple eyes – no wonder they came alive as the villainous
Big Bad Banksia Men in May Gibbs' Gumnut stories.

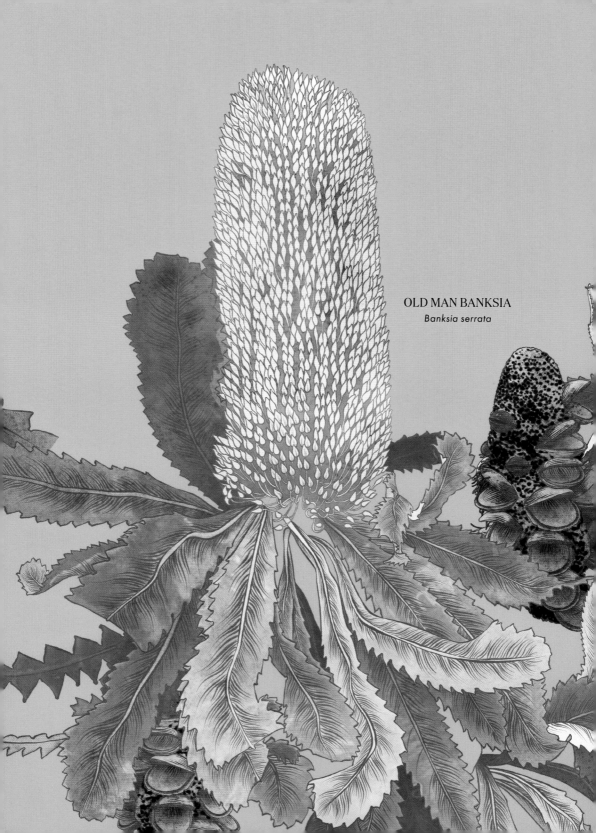

OLD MAN BANKSIA
*Banksia serrata*

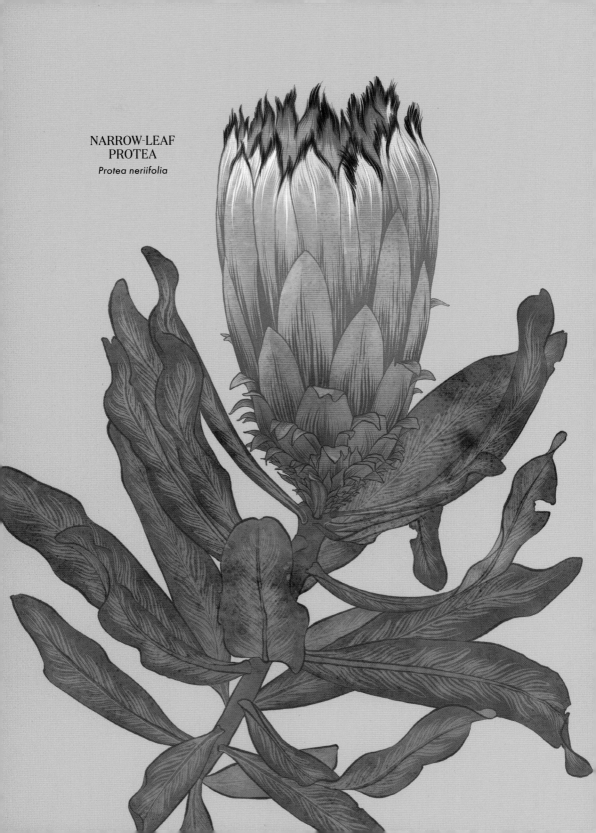

NARROW-LEAF
PROTEA
*Protea neriifolia*

# KING PROTEA
*Protea cynaroides*

The biggest flowers in the family, growing up to
30 centimetres (about 12 inches) wide, they are also South Africa's
national flower and the name of the country's international cricket team.

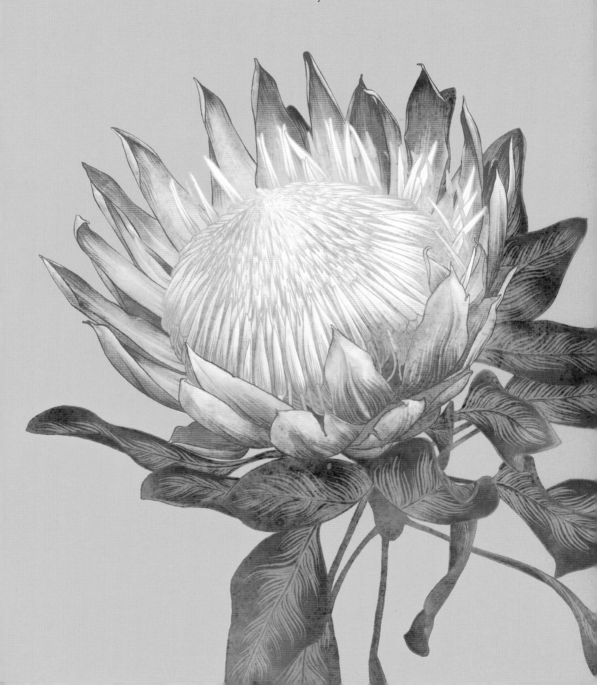

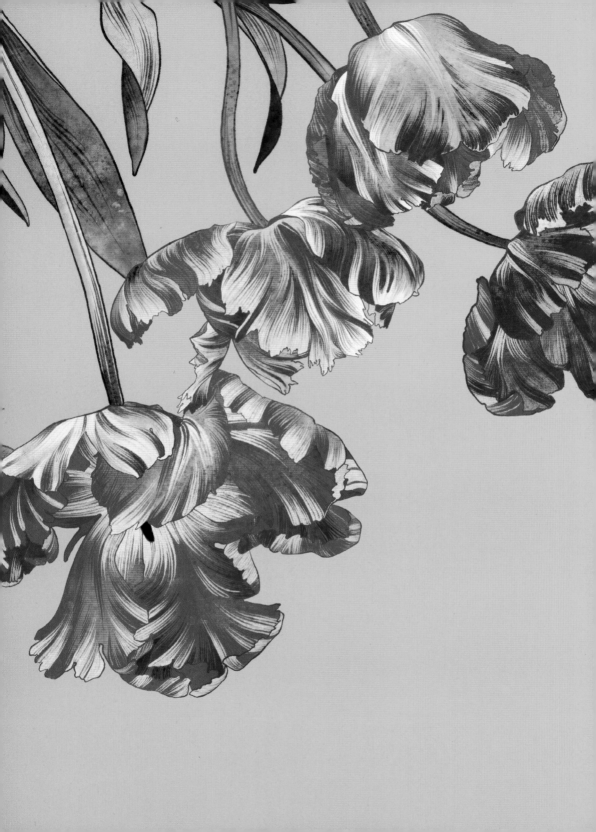

# LILY

LILIACEAE

Behold the tulip, the most notorious of all Liliaceae. This humble bloom sparked the crazy-making frenzy that swept seventeenth-century Europe, causing the economic crash of the century.

Tulips originally came from the Tian Shan and Pamir mountains of Central Asia but had long been cultivated by smitten growers in the Ottoman Empire. During the period of florilegia, when the fashionable new art form of botanical illustration was at its zenith, it was these rare and exotic 'Turkish tulips' that really set investors' hearts racing. Then, when the flowers themselves travelled to Europe, tulipmania really took off.

There was an unprecedented market for buying and selling tulip bulbs, spelling untold wealth for canny traders – and financial doom for the less savvy. The Dutch were the main culprits, with fevered dealings happening in smoky backroom bars, usually with plenty of 'drink taken'. Cobblers, woodcutters and gentlemen gambled acres of land and sold their possessions to be in the race. Bulbs could change hands many times in a single day, with many bought sight unseen, pushing prices to astronomical heights.

## TULIPMANIA GRIPPED THE ENTIRE DUTCH POPULATION, FROM PEASANTRY TO GENTRY.

*Semper augustus*, with its candy-striped crimson and white petals, was the holy grail, the most valuable of all bulbs for its 'broken' colour (the fact that its variegated stripes were caused by a virus is a retrospective irony). Average annual incomes in the Netherlands were about 150 to 300 florin, yet single bulbs of *Semper augustus* fetched about 1000 florin in 1627. A decade later, right before the market crash, a single *Semper augustus* bulb was worth 10,000 florin. Tulipmania is considered the world's first recorded speculative bubble, and even today tulips are a billion-dollar industry, led mainly by the Dutch.

But Liliaceae has a history that reaches much further than the tulip. Evolving more than 52 million years ago, this wondrously fragrant family includes the mountain lilies of Syria and Turkey, lush Asiatics hailing from Japan and Taiwan, the tiger lily (*Lilium humboldtii*) flowering in North America's Rocky Mountains, and the regal lily (*Lilium regale*) in the valleys of Sichuan and Tibet. Lilies were used in fragrant garlands (along with crocuses and narcissuses) to adorn the goddess Aphrodite in ancient Greece, and were found in the tombs of ancient Egyptian pharaohs. Their leaves have been used medicinally throughout history to cure snakebite and soothe burns and ulcers.

Another venerated Liliaceae is the Madonna lily (*Lilium candidum*), sacred to the Minoans of the Bronze Age and to the ancient Romans, who immortalised its image in ancient wall frescoes and artefacts. Cultivated for more than 3500 years by the Greeks, the Madonna lily was a symbol of the virgin Mary's purity. It appears in many important artworks, including Sandro Botticelli's *Cestello Annunciation*.

One story from ancient Roman mythology tells of Juno, the goddess of Rome, queen of the Roman pantheon, and wife of Jupiter. Soon after Juno gave birth to Hercules, she was breastfeeding her baby before she dozed off to sleep. As Hercules pulled away from his mother's breast, milk spilt – some to earth, from which grew the most fragrant of lilies, and some to heaven, forming the Milky Way.

Previous:

*SEMPER AUGUSTUS*

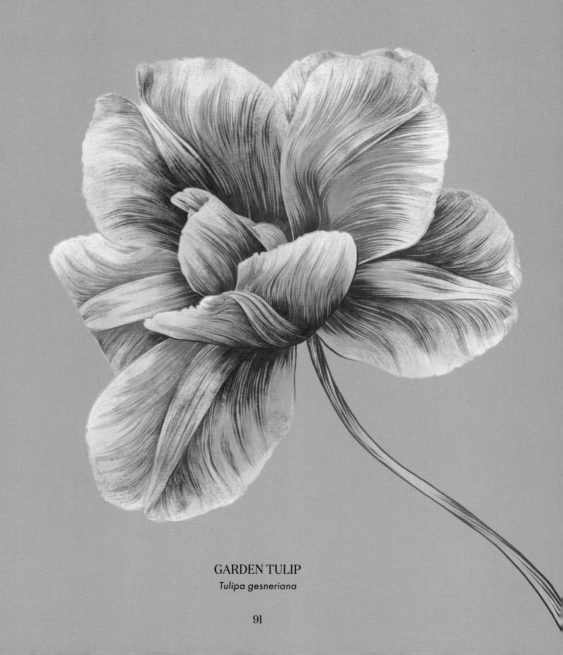

GARDEN TULIP

*Tulipa gesneriana*

91

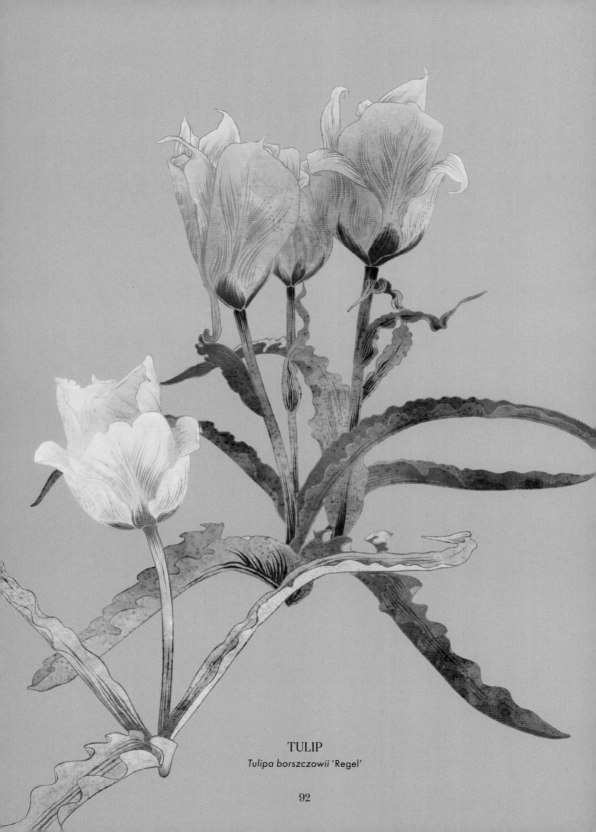

**TULIP**
*Tulipa borszczowii 'Regel'*

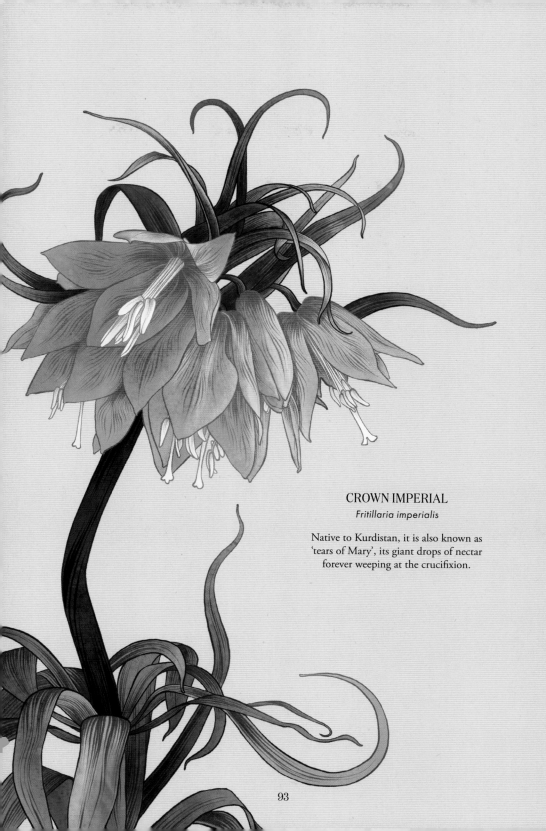

## CROWN IMPERIAL

*Fritillaria imperialis*

Native to Kurdistan, it is also known as
'tears of Mary', its giant drops of nectar
forever weeping at the crucifixion.

PERSIAN LILY

*Fritillaria persica*

# CHESS FLOWER
### *Fritillaria meleagris*

The name comes from its amazing petals, patterned with
red and pale-pink squares resembling a chessboard.

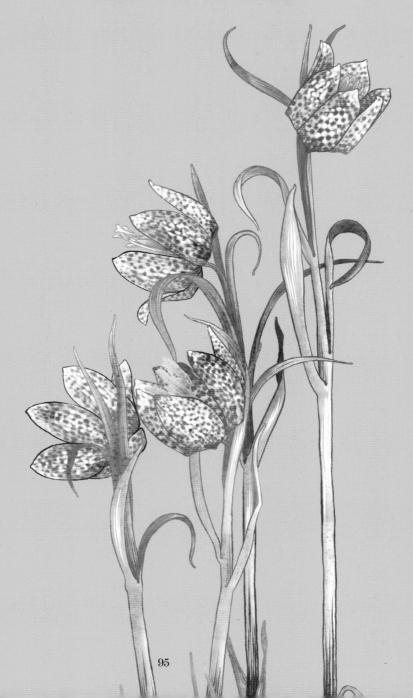

# FORMOSA LILY
*Lilium formosanum*

A stylised fleur-de-lis, which means 'flower of lily', was a powerful symbol of French kings in the fourteenth century and is also the emblem of New Orleans.

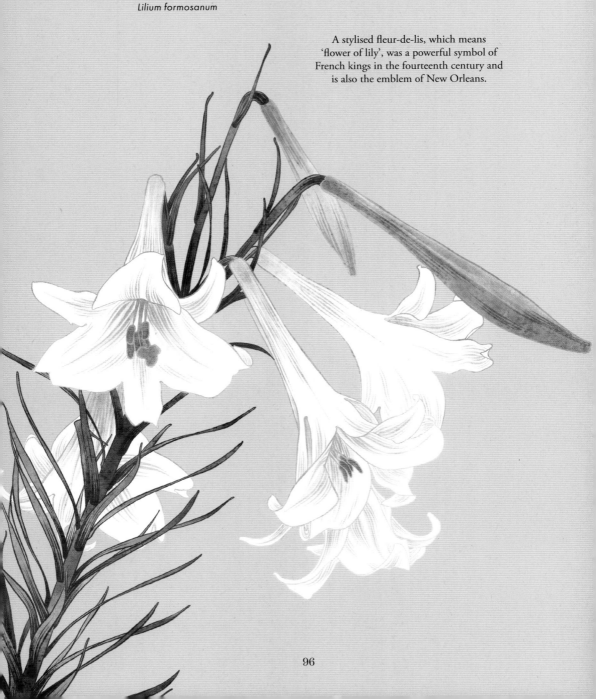

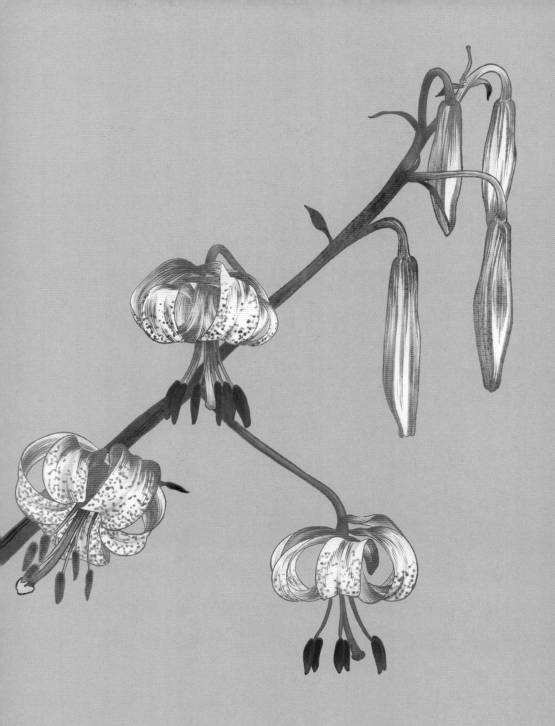

**KELLOGG'S LILY**

*Lilium kelloggii*

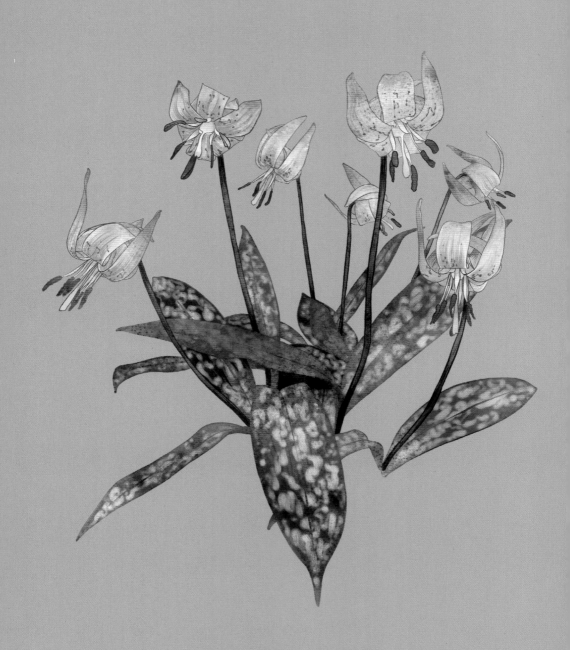

**DOGTOOTH VIOLET**

*Erythronium dens-canis*

98

# DECEIVING TRILLIUM
*Trillium decipiens*

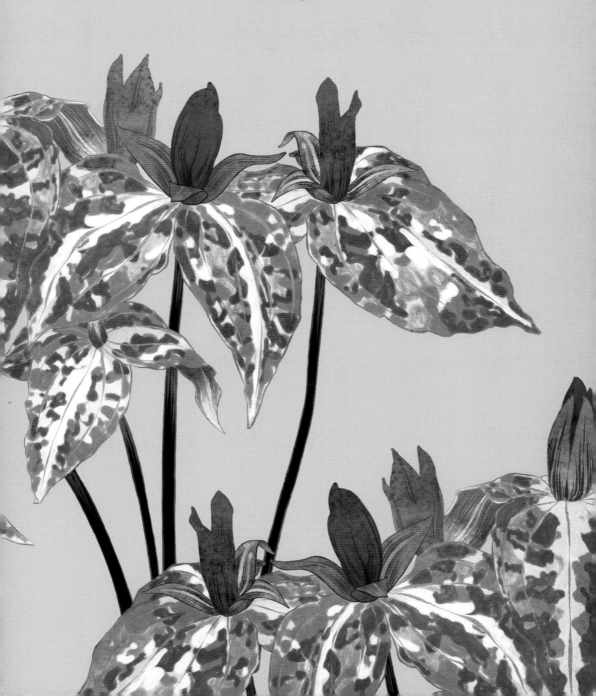

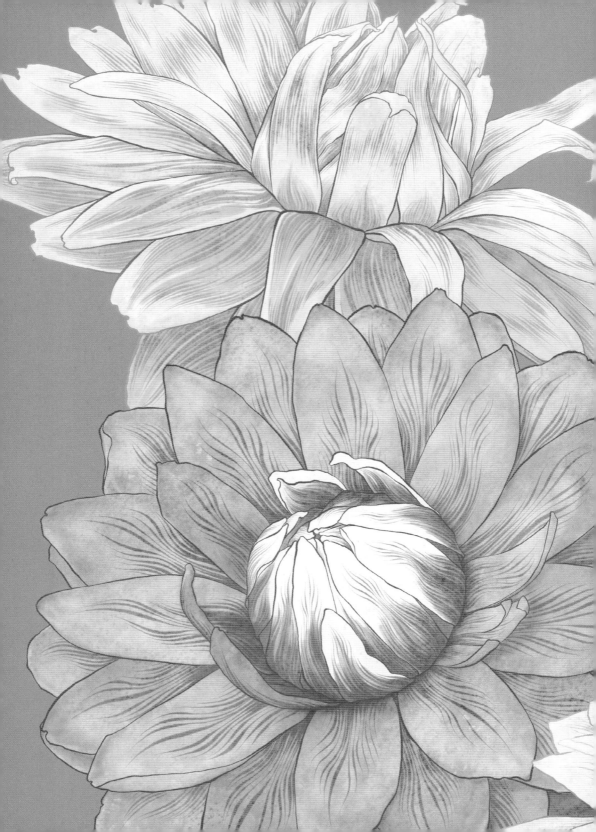

# WATERLILY

## NYMPHAEACEAE

Flourishing in the world's tropical waterways, from the shallow bayous of Amazonia to the hot springs of Rwanda and fertile Paraguayan lagoons, freshwater Nymphaeaceae is a family of aquatic wonders.

Its flowers bloom as tiny as buttons or as big as bowling balls. The family's grandes dames are the giant waterlily (*Victoria amazonica*) and Santa Cruz waterlily (*Victoria cruziana*), majestic mega-plants named in honour of Queen Victoria. Indigenous South Americans used the giant waterlily as medicine, making tea to soothe asthma and other bronchial troubles.

Growing from fleshy underground stems buried in the silty river bottoms, long stalks support the stiff, rimmed leaves of the giant waterlily. The pads have spikes underneath to deter nibbling fish. Their dramatic, solitary flowers bloom but two days a year, and only at night. Slowly, the white female flower rises above the water's surface, releasing a sweet pineapple fragrance, using its heat-producing power to warm its core. Lured by the pungent perfume, native scarab beetles fly inside, searching for nectar. Gently, the petals close around the beetle, keeping it trapped and warm. On the second night, the flower opens once again, this time as a pollinated male, with pink petals. The beetle flits to the next white flower, unaware its sleepover has fertilised the magnificent giant whose flower slowly closes to descend below the water's surface for another year.

> # LILY PADS CAN BE BROAD ENOUGH TO SIT ON OR NO BIGGER THAN A COIN.

These exotic, oversized beauties were a must-have for fashionable greenhouses of nineteenth-century Europe, and French impressionist Claude Monet was so obsessed with Nymphaeaceae he imported a number of rare waterlilies from the Amazon and Egypt for his water garden at his home in Giverny. Local authorities demanded he uproot them, claiming the plants would poison the water supply, but Monet refused, deeply inspired by the ethereal floating pads, distinctive flowers and ephemeral reflections of light on the pond – he painted canvas after canvas.

During this period Monet's wife and son died, and the artist was tortured by his inability to create. Devastated, in mourning, and distraught by a diagnosis of cataracts, it was the garden that healed him and, for the last two decades of his life, he finished his 'Nympheas', a series of 250 oils, all of his precious waterlilies. The works are each now worth more than $50 million.

Another waterlily achieved fame as a victim of a bold horticultural heist at the UK's Royal Botanic Gardens, Kew, in 2014. A pygmy Rwandan waterlily (*Nymphaea thermarum*), the world's smallest and rarest, was spirited from the gardens by a specialist plant thief who scooped a specimen from the damp soil near the pond in the Princess of Wales Conservatory.

A media frenzy ensued, with headlines such as 'Kew-dunnit?' and 'When plant obsession turns criminal' telling the tale of the tiny lily found only on the muddy banks of thermal hot springs in Rwanda, now extinct in the wild, its habitat destroyed. Scotland Yard feared it would be sold on the black market where unethical collectors pay thousands for rare or endangered specimens. Clearly the beauty of waterlilies is enough to drive some people to the limit.

Previous:

## VICTORIA WATERLILY

*Victoria amazonica*

Sometimes called 'alligator lilies' because their
enormous pads provide a perfect reptilian hiding place.

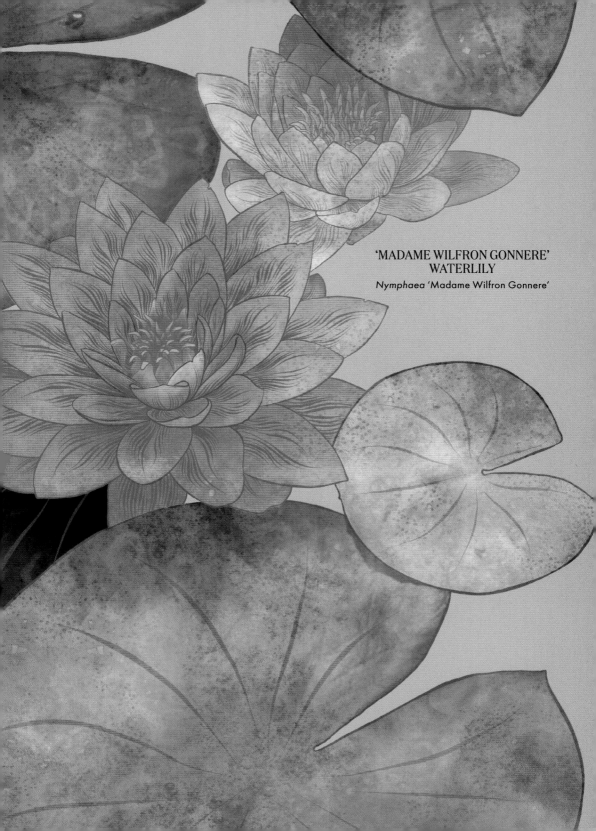

'MADAME WILFRON GONNERE'
WATERLILY

*Nymphaea 'Madame Wilfron Gonnere'*

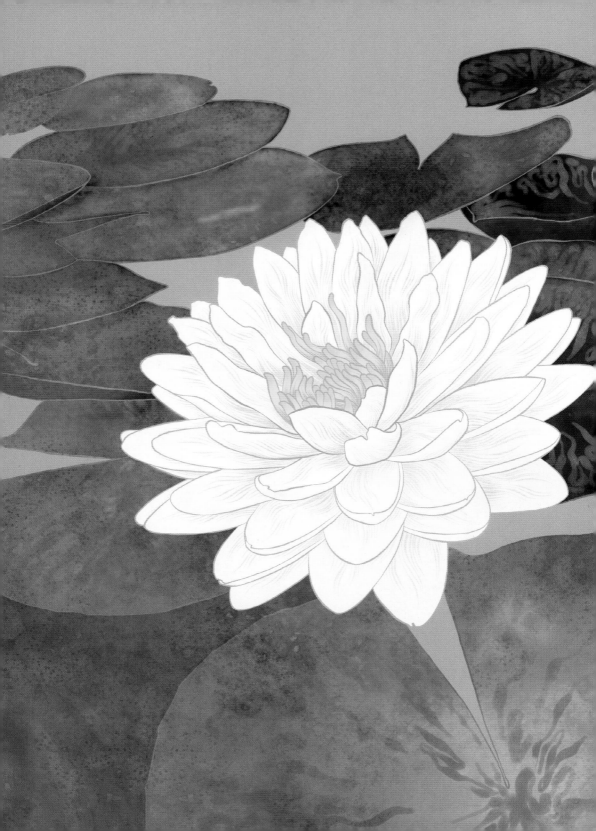

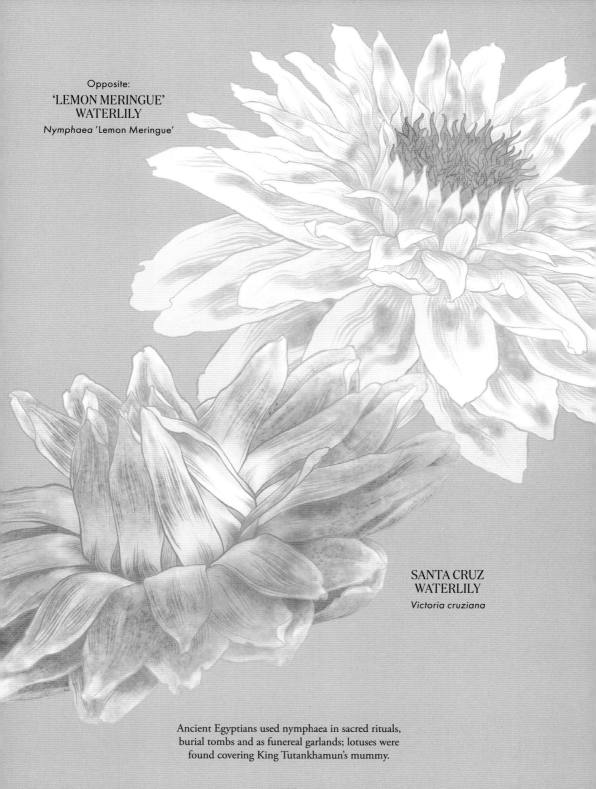

Opposite:
'LEMON MERINGUE'
WATERLILY

*Nymphaea 'Lemon Meringue'*

SANTA CRUZ
WATERLILY

*Victoria cruziana*

Ancient Egyptians used nymphaea in sacred rituals,
burial tombs and as funereal garlands; lotuses were
found covering King Tutankhamun's mummy.

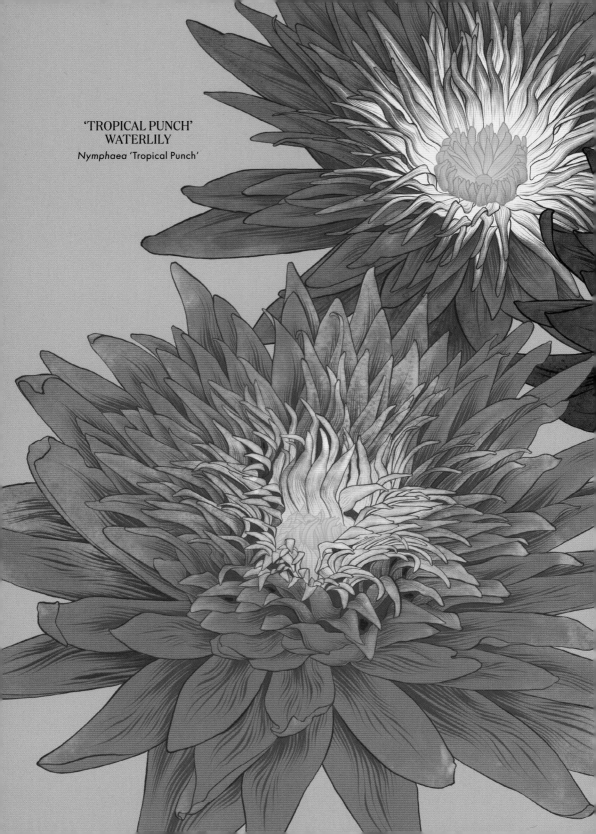

'TROPICAL PUNCH'
WATERLILY

*Nymphaea* 'Tropical Punch'

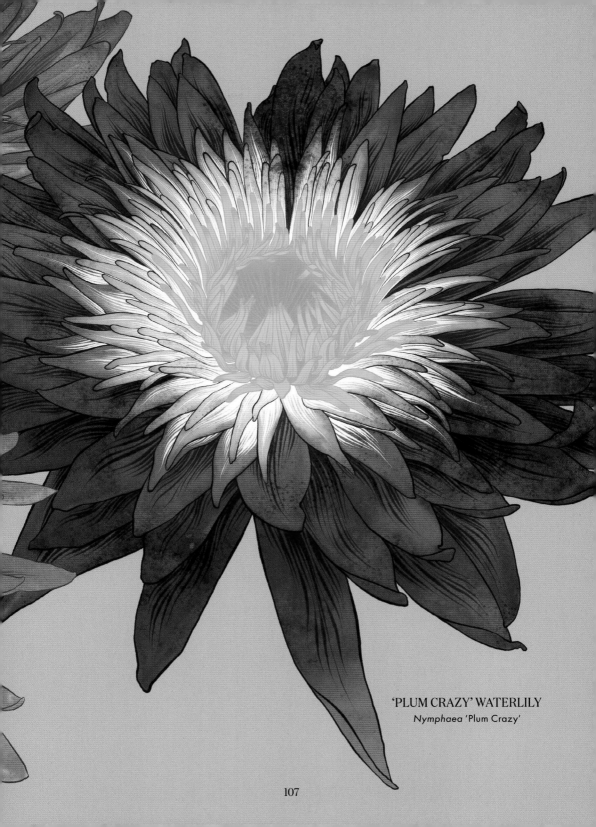

'PLUM CRAZY' WATERLILY
*Nymphaea 'Plum Crazy'*

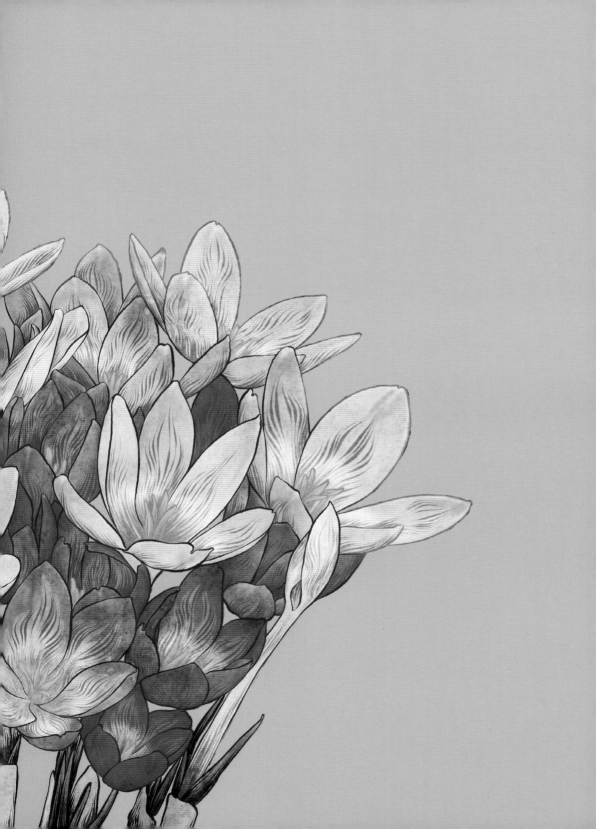

# IRIS

IRIDACEAE

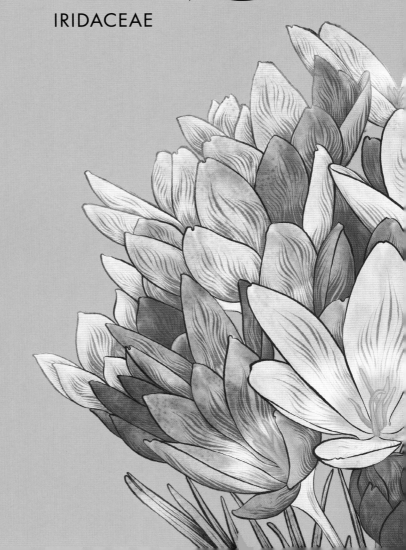

I ridaceae is an ornamental family of multi-hued blooms, wooing artists, scientists and gardeners for millennia. Glamorous gladioli sport tall, showy spires, while freesias are sweet-smelling surprises, heralding spring as they humbly poke through the earth.

Irises' perfectly symmetrical flowerheads have upward petals and downward 'falls' (some with hairy, fuzzy beards); these drooping sepals make a perfect landing strip for the pollinators that follow the petal's veins straight to the nectar. Their flowers are a kaleidoscope of reds, yellows, pinks, purples, oranges and intense blues. One flowerhead can have multiple colours thrusting from its clutch of sword-shaped leaves. Iridaceae is open-minded about its habitats, thriving in hot, harsh, semidesert conditions, as well as meadows, bogs and mountains across much of the globe. *Iris sofarana* is a large iris with purplish, almost black, petals, found only on the high-altitude rocky slopes of Lebanon; it's extremely rare and threatened by over picking.

## ANCIENT GREEK GODDESS IRIS WAS THE PERSONIFICATION OF THE RAINBOW.

By far the most famous Iridaceae is saffron crocus (*Crocus sativus*). Not to be confused with autumn crocus (*Colchicum autumnale*), which is highly toxic, saffron crocus is an extremely valuable plant prized for its long, orange-red stigmas.

Saffron crocus isn't wild, but is a hybrid of its ancestor *Crocus cartwrightianus*, thought to have grown on the limestone soils of Greece during the Bronze Age when ancient Minoans ruled. Part of a wall fresco from this era in Thera shows two young women collecting crocuses and, in Iraq, prehistoric paints coloured with saffron pigment are found on cave art dating some 50,000 years.

During the Middle Ages saffron was an unparalleled luxury, used in medicine, to dye royal robes, as a perfume, and to flavour and colour food a golden hue. Sprinkling saffron in the bath was a tradition of wealthy ancient Egyptians, Greeks and Romans, including Alexander the Great, who took saffron baths to help heal his wounds, and Cleopatra, who'd soak in saffron before lovemaking, to add to her pleasure.

When Black Death gripped Europe in the 1340s, demand for saffron – thought to be a cure for the plague – became frenzied. One remedy, to be drunk by the afflicted, included 'snakeskin, bone from the heart of a stag, Armenian clay, precious metals, aloe, myrrh and saffron'. Piracy was rampant and the theft of a massive saffron shipment en route to Basel (worth about half a million dollars today) sparked the Saffron War, a months-long battle between Basel and Austria to recover the cargo. Its medicinal value endured: seventeenth-century doctors would prescribe a 'scruple' of saffron (just a tiny pinch) to stimulate the blood, treat urinary tract infections and settle the stomach.

Saffron crocus blooms once a year, each flower producing only three stigmas, which are painstakingly picked by hand. Once the stigmas are separated, the filaments are dried into rust-red strands, sold whole or ground into powder. Depending on the size of the stigmas, it takes about 80,000 flowers to yield 1 kilogram (2.2 pounds) of saffron, but beware imitations: some merchants proffer fake saffron, substituted with marigold and safflower. By weight, it's the world's most expensive spice, often called 'red gold'; when the Pennsylvania Dutch introduced saffron to the Americas in the sixteenth century, its price was indeed equal to gold. It's used to colour rice, such as Indian biryani and Italian risotto, and gives Spanish paella and French bouillabaisse a distinct pungency; Kashmiris infuse milk with saffron to break fast during Ramadan.

Previous:
## SILVERY CROCUS
*Crocus biflorus*

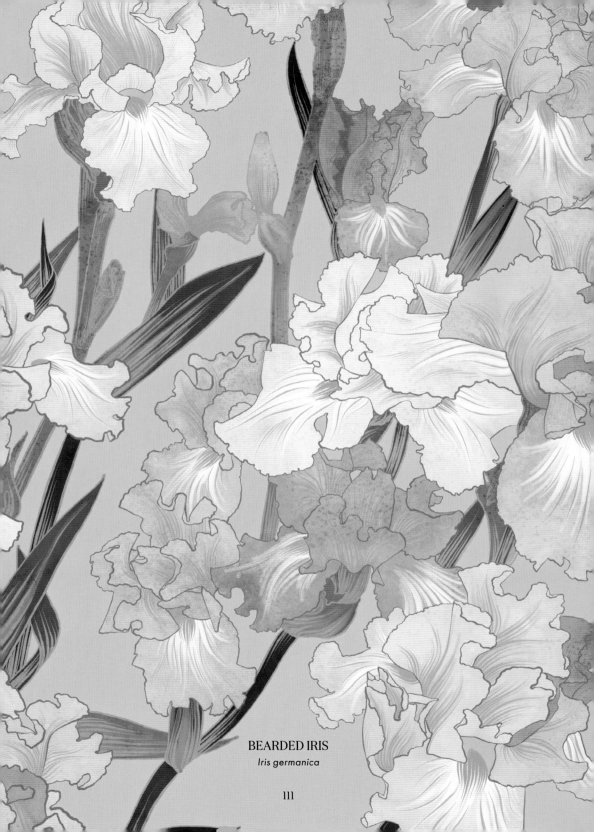

**BEARDED IRIS**

*Iris germanica*

111

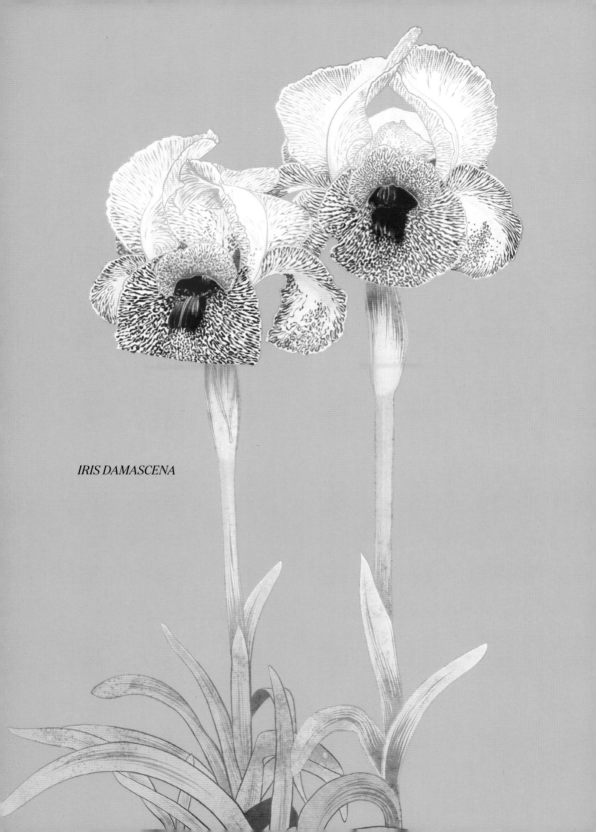

IRIS DAMASCENA

In Greek mythology, Iris was a messenger for the Olympian gods;
she'd feed them nectar and whiz their missives from the sky to the
dark depths of the underworld.

*IRIS ACUTILOBA*

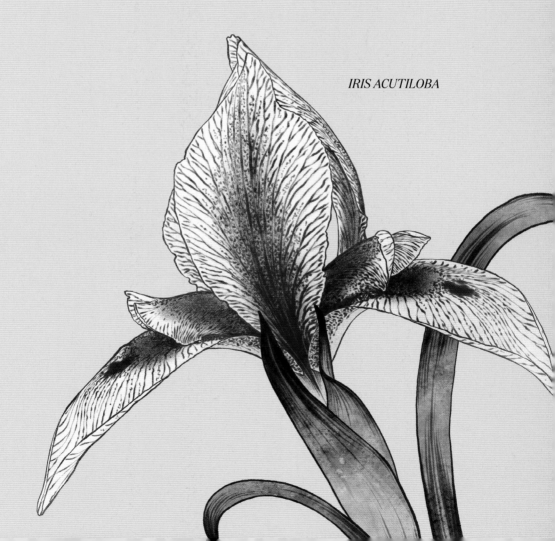

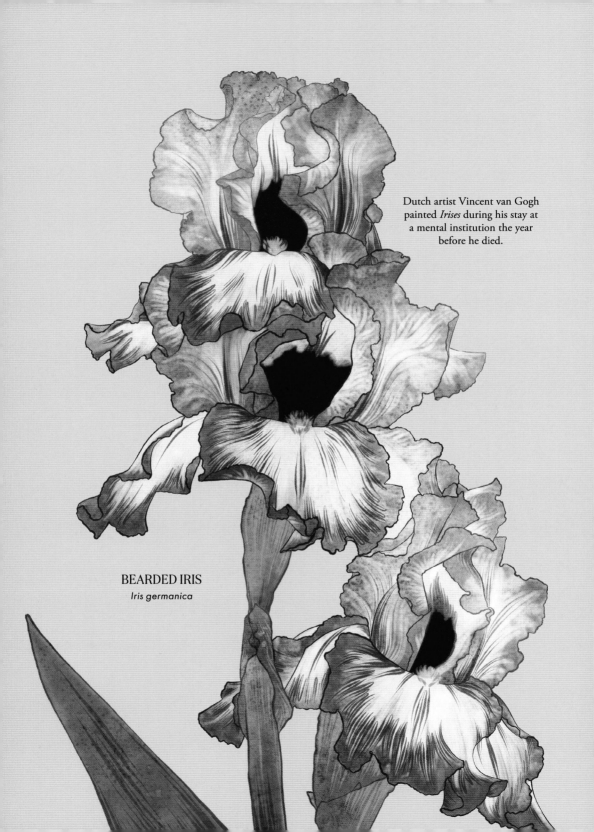

Dutch artist Vincent van Gogh painted *Irises* during his stay at a mental institution the year before he died.

BEARDED IRIS
*Iris germanica*

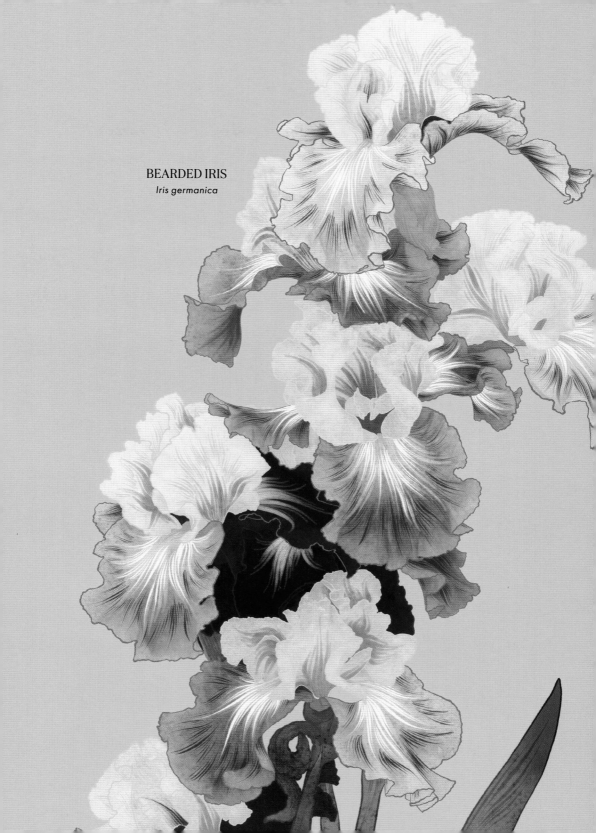

BEARDED IRIS
*Iris germanica*

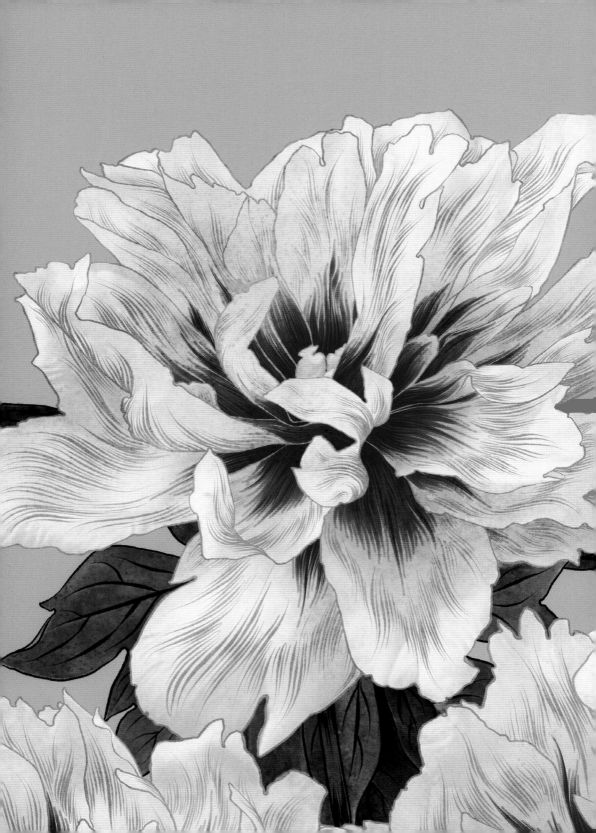

# PEONY

PAEONIACEAE

P eonies are voluptuous, sensuous, exquisite, their heavy blooms ruffled and rippled, their perfume heady with notes of musk or citrus. In China and Japan, 'peony gazing' describes deep contemplation of these flowers' intricate blossoms, the petals the colours of an artist's palette – bright red, raspberry, pastel pink, creamy white. Peonies can be herbaceous and compact. Or tall, like the prized tree peony from the mountains of Central Asia, revered as 'king of flowers' by the Chinese, symbolising wealth, honour and luck. Then there's the itoh, named after the Japanese grower who crossed a tree peony with a herbaceous peony, creating the best of both – a plant with strong stems, long flowering periods and an extended vase life. Toichi Itoh died before his specimens bloomed, unaware of the legacy he'd left the horticultural world.

## UTAGAWA KUNIYOSHI, A MASTER OF UKIYO-E WOODBLOCK PRINTS, DEPICTED REBEL WARRIORS WITH PEONY TATTOOS.

Cultivated in China for nearly 2000 years, the peony's heartland is in the sacred capital of Luoyang, where the Luo and Yellow rivers converge. Folklore tells of Wu Zetian, China's only female empress, who demanded the flowers in her royal garden of Chang'an bloom in the depths of winter. The frightened plants obeyed, except the peony. Outraged, the empress imprisoned the peonies east in Luoyang where the renegade flowers bloomed bigger and brighter. Wu then moved her court to Luoyang, creating gardens full of peonies and prestige.

Like all good stories, it's a tale based in truth. Historians suggest the empress insisted the royal gardeners use greenhouses to force the flowers to bloom year-round, helping prove her leadership. Wu would be happy modern-day Luoyang is the world's peony mecca where millions flock each spring to marvel at the week-long display of blooms.

In Serbian folklore, *Paeonia peregrina*'s dark-red flower represents the blood spilled by soldiers on the Kosovo battlefield during a fourteenth-century conflict, while in ancient Greek mythology, peony transformation was all the rage. Modest nymphs turned into peonies to hide their nudity, and when Apollo was caught flirting with Paeonia, a furious Aphrodite turned her into a red peony. Another legend tells of Paeon, a doctor to the Olympian gods, mentored by the god of medicine, Aesculapius. Paeon used liquid from the peony root to heal the gods' wounds, angering a jealous Aesculapius. Zeus came to Paeon's rescue, transforming him into a peony to escape Aesculapius's wrath.

Peony roots and seeds have long been used by ancient herbalists as love potions and, at the other end of the spectrum, to heal carbuncles and boils. Seventeenth-century children were encouraged to wear peony-seed necklaces to ward off 'falling sickness' (epileptic seizures). Superstitions surround these flowers, mainly to preserve them as a medical resource: it was said picking peonies would invoke the curse of faeries or the picker's eyes would be pecked out by a woodpecker!

In the Middle Ages, artists depicted peony seed pods, as these were considered the most valuable part of the plant; Renoir painted the flowers, and many tattoo artists have since inked the complicated blossoms on people's skins.

Don't judge a peony by its petals; they may look delicate, but this family has a quiet strength.

Previous:
*PAEONIA ROCKII*

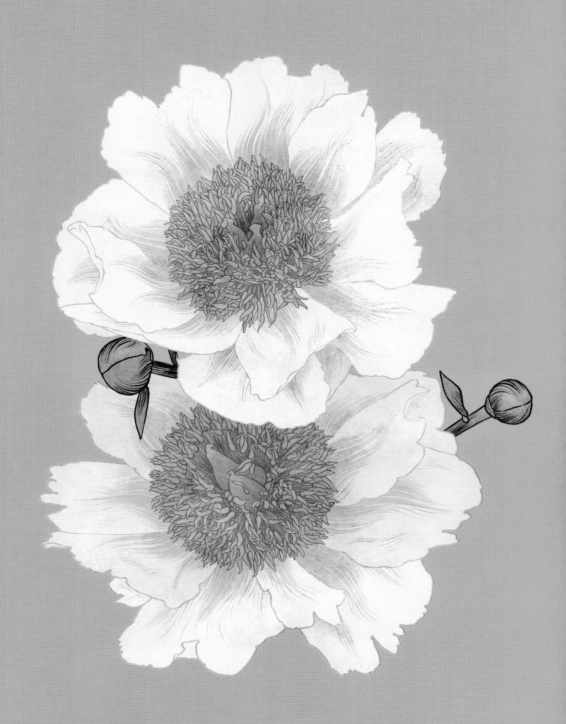

*PAEONIA × ARENDSII* 'CLAIRE DE LUNE'

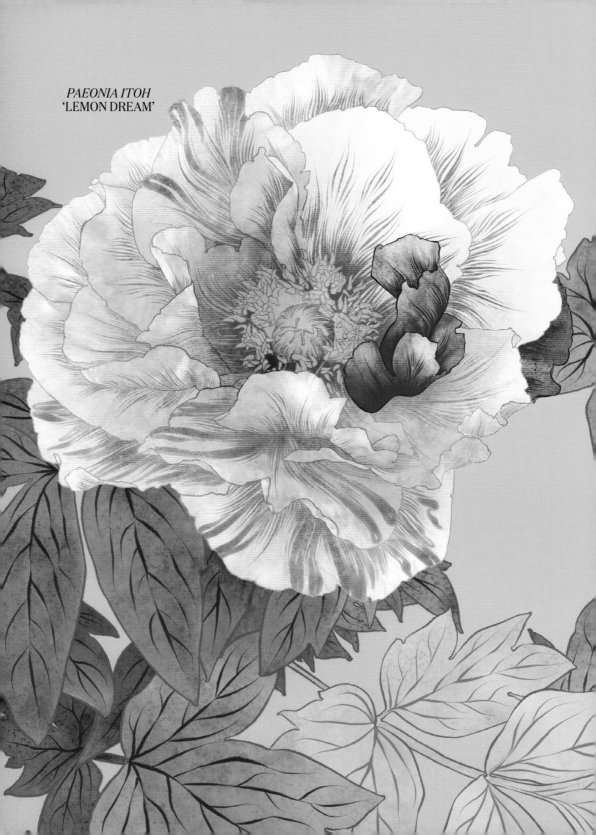

PAEONIA ITOH
'LEMON DREAM'

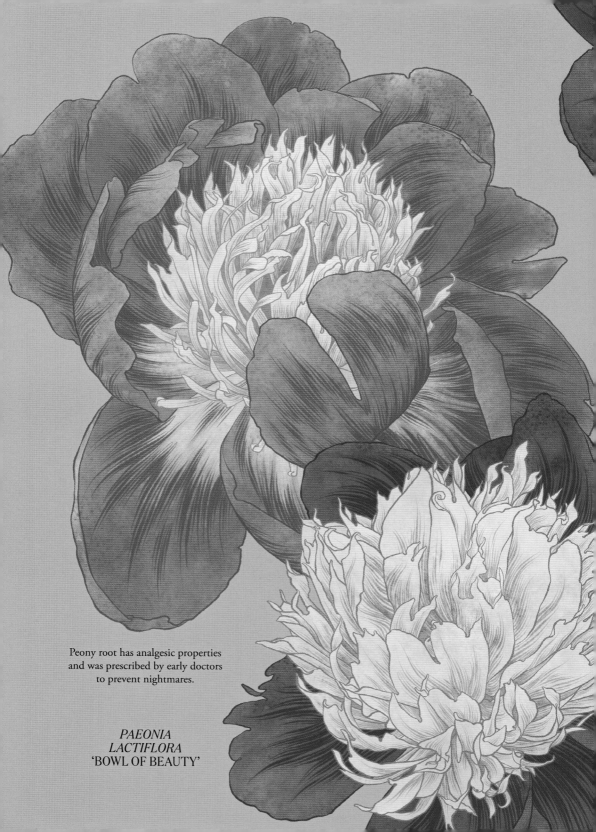

Peony root has analgesic properties
and was prescribed by early doctors
to prevent nightmares.

*PAEONIA
LACTIFLORA*
'BOWL OF BEAUTY'

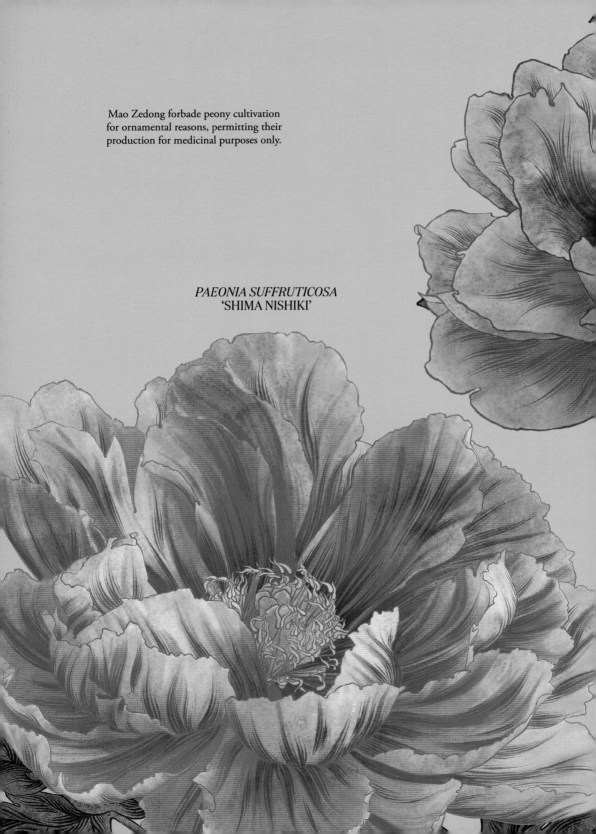

Mao Zedong forbade peony cultivation
for ornamental reasons, permitting their
production for medicinal purposes only.

*PAEONIA SUFFRUTICOSA*
'SHIMA NISHIKI'

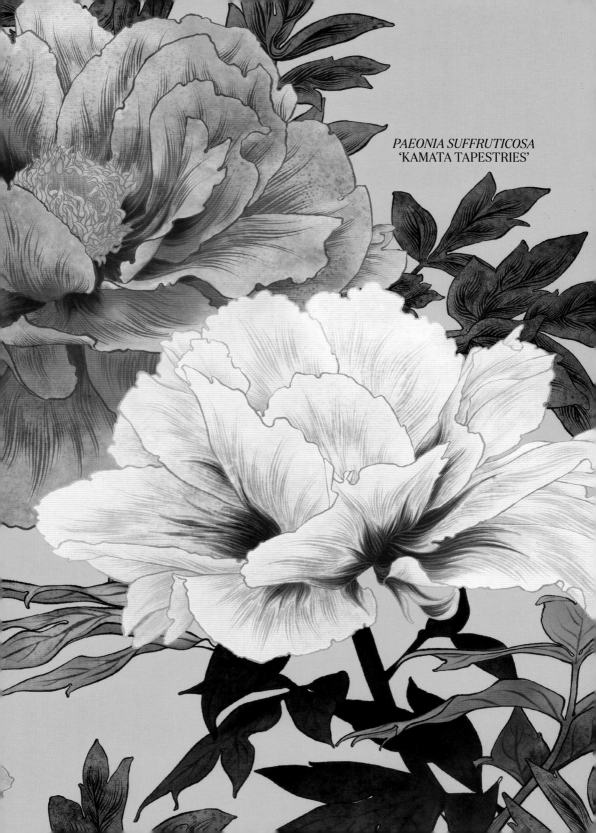

*PAEONIA SUFFRUTICOSA*
'KAMATA TAPESTRIES'

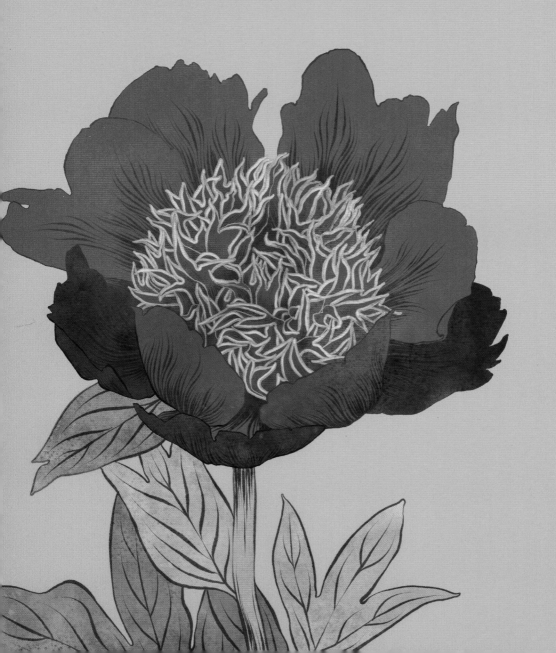

*PAEONIA* 'WALTER MAINS'

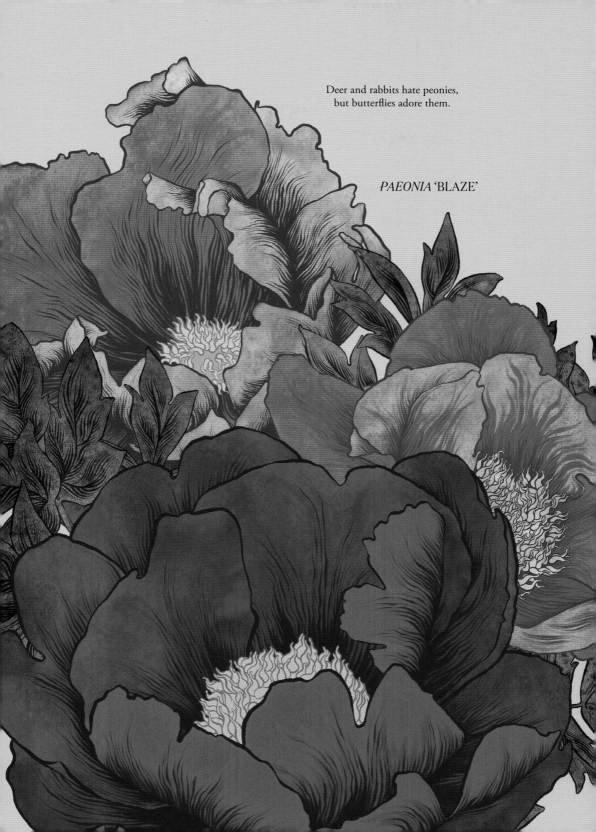

Deer and rabbits hate peonies,
but butterflies adore them.

*PAEONIA* 'BLAZE'

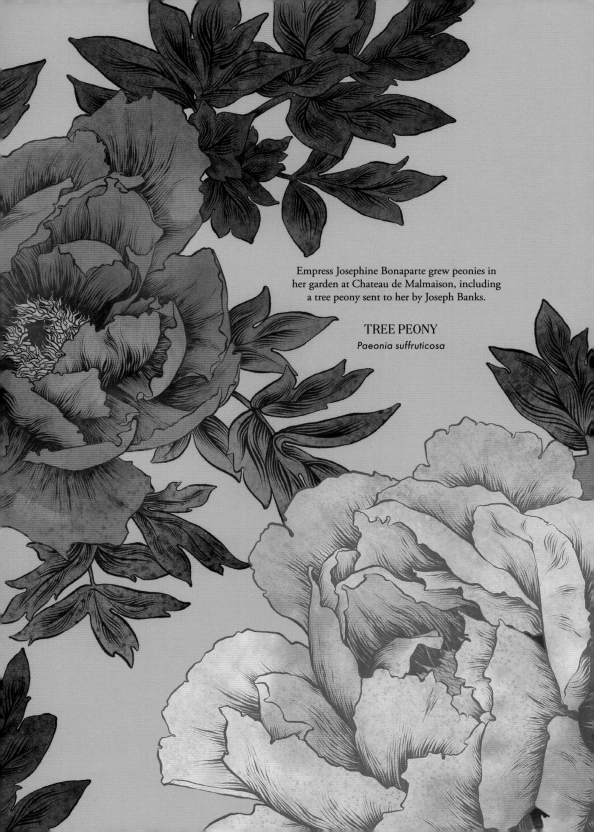

Empress Josephine Bonaparte grew peonies in
her garden at Chateau de Malmaison, including
a tree peony sent to her by Joseph Banks.

## TREE PEONY
*Paeonia suffruticosa*

*PAEONIA LACTIFLORA*
'RARE FLOWER OF FROSTY DEW'

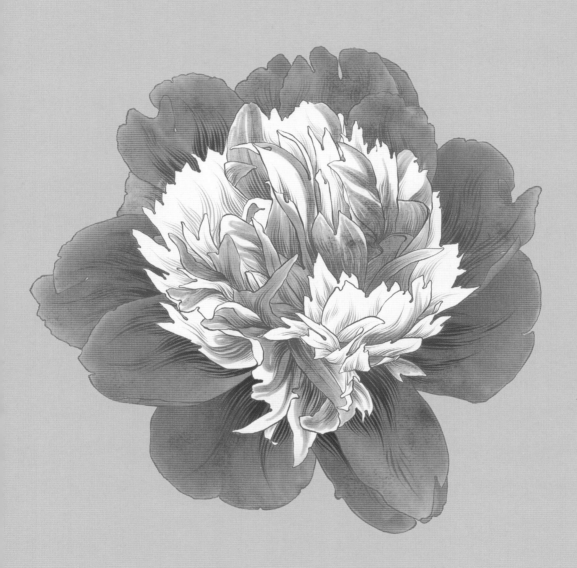

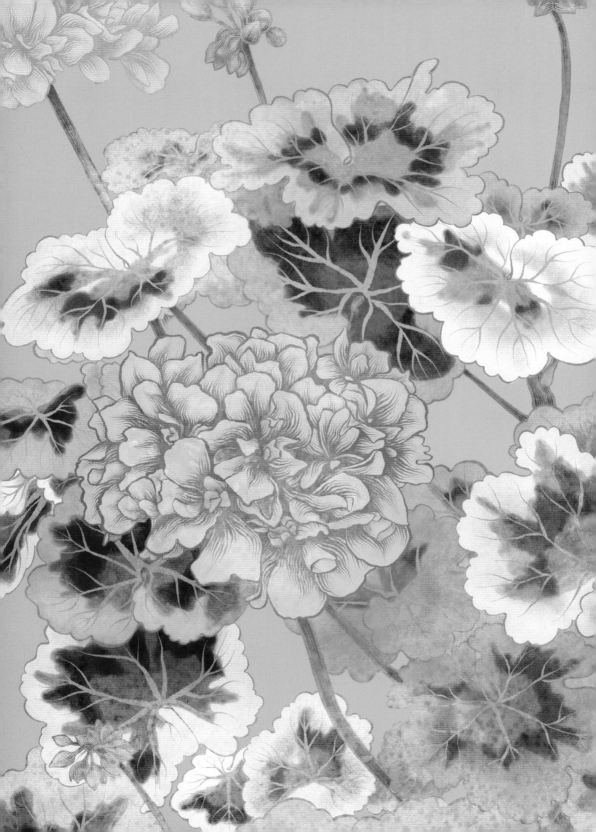

# GERANIUM

GERANIACEAE

Spillers, fillers and thrillers; that's Geraniaceae, a hardy gang of profuse bloomers delighting – and confusing – gardeners for centuries. Early botanists bundled geraniums and pelargoniums together, but they're not the same. Geraniums, pelargoniums and storksbills are all classified as *Pelargoniums* and are one group of plants within the Geraniaceae family. But then, also within the Geraniaceae family, is another genus of plants called *Geranium*!

Call them what you will, these home garden heroes are doers, surviving hot, dry summers, and blooming for weeks on end. They grow wild across Madagascar, New Zealand, Yemen, Turkey's Anatolian Peninsula and Australia. After World War II, geraniums were big news in Australia, which had its own mini bout of 'geranium fever'. South Africa has the lion's share; southernwood-leaf pelargonium (*Pelargonium abrotanifolium*) is an arid-loving little winner, native to the Western Cape's rocky outcrops.

Zonal pelargoniums (*Pelargonium hortorum*) are the family's tough stalwarts, with fat clusters of vivid blooms. Their fancy-leaved foliage gave seventies gardens that extra va-va-voom, with their snazzy, tricoloured leaves of silver, bronze, gold and reds.

Ivy leaf pelargonium (*Pelargonium peltatum*) adds romantic flair with its cascading waxy leaves trailing from hanging baskets and window boxes all over Europe, while regal pelargoniums (*Pelargonium domesticum*) are hybrids with crinkly leaves and spectacular multicoloured blooms, more like a pansy or azalea with their stripy throats.

During the Victorian era, some geraniums and other plants were named 'Mrs', 'Mme' and 'Mr'. There was geranium Mrs Pollock, with her single bright-red blossoms, and the geranium double Mrs Pollock (also known as Mrs Strange), with twofold flowers; modern-day nomenclature omits these titles but includes their first names.

More loosely named are scented-leaf pelargoniums. One of life's sensory joys is rubbing their velvety leaves, releasing aromas of apple-mint, rose, citrus, cinnamon and pineapple. The leaves' essential oils are used in aromatherapy and to make soap and perfume. Some make their way into the kitchen to be brewed up as tea, and some cooks recommend lining the base of a cake tin with peppermint-scented pelargonium (*Pelargonium tomentosum*) for extra flavour.

Pelargoniums are also known for their medicinal properties, and an extract from the root of the South African geranium (*Pelargonium sidoides*) is used as a remedy for respiratory ailments. Indigenous healers knew of its power for centuries, but it was Charles Stevens who introduced the South African geranium to Britain during the late nineteenth century, claiming it had cured him of tuberculosis. Diagnosed at age seventeen, he moved to South Africa, where local medical men reportedly treated him using a 'secret remedy'. He returned to England spruiking the tonic, known as 'umckaloabo', but was ridiculed and discredited by the medical community. It wasn't until the 1970s that the extract of South African geranium became an approved drug, sold today like echinacea, to ease respiratory infections and reduce symptoms.

There's plenty to love about Geraniaceae and, whether you choose geranium or pelargonium, both are beautiful.

## PHARMACIST JOHN DALTON REALISED HE WAS COLOUR BLIND WHEN HE THOUGHT A RED *PELARGONIUM ZONALE* WAS BLUE.

Previous:

*PELARGONIUM* 'WARRENORTH CORAL'

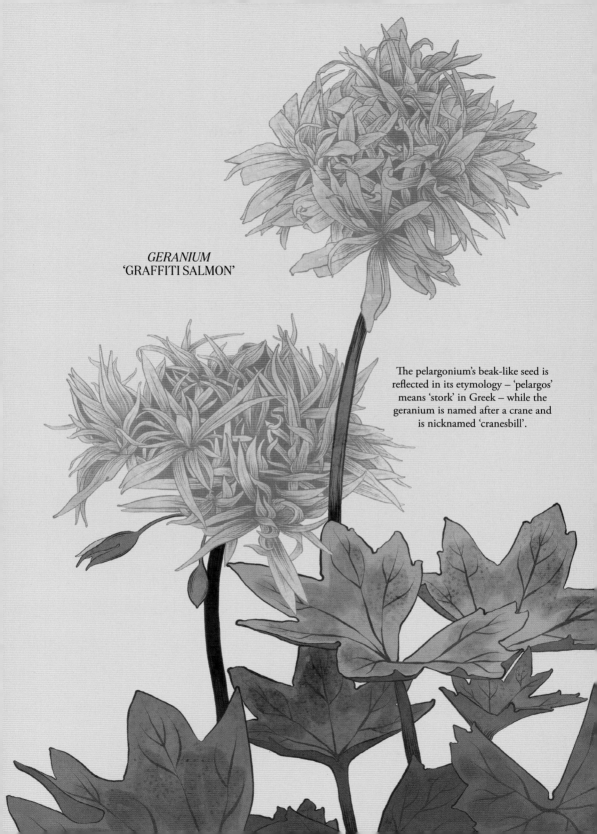

*GERANIUM*
'GRAFFITI SALMON'

The pelargonium's beak-like seed is reflected in its etymology – 'pelargos' means 'stork' in Greek – while the geranium is named after a crane and is nicknamed 'cranesbill'.

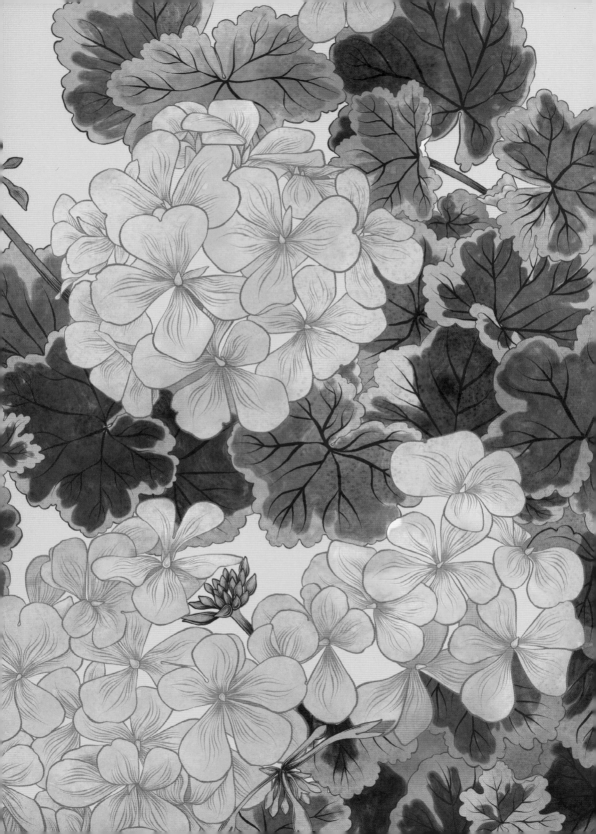

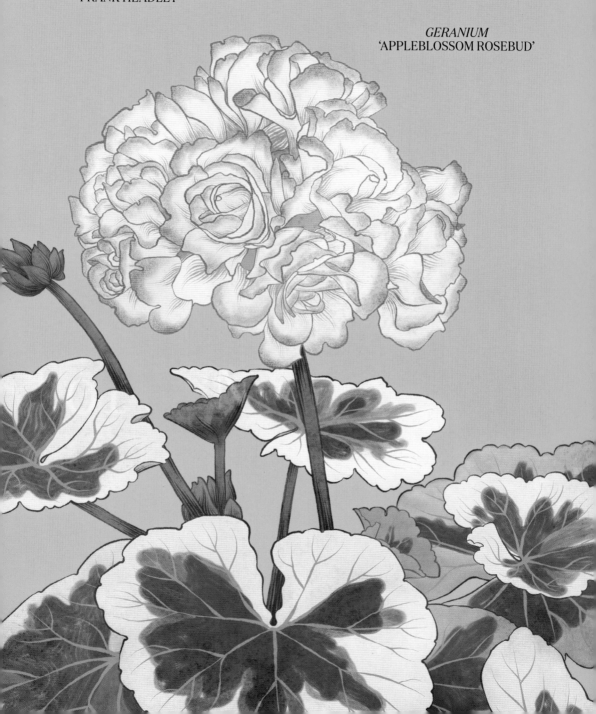

Opposite:
*GERANIUM PELGARDINI*
'FRANK HEADLEY'

*GERANIUM*
'APPLEBLOSSOM ROSEBUD'

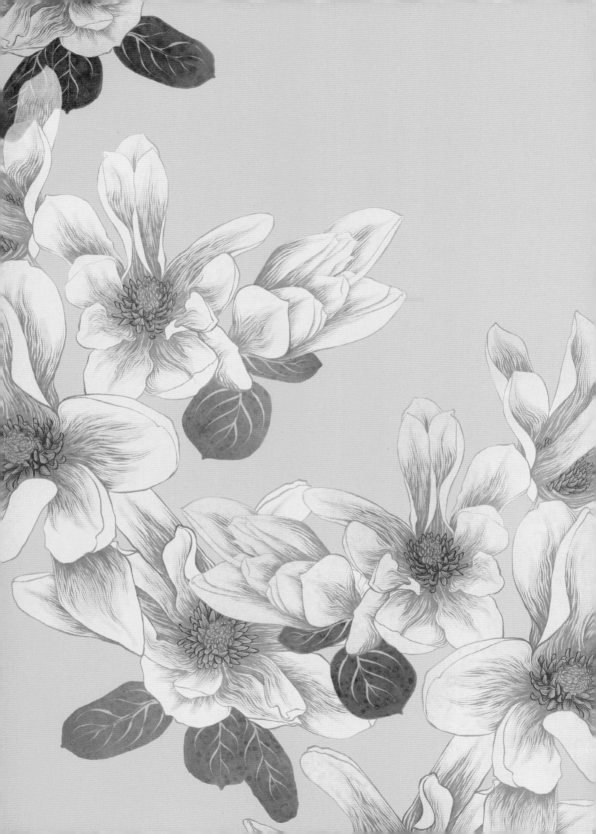

# MAGNOLIA

MAGNOLIACEAE

Over 95 million years ago – way before bees existed – prehistoric beetles pollinated the primitive family of Magnoliaceae, rummaging in the flowers' pollen-rich stamens to eat their fill of protein. The beetles were lured by the trees' big blooms and tangy, come-hither scent.

Nineteenth-century plant hunters were also enticed by magnolias' flamboyant flowers when searching for rare specimens in the Himalayan valleys of Nepal, Sikkim and Yunnan. They found magnolia forests of mostly deciduous, cool-climate trees, their goblet-shaped flowers of ivory, pink and purple bravely flowering on naked, silvery branches.

Finding a tree in bloom meant returning seasons later to collect its seeds. One story tells of Ernest Wilson, ecstatic to discover the giant Sargent's magnolia (*Magnolia sargentiana*) in China's Sichuan province. When he was able to return years later, it had been chopped down. Through hard work, these horticultural collectors were responsible for introducing nearly all cool-climate magnolias to the West.

## A MAGNOLIA TREE CAN LIVE FOR UP TO 100 YEARS.

Magnolia is also native to the USA and West Indies, thriving on the subtropical coast of America's southern states on the Gulf of Mexico. It's part of the South's culture and identity, the fragrant vanilla-scented sweetbay magnolia (*Magnolia virginiana*) an aromatic harbinger of a languid Florida spring. Southern magnolia (*Magnolia grandiflora*), with its elegant ivory blooms, is the official flower of Louisiana and Mississippi, often dubbed 'the magnolia state', and southern women are nicknamed 'steel magnolias', suggesting great beauty combined with a hardiness and inner strength. Further west, the Texan metropolis of Houston is colloquially known as 'Magnolia City', a moniker from the 1870s when the town was home to thick magnolia forests, many still growing along the banks of the Buffalo Bayou.

In Japan, magnolias are more than just ornamental, and the big, leathery leaves of the Japanese cucumber tree (*Magnolia obovata*) are used like banana leaves, to wrap meats and vegetables to be grilled over charcoal. Young petals of the Southern magnolia are pickled and eaten, as are its buds, pickled to flavour rice or tea. In China, Yulan magnolia (*Magnolia denudata*) symbolises purity – this ancient cultivar has been growing in Buddhist temples since 600 AD.

Magnolia flowers are bisexual, which means the flower first opens with its female parts, then closes to reopen with its male parts, boosting the chances of cross-pollination. In recent years, particularly in New Zealand and at the Brooklyn Botanic Gardens, breeders have been expanding the colour palette of magnolias, with cultivars including 'Vulcan' (deep magenta), 'Black Tulip' (rich purple), 'Felix' (hot pink), 'Yellow Bird' (golden yellow) and the fragrant 'Burgundy Star' (claret-coloured).

No doubt the Magnoliaceae family welcomes newcomers, but these ancient stars of the plant world are comfortable in their own skin. Hardy and tough, their elegant, aristocratic blooms will continue to entrance gardeners for centuries to come.

Previous:

## YELLOW MAGNOLIA

*Magnolia × brooklynensis 'Yellow Bird'*

Bred by the Brooklyn Botanic Gardens, this is considered the world's most beautiful yellow magnolia.

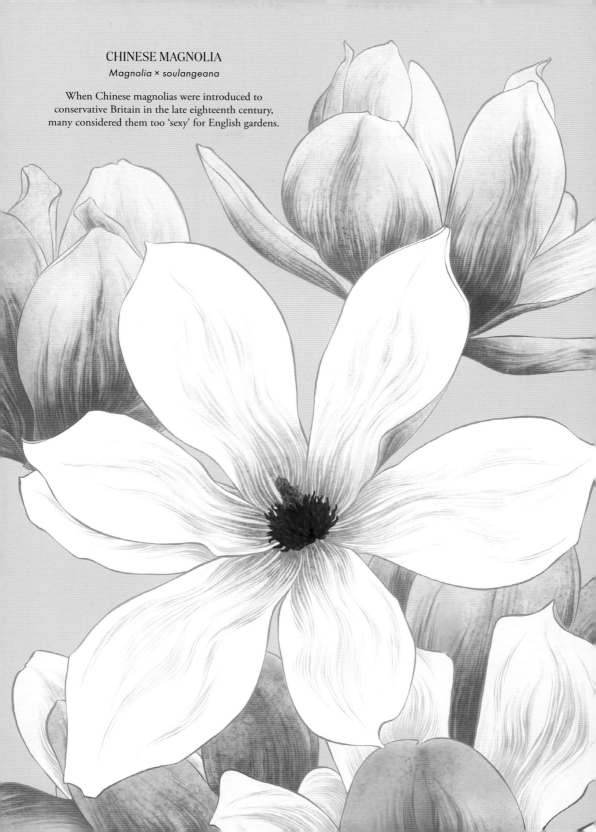

## CHINESE MAGNOLIA
*Magnolia × soulangeana*

When Chinese magnolias were introduced to
conservative Britain in the late eighteenth century,
many considered them too 'sexy' for English gardens.

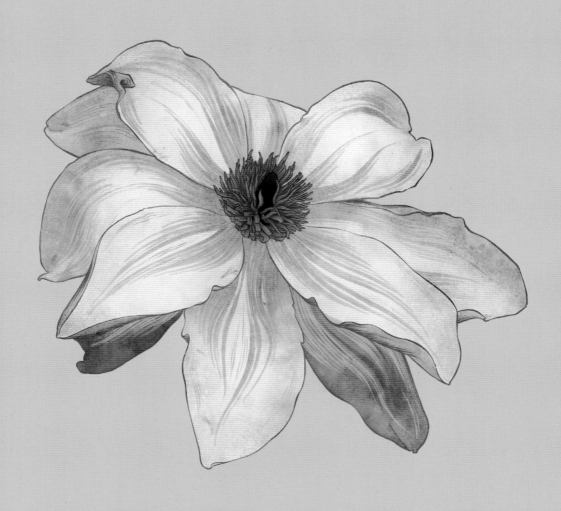

SPRENGER'S MAGNOLIA
*Magnolia sprengeri*

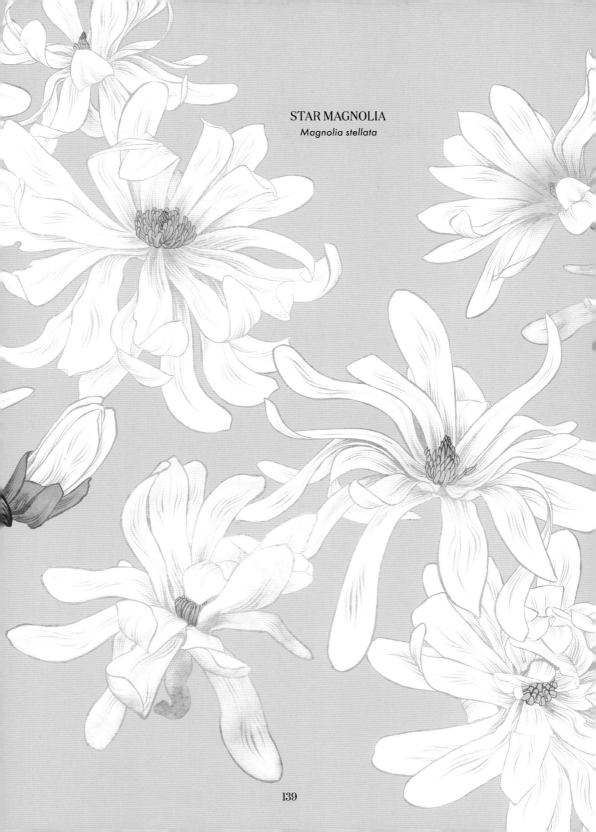

STAR MAGNOLIA
*Magnolia stellata*

MAGNOLIA 'VULCAN'

*Magnolia × soulangeana*

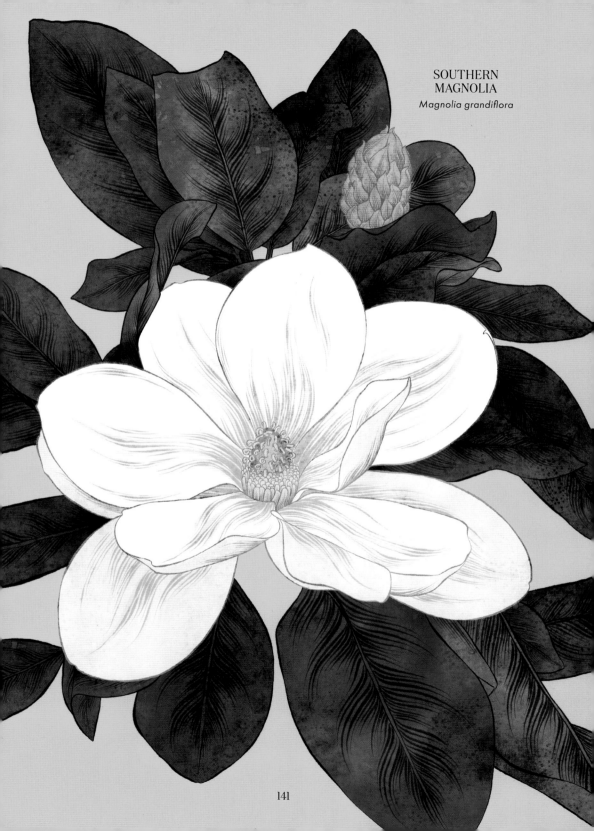

SOUTHERN
MAGNOLIA
*Magnolia grandiflora*

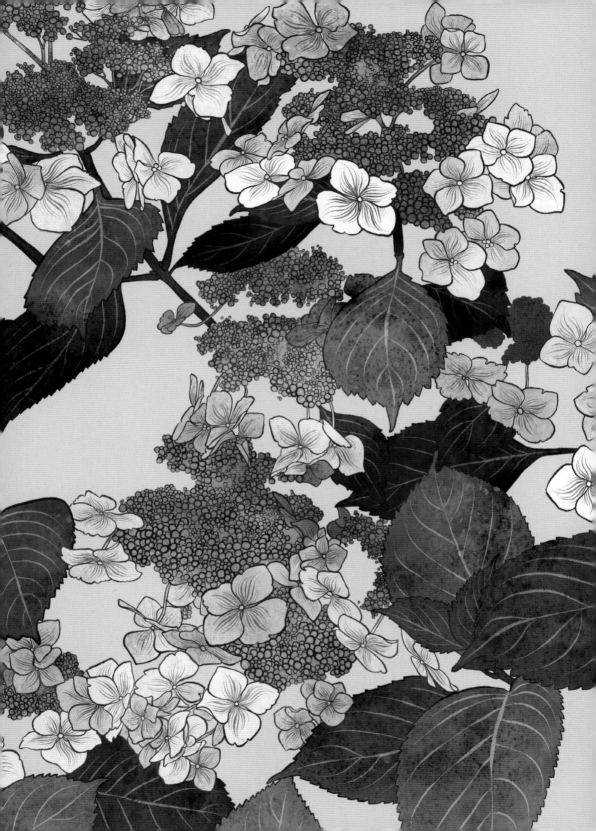

# HYDRANGEA

## HYDRANGEACEAE

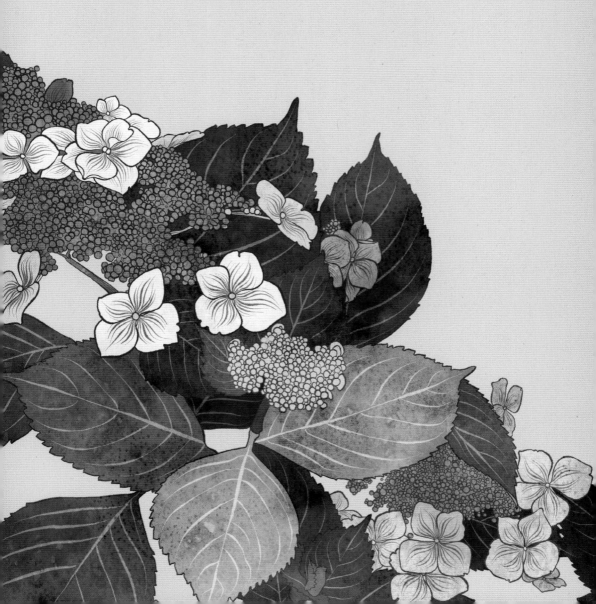

Ah hydrangea, treasured for adding big-bloomed glam to shady corners, loved by grandmothers the world over, and in vogue once again with young gardeners inspired by a host of compact new hybrids.

Many know the clever chameleon trick of bigleaf hydrangea (*Hydrangea macrophylla*), its showy rounded flowers able to change colour according to the pH of the soil. In acidic ground, expect rich, purply-blue blooms, like the stunning hydrangeas growing on the coast of America's Cape Cod, while an alkaline soil yields flowers hued pink and red. Why? Because hydrangeas are hyperaccumulators, able to amass aluminium ions from the soil that react with its flower pigments.

Hailing from Central Asia and the Americas, hydrangeas are commonly known as 'hortensia', Latin for 'from the garden'. Hydrangea hit the headlines a few years back when French gendarme were tracking the 'Hortensia Gang', a group of youths stealing the plants from public and private gardens to dry and smoke with tobacco, getting a euphoric, mildly hallucinogenic high similar to that of cannabis. Side effects might be stomachaches and dizziness, while consuming hydrangea in bulk quantities can be poisonous. Its buds, flowers and leaves contain glycoside amygdalin, which can break down into hydrogen cyanide, the base of Zyklon B, the gas used in the death chambers of World War II.

**ONE ENGLISH SUPERSTITION WAS THAT GROWING HYDRANGEA WAS UNLUCKY, CURSING ANY DAUGHTERS IN THE HOUSE TO LIVE A LIFE OF SPINSTERHOOD.**

But usually hydrangea's showy blooms are coveted purely for ornamental reasons. Bigleaf hydrangeas, with their dark-green leaves and mophead flowers like old-fashioned bathing caps, are the most well-known of the family, but delicate lacecaps are equally splendid, with a cluster of closed buds surrounded by a crown of open flowers. Oakleaf hydrangea (*Hydrangea quercifolia*) has distinctive oak-shaped leaves, panicled hydrangea (*Hydrangea paniculata*) sports conical flowers, and climbing hydrangea (*Hydrangea petiolaris*) can scramble over an arbour, producing a mass of creamy white flowers. Hydrangea 'Sir Joseph Banks' (*Hydrangea macrophylla* cv.), an old cultivar honouring the famed botanist, is thought to be one of the first introduced to Europe from Japan.

Hydrangea is revered in Japanese culture, appearing on kimono, ancient woodblocks, ceramics and fabrics. It's planted extensively in parks and temple gardens, its blooms heralding the start of Japan's rainy season. Japanese brew the leaves of native mountain hydrangea (*Hydrangea serrata*) to make a sweet herbal tea called 'tea of heaven', used ceremoniously to bathe Buddha on his birthday in April, and the young shoots and leaves are eaten as leafy greens.

Fresh colours are giving this diverse family renewed zing, with dark burgundy and two-tone hybrids up for grabs.

Previous:

MOUNTAIN HYDRANGEA

*Hydrangea serrata 'Bluebird'*

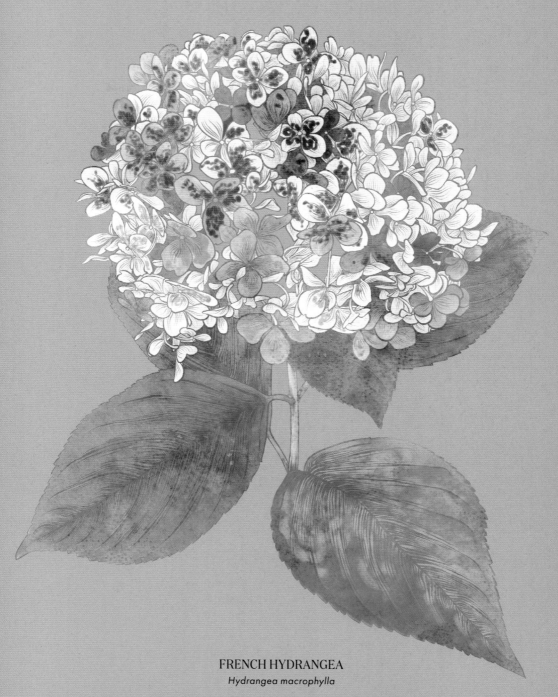

## FRENCH HYDRANGEA

*Hydrangea macrophylla*

Nicknamed 'change rose' for their petals of ephemeral colours;
the Japanese call them *nanahenge*, meaning 'seven transformations'.

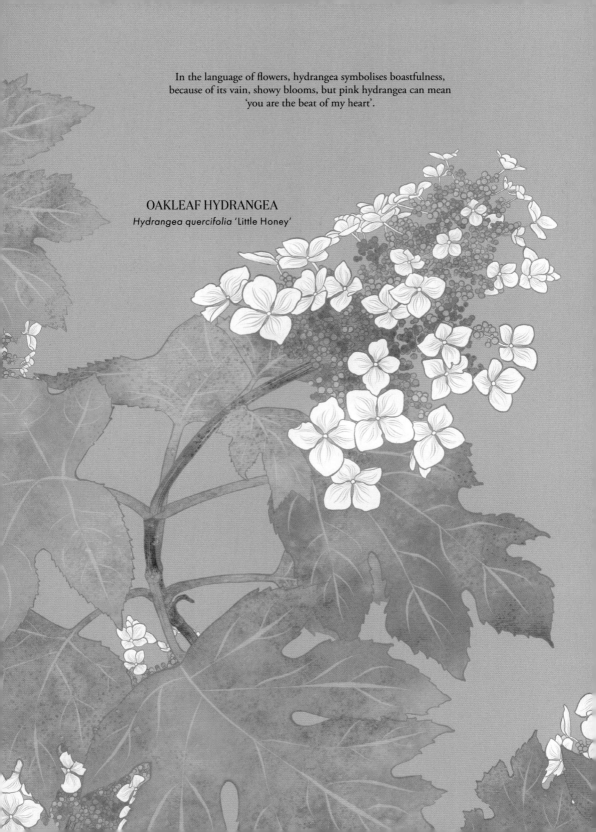

In the language of flowers, hydrangea symbolises boastfulness,
because of its vain, showy blooms, but pink hydrangea can mean
'you are the beat of my heart'.

OAKLEAF HYDRANGEA
*Hydrangea quercifolia* 'Little Honey'

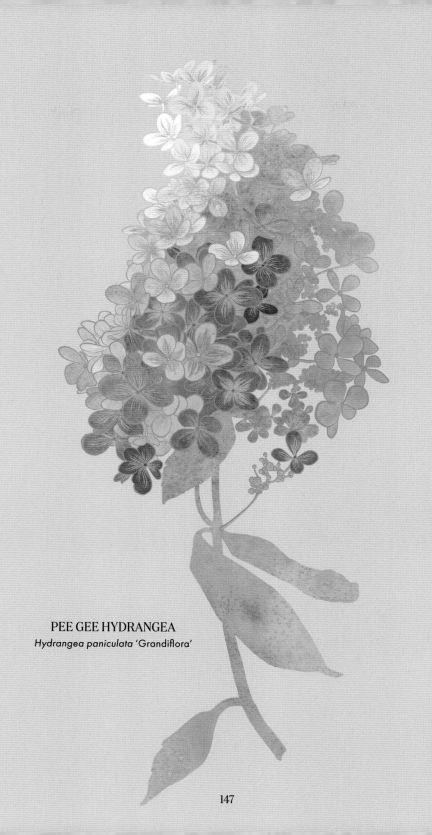

**PEE GEE HYDRANGEA**
*Hydrangea paniculata 'Grandiflora'*

# FRENCH HYDRANGEA
*Hydrangea macrophylla*
'Endless Summer'

# LACECAP
# HYDRANGEA
*Hydrangea macrophylla*
'Mariesii Variegata'

In witchcraft, hydrangeas
are used to break hexes.

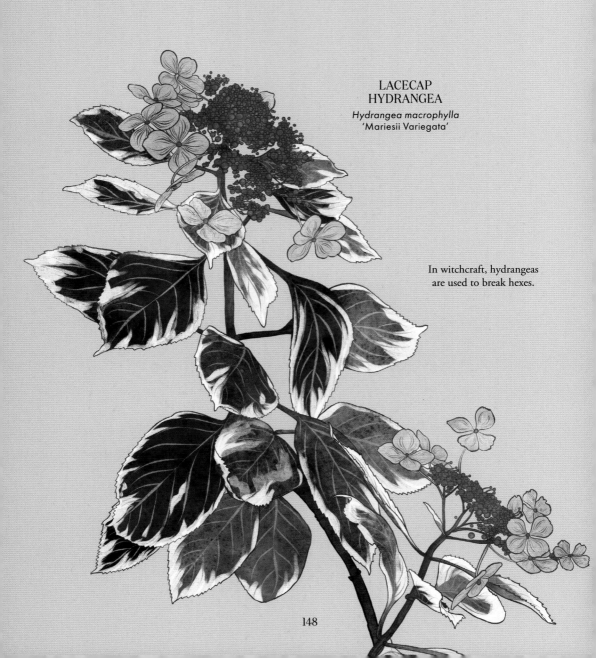

148

# OLIVE

OLEACEAE

'T he olive tree, what a brute!' wrote impressionist painter Pierre-Auguste Renoir in a letter to his friend and art dealer in 1918. 'A gust of wind, and my tree's tonality changes. The colour isn't on the leaves, but in the spaces between them.'

Like Monet, whose inspiration was his garden of waterlilies, Renoir was smitten with an ancient olive grove suffused in the beautiful, distinctive light of southern France at his farm, Les Collettes. For six years he tried to capture the soul of the olive (*Olea europaea*) on canvas, thwarted by its gnarled branches and the ephemeral beauty of its silvery-green leaves. He wasn't alone. Many of the greats – including van Gogh, Monet, Edgar Degas, Henri Matisse and Salvador Dali – dabbled with varied success at portraying the essence of this elusive Mediterranean muse.

## THE OLIVE IS ONE OF THE WORLD'S MOST EXTENSIVELY CULTIVATED CROPS, WITH AN ESTIMATED 900 MILLION TREES AROUND THE GLOBE.

But artists weren't the only ones enchanted by the enigmatic olive. Its oil, highly prized for millennia, was used to anoint kings and priests and for sacrificial ceremonies of worship from ancient Israel to Greece and the Levant. Biblical stories write of Noah and the Ark during the great flood; in search of land, Noah sent a dove which returned with an olive branch, a sign from God of life after the flood. Muhammad, too, refers to the olive as a blessed, sacred tree many times in the Quran.

Mythology has it the Greek goddess Athena, daughter of Zeus, magicked an olive tree to grow in the Acropolis, a gift that left Athenians forever in her debt. But the olive's exact origin is hazy. Fossils tell us *Olea* grew in the volcanic limestone soils of the Greek Isles, and it's likely cultivation began over 5000 years ago from domestication of wild fruit thriving in the Mediterranean's long, hot summers. Wood from olive trees was used to make ancient cult figures in Greece called *xoana*, and olive oil was used to burn the eternal flame at the world's inaugural Olympic Games in ancient Athens. Later, sixteenth-century Spanish traders introduced olive oil to the New World of the Americas where groves would thrive in sunny California climes.

Traditionally on harvest days, extended Mediterranean families would gather to pick the olive's ripe fruit, shaking the trees to dislodge the plump, purply-black and green orbs, catching them on cloths laid on the ground. The fruit was cold-pressed and milled to extract the oil; extras were brined and stored for a year-round supply. Depending on its terroir, the taste of olive oil differs, so Italian olive oil drizzled on a caprese salad has a different fruitiness, pepperiness and spiciness to oil used for dipping za'atar-dusted flatbread in Lebanon.

Another star of the Oleaceae clan is common jasmine (*Jasminum officinale*), known as the 'king of oils' for its heady, sweet fragrance that can be deeply inhaled at dusk when the flowers release their summery scent.

So did Renoir ever capture his *Olea europaea*? History says yes: the painting of his precious groves, *Les Oliviers de Cagnes,* is renowned as an important genre piece.

Previous:

## COMMON JASMINE

*Jasminum officinale*

Its oil is used to make perfume and in aromatherapy
for its soothing properties.

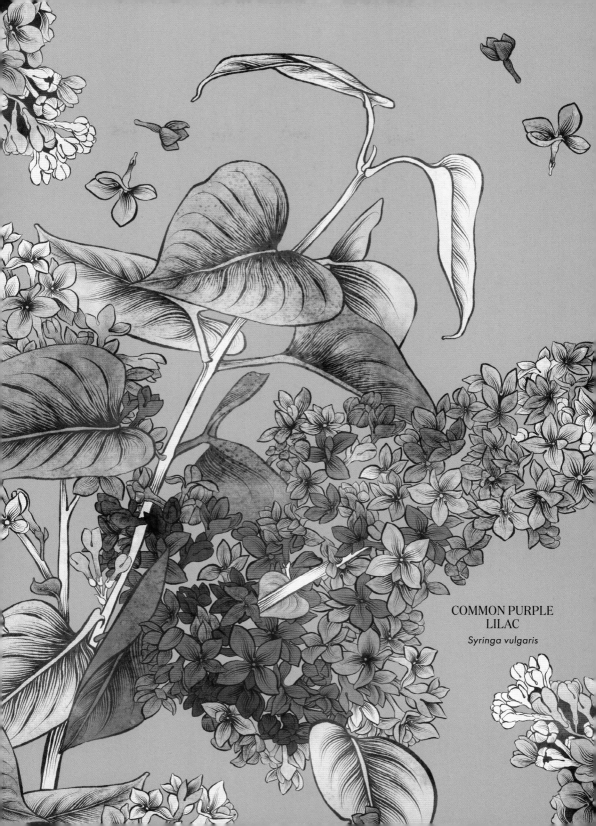

COMMON PURPLE
LILAC

*Syringa vulgaris*

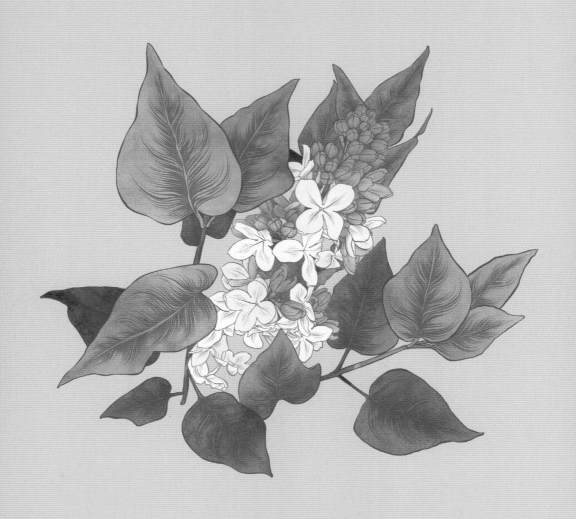

## 'LITTLE BOY BLUE' LILAC
*Syringa vulgaris* 'Little Boy Blue'

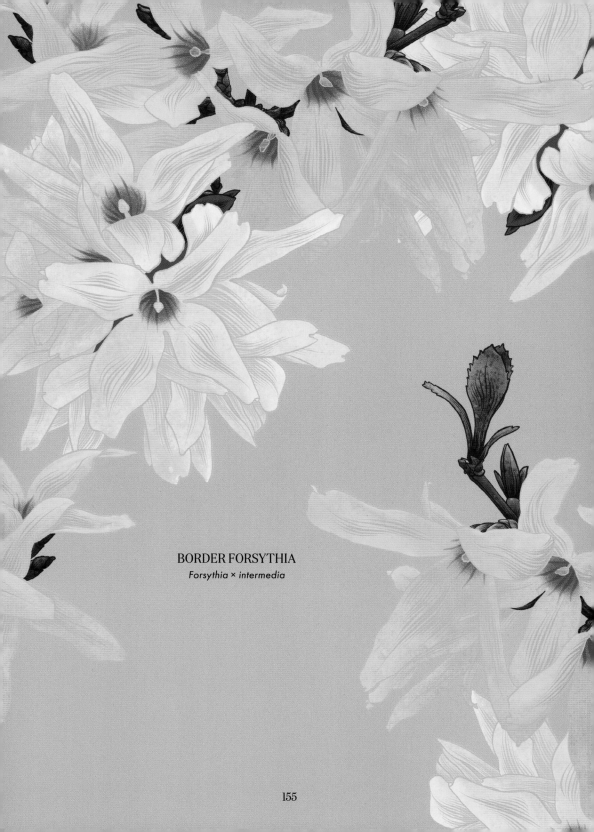

BORDER FORSYTHIA

*Forsythia × intermedia*

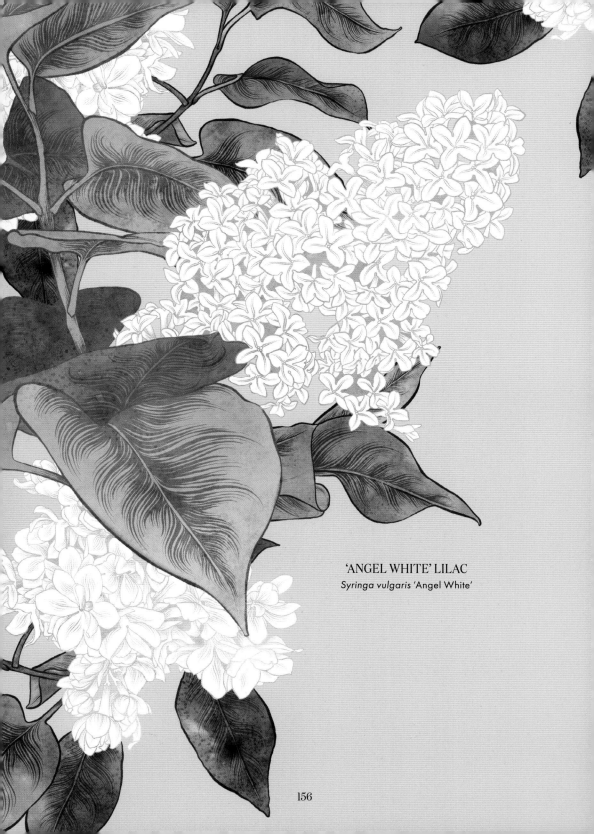

'ANGEL WHITE' LILAC

*Syringa vulgaris* 'Angel White'

The olive branch has long been a symbol of peace; the 'Olive Branch Petition' staved off war between eighteenth-century America and Britain, and the United Nations flag features a world surrounded by olive branches.

LILAC 'SENSATION'
*Syringa vulgaris*
'Sensation'

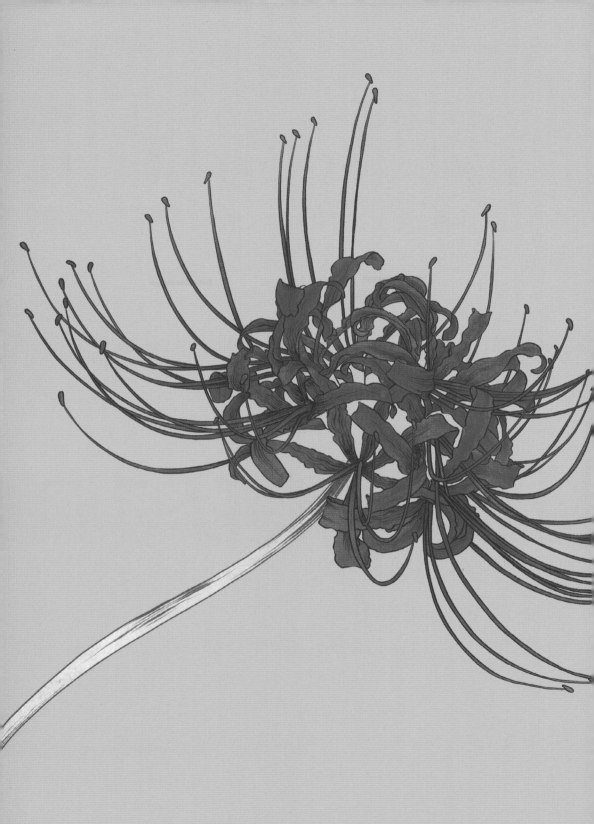

# ALLIUM

AMARYLLIDACEAE

Bulbous and beautiful, Amaryllidaceae is known for its smiling assassins, springtime bloomers wild daffodil (*Narcissus pseudonarcissus*) and jonquil (*Narcissus jonquilla*), along with edible heroes onion (*Allium cepa*), garlic (*Allium sativum*) and leek (*Allium ampeloprasum*).

One of the world's oldest vegetables, onion's gossamer pompom flowers balance on long, tubular stalks, its multilayered swollen bulb a global food staple. Many have cried over this humble vegetable, its cells releasing a chemical when sliced apart that causes our eyes to water. Shakespeare called them 'the tears that live in the onion', but onion tears are 'fake' tears. All mammals' eyes water, but only humans shed 'real' tears. Biochemist William Frey discovered tears of sadness or emotion have higher protein content than onion tears, and are a way humans release toxic, stress-induced chemicals.

Onion is forever linked to the stereotypical Frenchman, a curly-moustachioed chap in a striped shirt and beret with strings of onions dangling over a pole. In twentieth-century Brittany, salesmen known as 'Onion Johnnies' crossed the Channel with their produce, bicycling door to door to sell alliums to English housewives. During the Johnnies' heyday of the 1920s, it's estimated they sold about 9000 tonnes of onion to the UK.

As well as adding flavour to food, garlic has also been thought to ward off vampires, which many cultures believed to be real. Roman soldiers would rub garlic – a known anticoagulant – on their swords so their victims in battle would bleed to death.

Domesticated since the Middle Ages, the sunny narcissus is native to the Iberian Peninsula of Spain and Portugal, heralding spring in millions of gardens around the globe. They look so sweet, nodding in the open woodlands and meadows, and were used to make garlands in sixteenth-century Europe, favoured for their sweet perfume. But *Narcissi* stems, bulbs, leaves and flowers are all toxic, the name referencing the Greek term for 'narcotic'. Ingesting small amounts of daffodil causes only mild nausea, but consuming bulk quantities can cause cardiac events. A decade or so ago in England, a bunch of primary school children were hospitalised after cookery class when one student added a daffodil bulb to the soup!

In Greek mythology narcissus symbolises hell, death and vanity. One tale tells of the beautiful Persephone, daughter of Zeus and Demeter, who was entranced by a daffodil. When she bent to pick the yellow bloom, the ground opened beneath her and Hades spirited her away, deep into his underworld. Another version involves the absurdly handsome Narcissus, son of river god Cephissus and nymph Liriope. While hunting, he caught sight of his own reflection in water and fell desperately and completely in love. Refusing to abandon his true desire, he died, and a downward-facing flower grew there, as if gazing at its own reflection. Later, psychiatrist Sigmund Freud coined the term 'narcissist' based on this tale.

Bulb-hunters beware when seeking the beauteous Amaryllidaceae, which are dangerously pretty and potently toxic – unless it's a dear old onion, of course.

> **BULBS CAN BE HARD TO IDENTIFY; POISONING HAS OCCURRED FROM ACCIDENTALLY COOKING OR EATING TOXIC NARCISSUS INSTEAD OF SAFE OLD ONIONS.**

Previous:

## RED SPIDER LILY

*Lycoris radiata*

The poisonous bulbs of this Asian native are used
around rice paddies as a natural pest deterrent.

# ONION

*Allium cepa*

The onion was the (light)bulb that inspired Swedish botanist
Carl Linnaeus to devise a system for naming plants,
the horticultural nomenclature still used today.

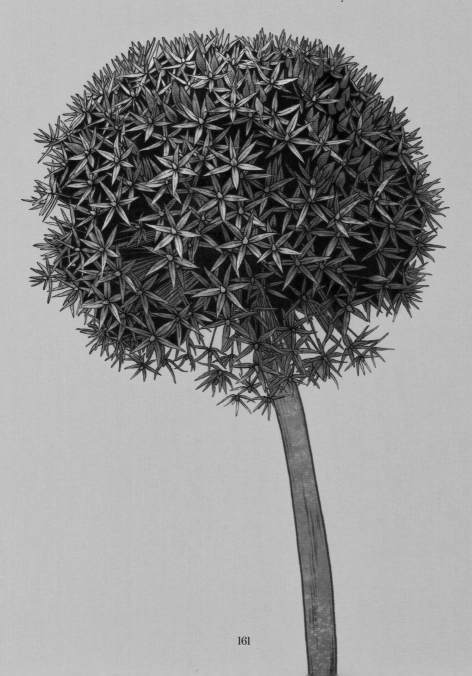

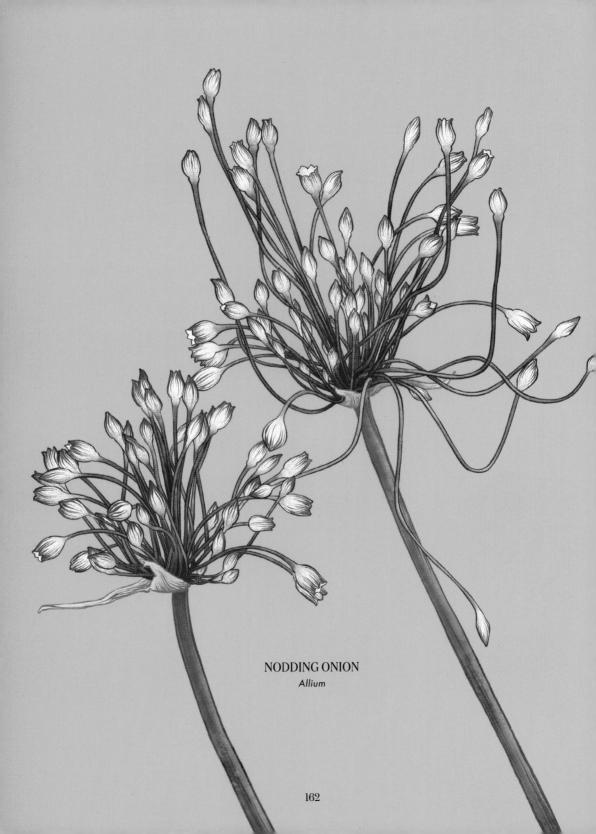

NODDING ONION

*Allium*

162

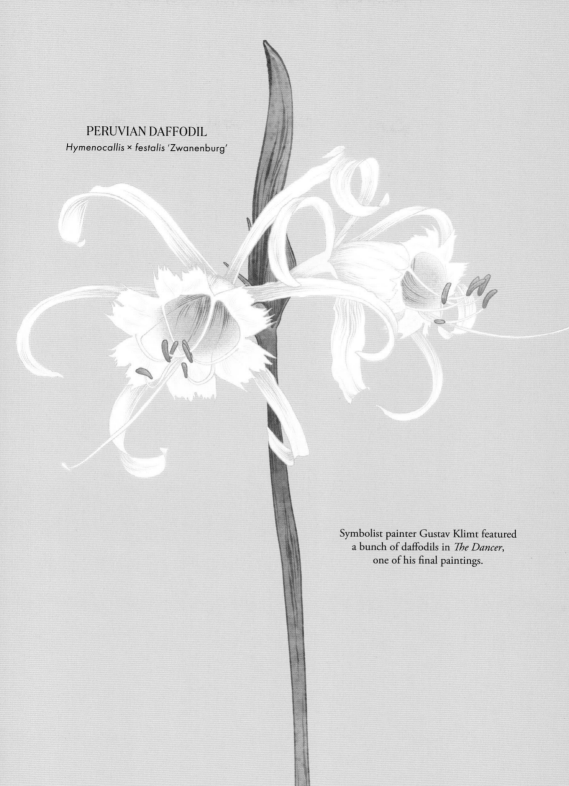

## PERUVIAN DAFFODIL
*Hymenocallis × festalis* 'Zwanenburg'

Symbolist painter Gustav Klimt featured
a bunch of daffodils in *The Dancer*,
one of his final paintings.

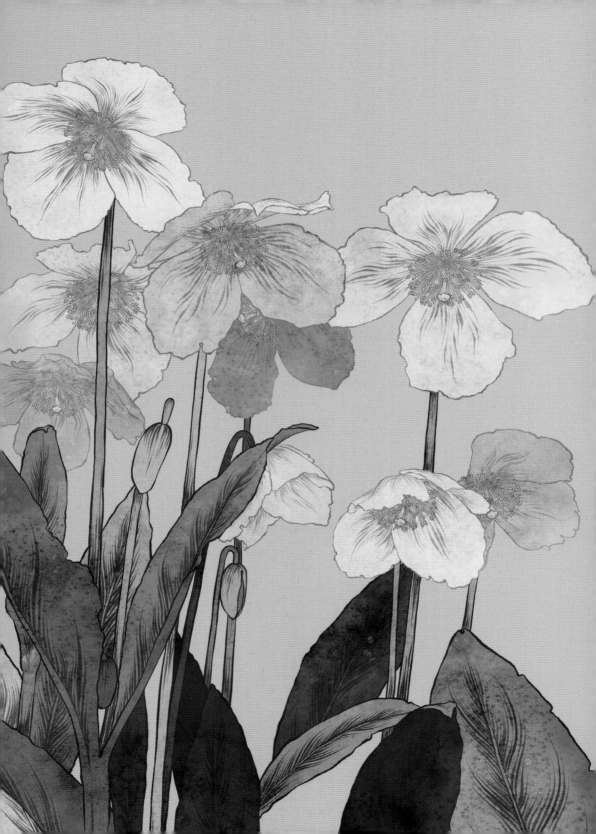

# POPPY

PAPAVERACEAE

O pium poppy (*Papaver somniferum*) is notorious the world over, its papery petals vividly scarlet, pink and purple, its opium-rich sap the cause of much pleasure and pain.

Native to the western Mediterranean, opium has travelled the ancient Silk Road from Europe to China and beyond, thriving in the hot, dry temperatures of Mexico and the infamous Golden Triangle (Myanmar, Laos and Thailand), once a major source of the world's heroin supply, a mantle now held by Afghanistan.

Ancient Greeks and Romans used opium for pain relief, and no other drug since is known to be as powerful. First cultivated some 6000 years ago, opium has been used since Neolithic times for its milky-white, narcotic sap. The poppy's seed pod is cut, releasing the sticky gum, which oozes out to be collected, dried into resin and sold. The seed pod is also full of hundreds of tiny black seeds – poppy seeds, used for cooking, especially in Eastern Europe. It's possible to fail a drug test after eating too many vitamin-packed poppy seeds.

## A RED POPPY SYMBOLISES REMEMBRANCE FOR RETURNED SERVICEMEN AND WOMEN.

Morphine, the main ingredient of opium, was isolated in 1803, and it's still the benchmark used today when measuring pain relief. Morphine was named after Morpheus, the Greek god of dreams, for its sedative properties. Nineteenth-century doctors were enthusiastic, liberally prescribing this wonder drug as a cure-all for any number of ailments. The poppy's flower and fruit is even symbolised on the UK's Royal College of Anaesthetists coat of arms.

Legal consumption was peaking in the nineteenth century and opium dens – like pubs, where opium could be bought and smoked – sprang up in China, America and France. Reclining on daybeds, smokers used long pipes to heat the opium over oil lamps, inhaling the vapours. Opium and laudanum (an alcoholic draught containing morphine) were the recreational drugs of the bohemian set and the literati, including Thomas De Quincey, who wrote the bestseller of the day *Confessions of an English Opium Eater*. US President Thomas Jefferson was an opium user, and the Drug Enforcement Administration found and removed a number of opium poppies from his Monticello estate in the 1980s.

Opium trade routes were in contentious demand. The Chinese tried to stop western traders selling and smuggling opium into China but were no match for the British Empire. The countries fought two opium wars for the rights of trade, which China lost, and by the end of the nineteenth century, much of its population was in the grip of addiction.

Next came heroin, first synthesised from morphine in Germany, where participants of the early drug trials reported feeling *heroisch* (heroic). It was introduced to the world in 1898, legally sold as a non-addictive alternative to morphine and labelled 'Heroin' on the bottle, sparking a spate of major addiction before being made illegal in the US in 1924.

Legal cultivation of the opium poppy for the medicinal production of morphine still occurs in India, Turkey and Australia. But for many gardeners, most of this is beside the point. For them, the sight of blooming poppies is a happy scene, these colourful flowers the harbingers of another spring.

Previous:

## HIMALAYAN BLUE POPPY

*Meconopsis 'Lingholm'*

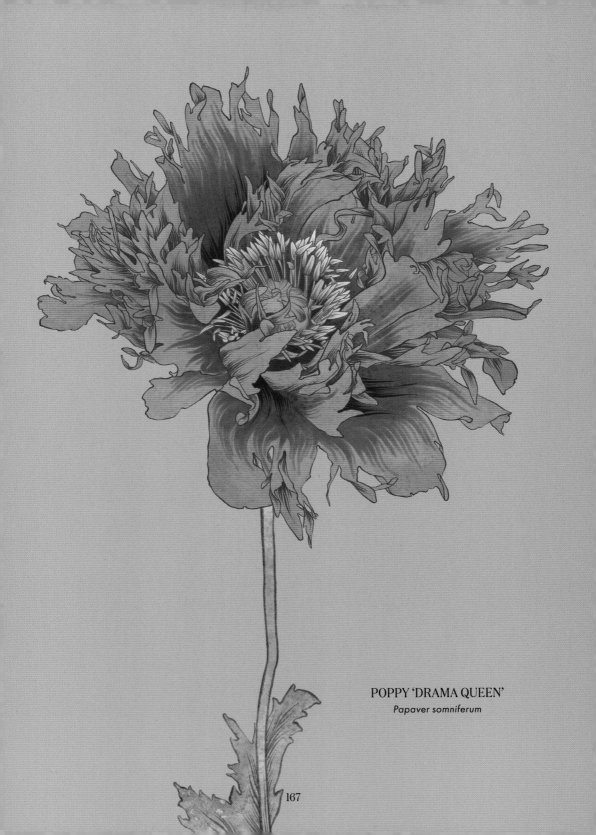

POPPY 'DRAMA QUEEN'
*Papaver somniferum*

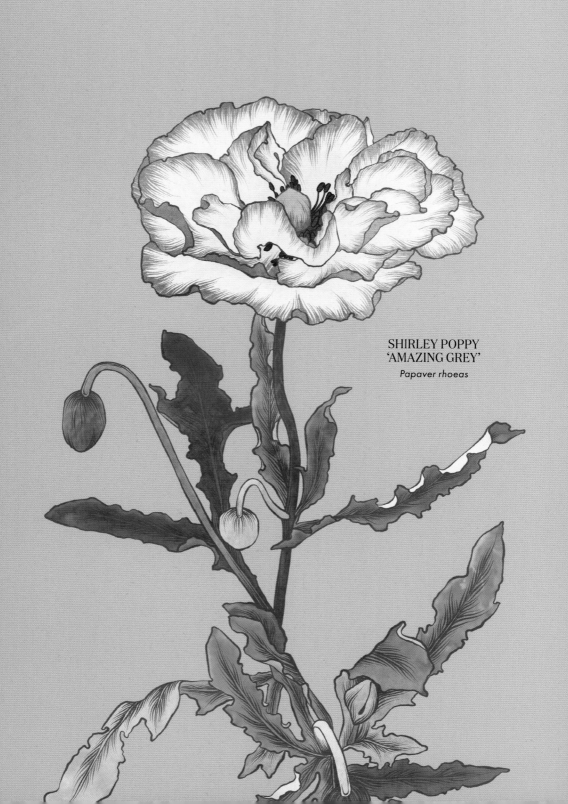

SHIRLEY POPPY
'AMAZING GREY'
*Papaver rhoeas*

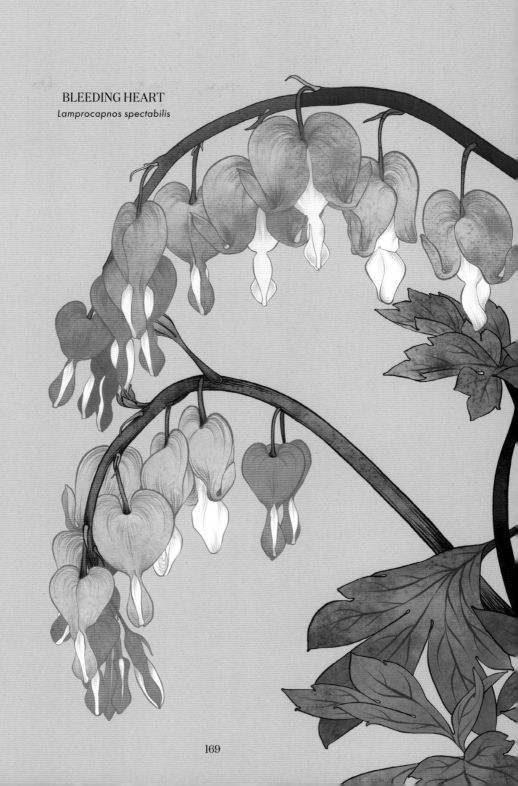

BLEEDING HEART
*Lamprocapnos spectabilis*

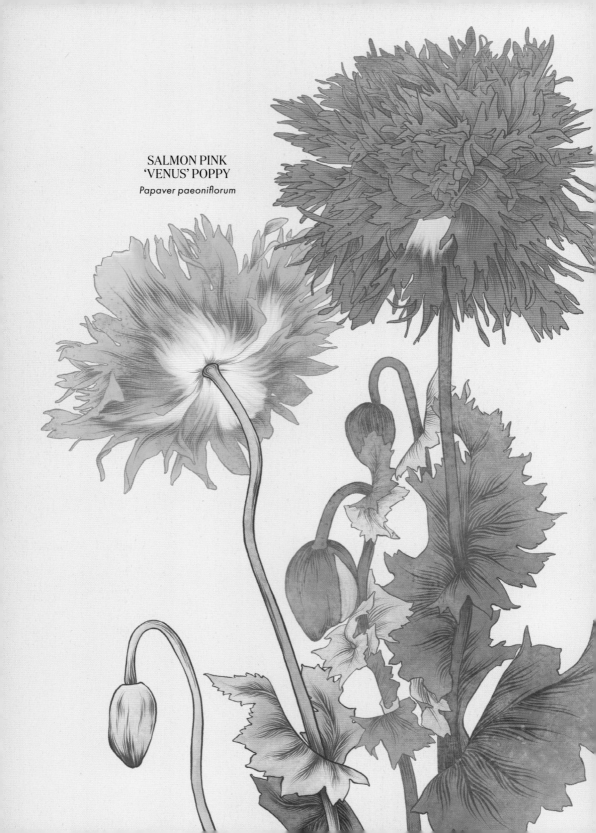

SALMON PINK
'VENUS' POPPY

*Papaver paeoniflorum*

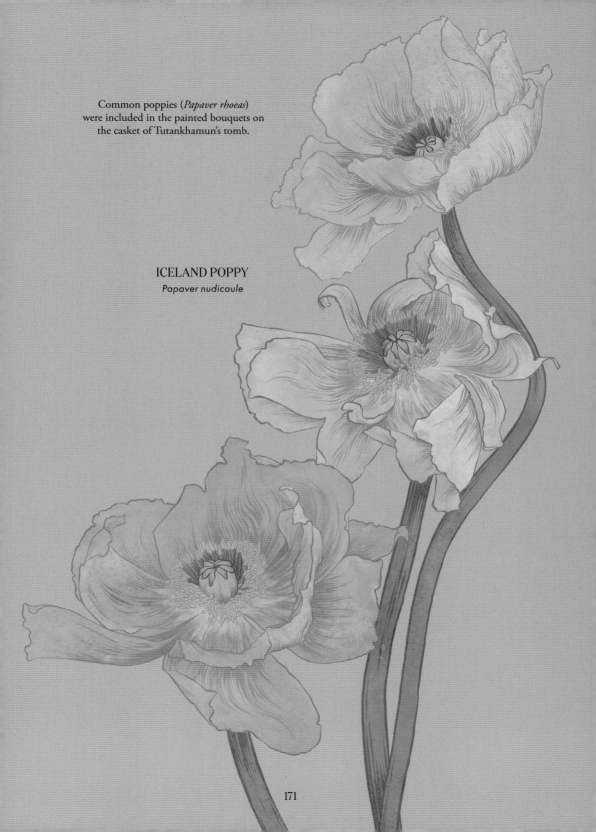

Common poppies (*Papaver rhoeas*)
were included in the painted bouquets on
the casket of Tutankhamun's tomb.

## ICELAND POPPY
*Papaver nudicaule*

# RANUNCULUS

RANUNCULACEAE

A fascinating family, Ranunculaceae is a band of killers and thrillers, rife with wild mythology, lavish beauty and scientific wonder.

Not one to lay dormant doing nothing, Ranunculaceae gets busy blooming mid-winter with showy hellebore and open-faced anemone, while clematis scrambles up arbours and sunny buttercup wows us with its magical petals that sparkle.

In Native American folklore, buttercups (*Ranunculus acris*) are called 'coyote's eyes'; the coyote threw his eyes skyward where they were caught by an eagle, so the coyote fashioned new eyes from buttercups. Children have played the buttercup game for centuries, holding the bloom under their chins, an olden-day test to see if they like butter: if the petals reflect yellow against their skin, the answer is yes! While the deductive powers of the buttercup may be fanciful, there is a something special in the science.

**RANUNCULUS MEANS 'LITTLE FROG' IN LATIN, DUBBED SO BECAUSE MANY OF ITS FAMILY GROW NEAR WATERWAYS WHERE FROGS ABOUND.**

Researchers have been studying the colour of buttercup for almost a century, exploring its glowing, intensely yellow petals. The petal's top layer is ultra-thin, containing blue light–absorbing pigments; it's attached to a bottom starchy layer, between which are sandwiched pockets of air. As wavelengths of light move through the petal, they scatter and interact with the flower's anatomical structures, creating an iridescence, like a mirror. When the sun is high, the flowers might 'flash', enticing bees and other pollinators. But that's not all. On cold days, buttercup warms itself by tracking the sun, its flowers forming a goblet shape to harness the solar energy, tilting its blossoms, as if warming its hands by a fire. It's a cosy place for pollinating insects to visit.

Buttercups don't always have to be yellow, though. The Persian buttercup (*Ranunculus asiaticus*), otherwise known as the 'florist's buttercup', has densely packed petals of magenta, pink, orange or white.

*Anemone nemorosa*, wood anemones, are open and wide with happy flower faces, thriving in temperate woodlands and tough alpine climates. Tales are woven in folklore about this colourful winter bloomer, and ancient Greek mythology tells of the great love story of the goddess Aphrodite and her handsome, mortal lover Adonis. While hunting, Adonis is killed by Ares, Aphrodite's jealous ex-lover, disguised as a wild boar. As a broken-hearted Aphrodite cries by her lover's side, her tears mingle with Adonis's blood and the scarlet poppy anemone (*Anemone coronaria*) grows where he once lay.

In the language of flowers, anemone has long symbolised bad luck, death and forsaken love, perhaps because all Ranunculaceae are toxic, full of poisonous compounds including protoanemonin, alkaloids and glycosides. Wolfsbane (*Aconitum*) was drunk in ancient times to cause death, often within hours, and even skin contact with this dangerous plant can cause symptoms of confusion and respiratory distress.

Previous:

LARKSPUR 'CORAL SUNSET'

*Delphinium elatum*

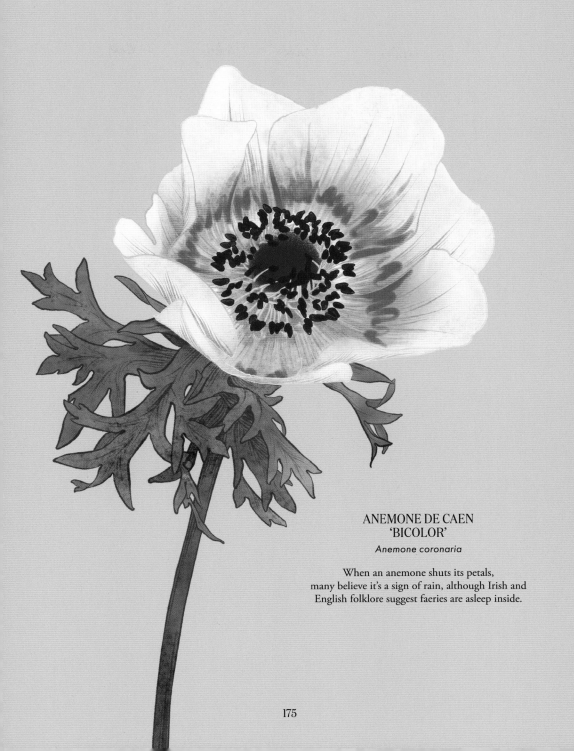

ANEMONE DE CAEN
'BICOLOR'

*Anemone coronaria*

When an anemone shuts its petals,
many believe it's a sign of rain, although Irish and
English folklore suggest faeries are asleep inside.

175

CLEMATIS 'MULTI BLUE'

## CLEMATIS 'PIILU'

An ingredient in Bach's Rescue Remedy,
a homeopathic tonic to relieve anxiety,
clematis was also used in microdoses to
treat headaches in some cultures.

Opposite page:

## HELLEBORE

*Hellebore 'Onyx Odyssey', Lenten rose
(Helleborus × hybridus double white spotted),
Hellebore 'Single Clear White', Helleborus
orientalis 'Double Ellen Picotee' and
Helleborus × hybridus single green*

*HELLEBORE*
'ANNA'S RED'

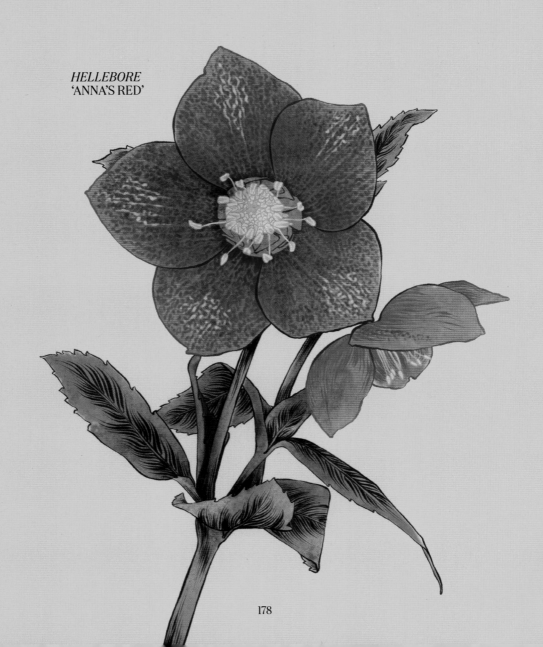

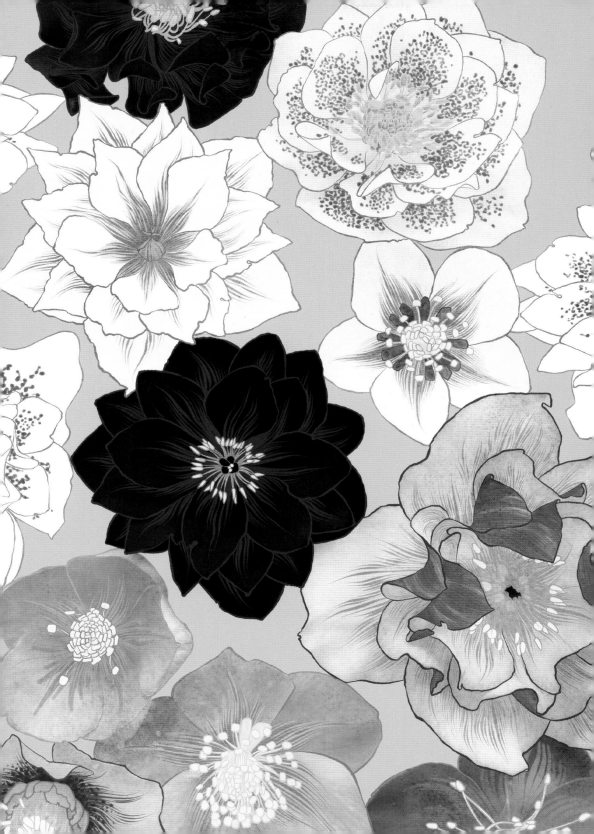

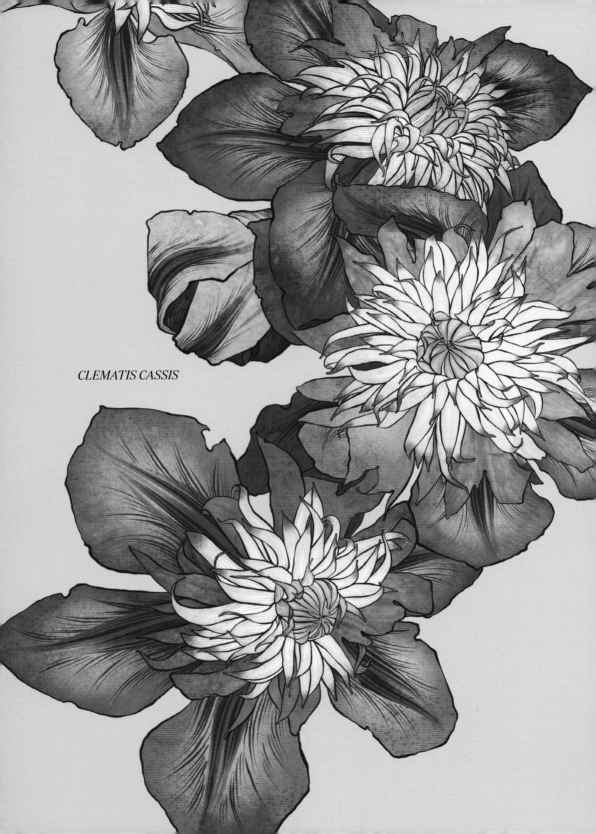

*CLEMATIS CASSIS*

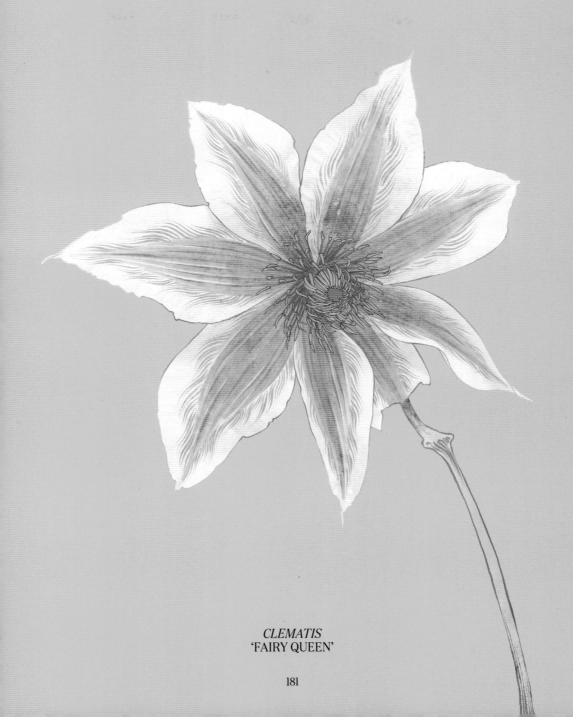

CLEMATIS
'FAIRY QUEEN'

181

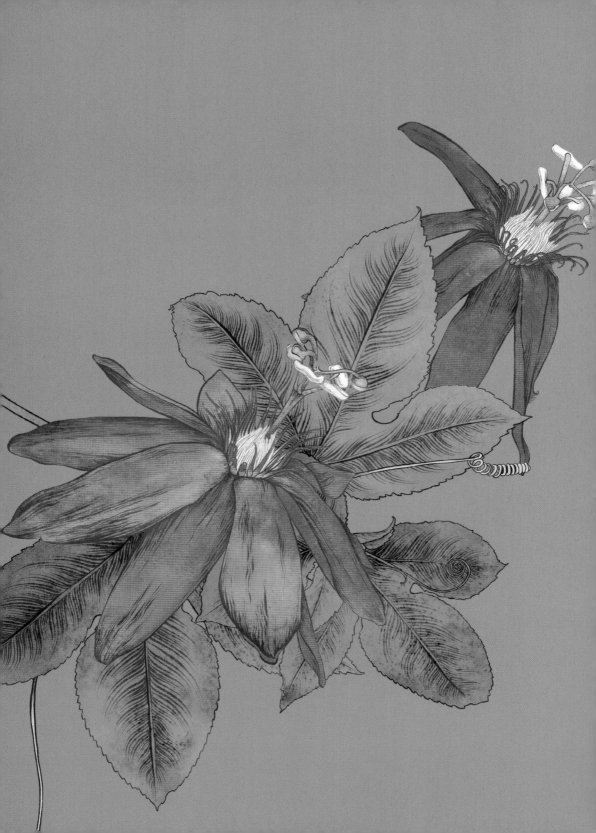

# PASSIONFLOWER

PASSIFLORACEAE

Wild, passionate and vigorous, Passifloraceae flourishes in the world's neotropical realm, its bold, otherworldly flowers blooming bright and proud.

Passionflowers are native to the humid subtropical and tropical forests of Florida, Mexico's Yucatan Peninsula, the islands of the Caribbean, and the muggy jungles of Central America, but they grow well all over the tropics, from Australia's north coast to steamy Vietnam.

Most of the family are fast-growing vines, scrambling over structures with alacrity, covering areas with glossy green leaves, their curly, clinging tendrils climbing high. Their fragrant flowers are amazing, with a base of five sepals and five petals, a crown of flashily coloured filaments, prominent stigma, and anthers that flip outwards, making it easier for bees, hummingbirds and bats to carry away the pollen on their backs.

## SOME PASSIONFLOWERS BLOOM ONLY FOR A SINGLE DAY.

Sometimes called 'Jesus flowers', passionflowers are immortalised in Christian mythology as symbols of the crucifixion. The sepals and petals tell of the ten faithful apostles, the number excluding Judas the traitor and Peter, who, according to the Bible, denied Jesus three times on the night of the Last Supper. The circle of filaments – the corona – represents the Crown of Thorns, the tendrils symbolise the whips used in flagellation, the stigmas denote the three nails, and the plant's ovary represents the Holy Grail. Even the sedative properties of the passionflower's leaves, used by Native Americans to treat insomnia and calm nerves, were thought to be a way Jesus helped his subjects.

A stunner of the family is giant granadilla (*Passiflora quadrangularis*), with large, fragrant flowers of deep red, fringed with hundreds of white and purple filaments. This unruly vine grows fast and strong, its melon-style fruits weighing as much as a newborn baby. The fruit's flesh is sweet and mild, and can be added to fruit salads, blitzed into juices, or used to make ice cream.

Rapid-growing maypop (*Passiflora incarnata*) is a robust climber unafraid of heights, scaling 9 metres (about 30 feet) within a few weeks. It sports showy pinky, bluish, purple and white flowers with a musky, lemony scent adored by butterflies, each flower blooming only for one day. As for the maypop's name? Squeeze or stand on the fruit and – POP! – it goes. It's a vine of significance for the Cherokee, used for centuries as a medicine, the leaves brewed into a calming tea or dried and smoked, the starchy roots eaten as food. But perhaps the most famous edible passionflower is the much-cultivated passionfruit (*Passiflora edulis*), its round purple fruit loaded with nutrients and antioxidants.

It's wow-factor all the way with passionflowers, their weird, unearthly blooms of hot, bright colours hanging from lush vines, giving tropical gardens ornamental zing all over the world.

Previous:

## CRIMSON PASSIONFLOWER

*Passiflora vitifolia*

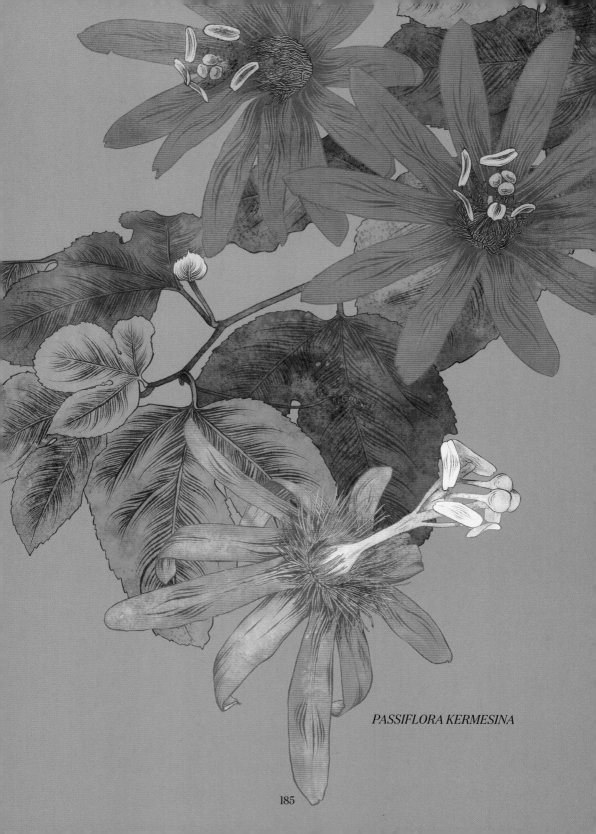

*PASSIFLORA KERMESINA*

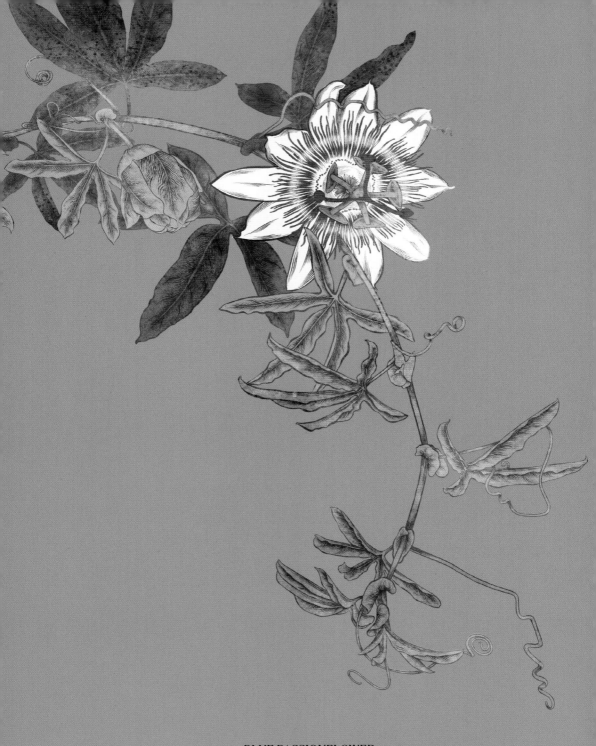

**BLUE PASSIONFLOWER**

*Passiflora caerulea*

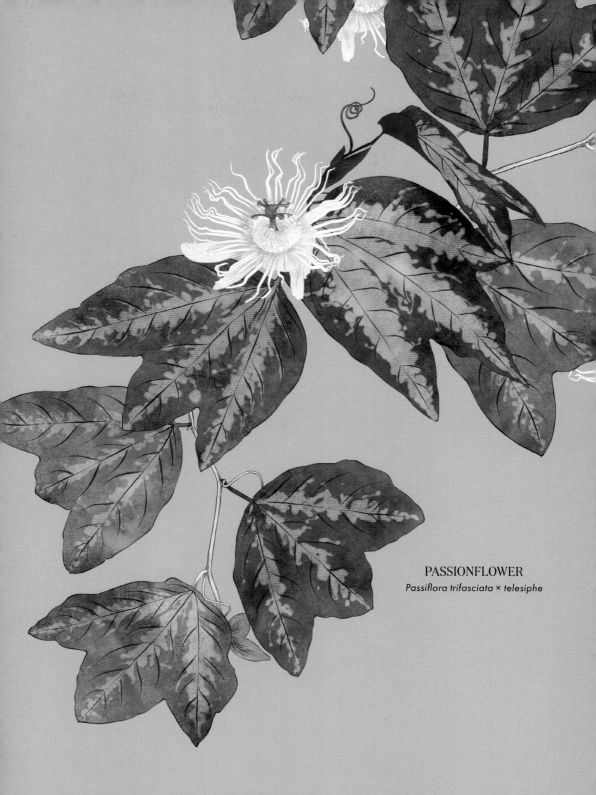

PASSIONFLOWER

*Passiflora trifasciata × telesiphe*

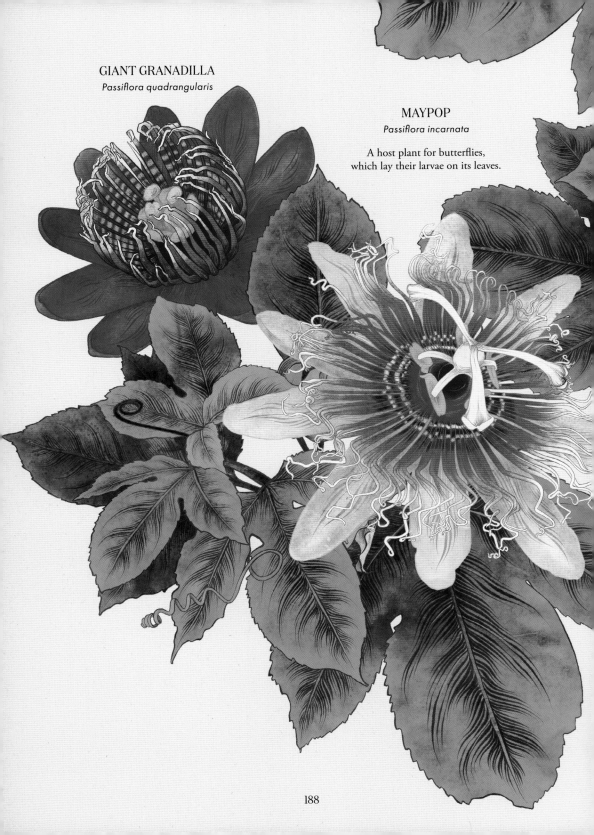

**GIANT GRANADILLA**
*Passiflora quadrangularis*

**MAYPOP**
*Passiflora incarnata*

A host plant for butterflies,
which lay their larvae on its leaves.

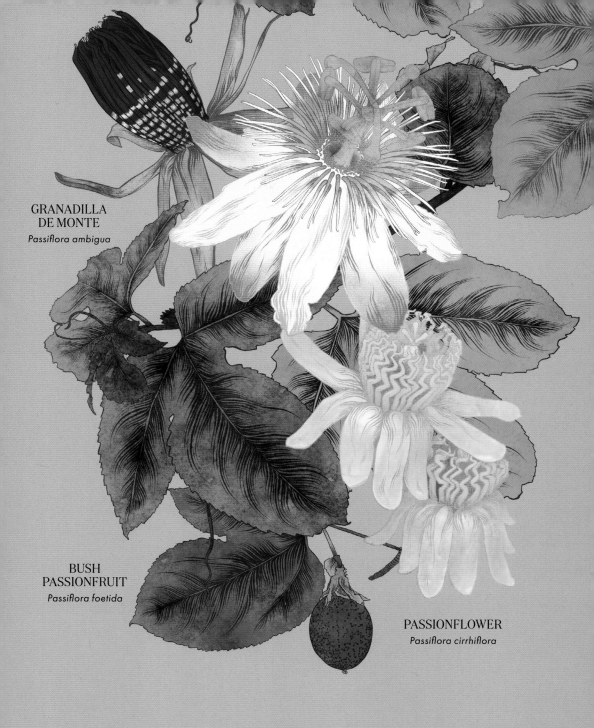

**GRANADILLA
DE MONTE**

*Passiflora ambigua*

**BUSH
PASSIONFRUIT**

*Passiflora foetida*

**PASSIONFLOWER**

*Passiflora cirrhiflora*

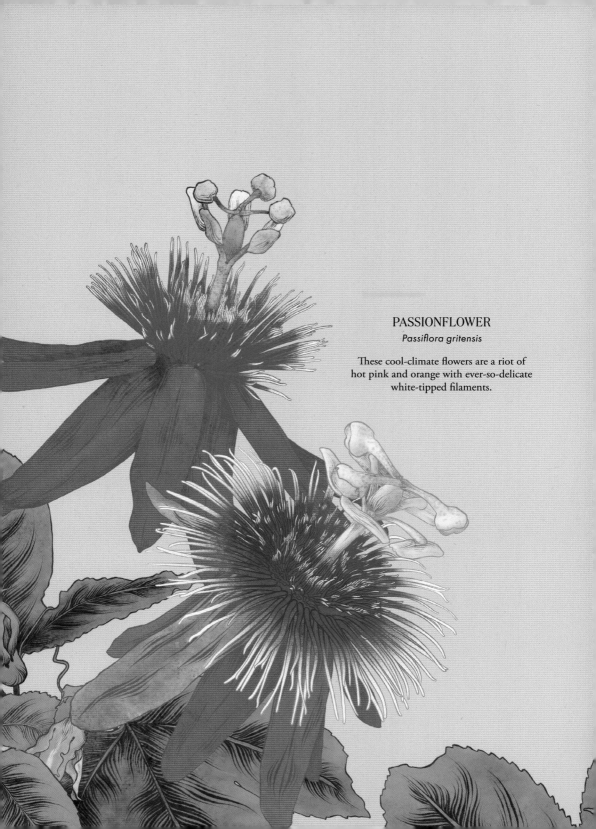

## PASSIONFLOWER
*Passiflora gritensis*

These cool-climate flowers are a riot of
hot pink and orange with ever-so-delicate
white-tipped filaments.

Passionflowers make gorgeous displays floating
in a bowl of water, a zen way to marvel at their
complex floral structure.

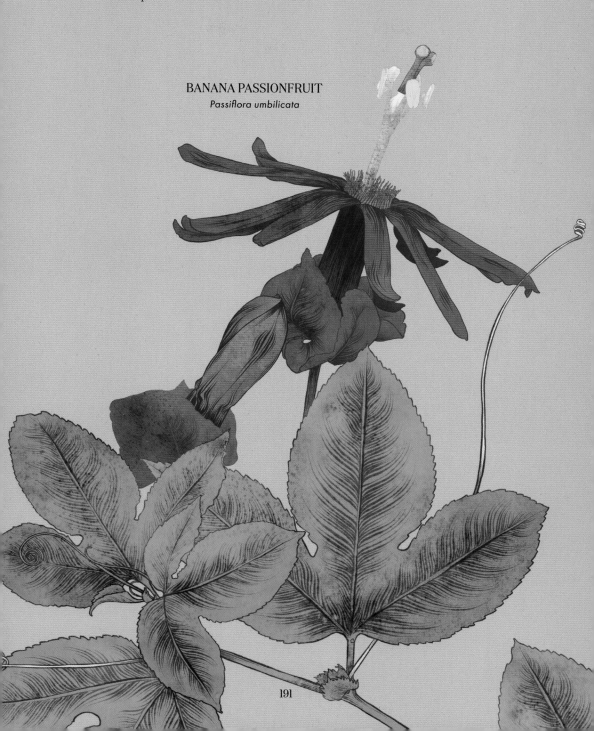

## BANANA PASSIONFRUIT
*Passiflora umbilicata*

# BEGONIA

## BEGONIACEAE

E asy-pleaser Begoniaceae is a big family of bloomers that flourish in the lush understorey of muggy Malaysian jungles and the mountainous microclimates of Hawaii.

The genus begonia is wildly diverse, with more than 1600 species. There are angel wing begonias with tall, cane-like stems, hairy begonias with soft velvety leaves, and rex begonias, prized for their flashy, patterned foliage. Some are shrubby, some are tuberous with big winter blooms, some have frilly petals, others trail and climb. Begonias are monoecious, which means female and male flowers both develop on the same plant.

Begonia's flowers bloom pink, red, white and orange, with sunny yellow hearts, and their quirky, lopsided leaves of many colours are as much a feature as their petals. *Begonia formosana* 'Hayata' Masam, from the highlands of Taiwan, has batwing-shaped foliage speckled silver and white, while the big leaves of begonia 'Escargot' (*Begonia rex hybrid*) are marked with a spiral, like a child's wonky drawing of a snail. The begonia 'Little Miss Mummey' has dramatic black leaves with red undersides, the tops of the leaves adorned with textural silver spots.

## BEGONIAS CAN BE FRAGRANT, THEIR BLOSSOMS AROMATIC WITH HINTS OF ROSE.

The rare peacock begonia (*Begonia pavonina*) is a scientific wonder, its leaves layered with iridoplasts so they appear to shimmer metallic blue or glow bright turquoise. Iridoplasts help the plant scavenge for light, allowing it to harvest and absorb longer red-green wavelengths, boosting photosynthesis. This biological adaptation means begonia can flourish in low-lit forest floors where other flowering plants wouldn't survive.

Some begonias are edible, although avoid any that have been treated with pesticides. Rhizomes from the painted leaf begonia (*Begonia picta*) can be turned into pickles, and the sour leaves of *Begonia deliciosa* and *Begonia subvillosa* add a fresh citrussy crunch to salads, their sweet, fleshy pink-and-white petals prettying up plates in some of the world's best restaurants. Begonia leaves have been used for centuries in Mexico and Asia for a vitamin-C boost, tossed in with stir-fries or curries, or used medicinally to help soothe sore throats or toothaches.

Lovers of the tropics, begonias thrive in the cloud forests of Central America, the swampy lowlands of America's south, subtropical Africa and Southeast Asia, the heartland of begonia biodiversity. The only other genus in the family, hillebrandia, hails from Hawaii. Its sole species member, aka aka awa (*Hillebrandia sandwicensis*), with its dainty pink and white flowers, grows in the deep ravines of Hawaii's magnificent Waimea Canyon. Fossils suggest primitive aka aka awa existed more than 50 million years ago, pre-dating the Hawaiian islands by about 20 million years – it's thought its tiny dust-like seeds hitched a ride on the muddy legs of birds, or in the wind, allowing it to island hop from now defunct landmasses to its current home.

Luminous and floriferous, begoniaceae brightens the deep, dark shade of the forest floor. It is a welcome garden or houseplant addition, and a collector's delight.

Previous:

### BEGONIA

*Begonia taliensis Gagnep*

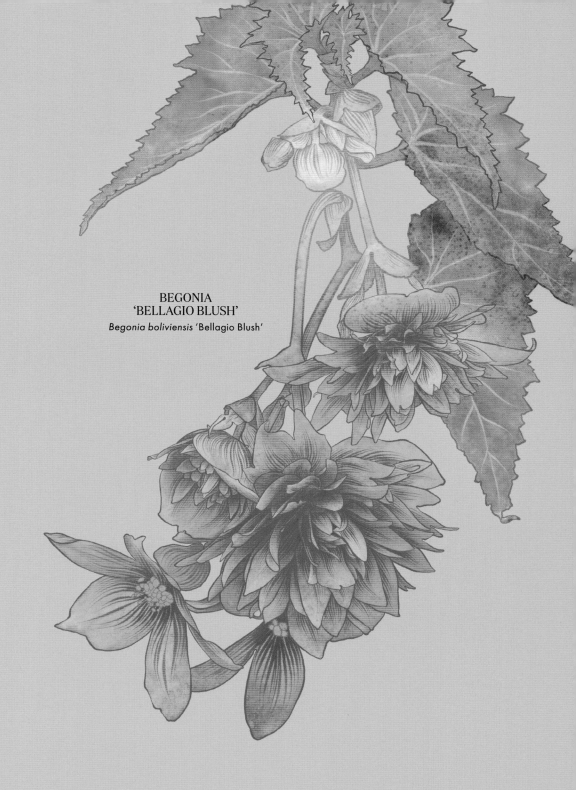

BEGONIA
'BELLAGIO BLUSH'
*Begonia boliviensis* 'Bellagio Blush'

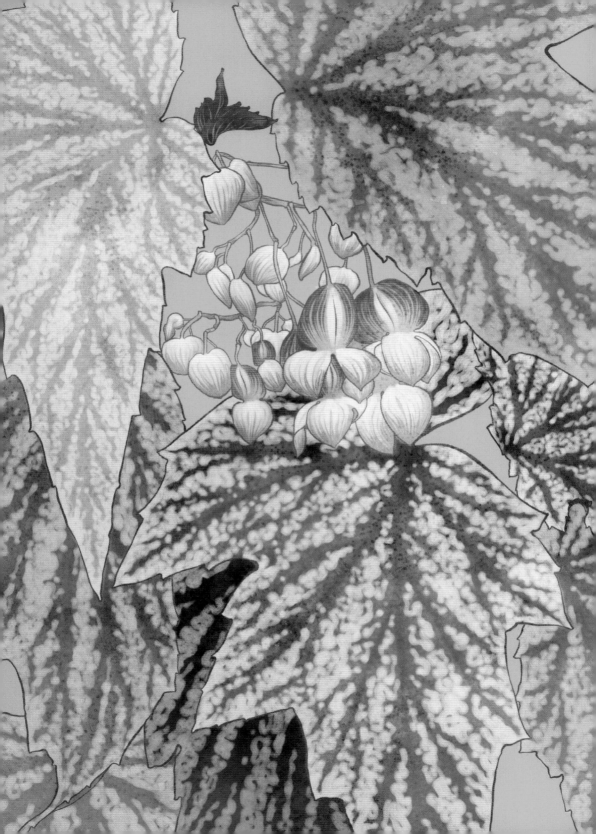

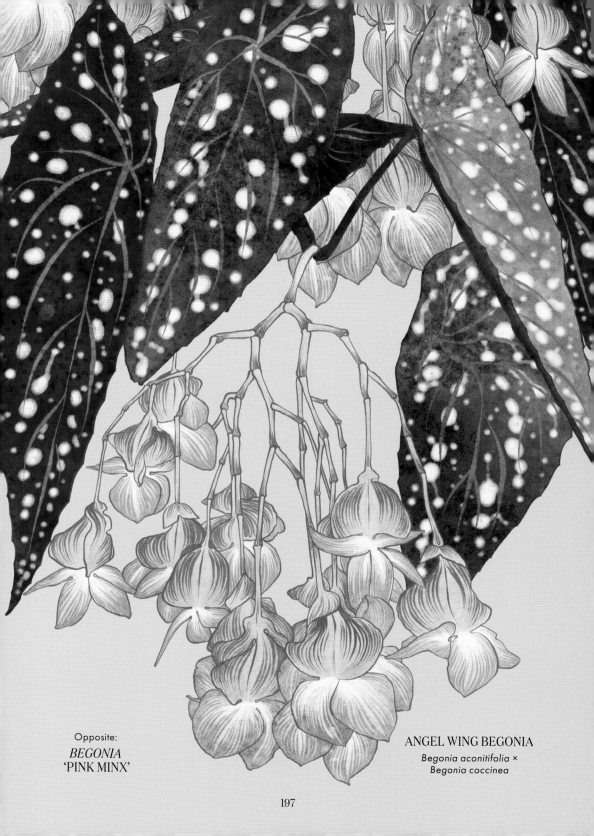

Opposite:
*BEGONIA*
'PINK MINX'

ANGEL WING BEGONIA
*Begonia aconitifolia ×*
*Begonia coccinea*

# BEGONIA
## 'PICOTEE LACE APRICOT'
*Begonia tuberhybrida 'Picotee Lace Apricot'*

Gifting a begonia can symbolise caution.

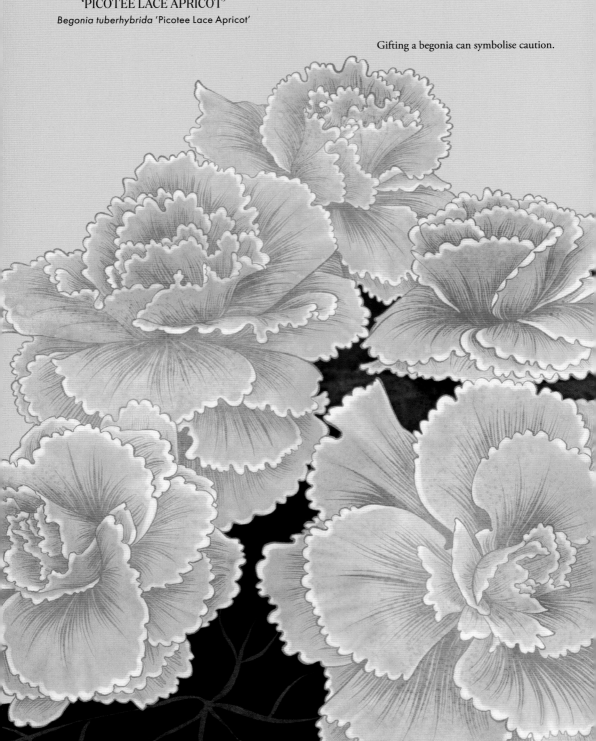

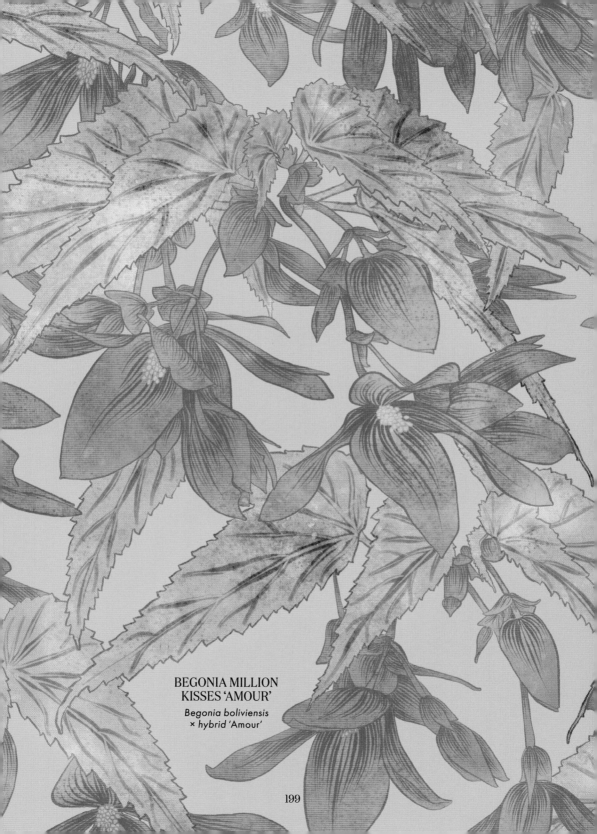

BEGONIA MILLION
KISSES 'AMOUR'

*Begonia boliviensis*
*× hybrid 'Amour'*

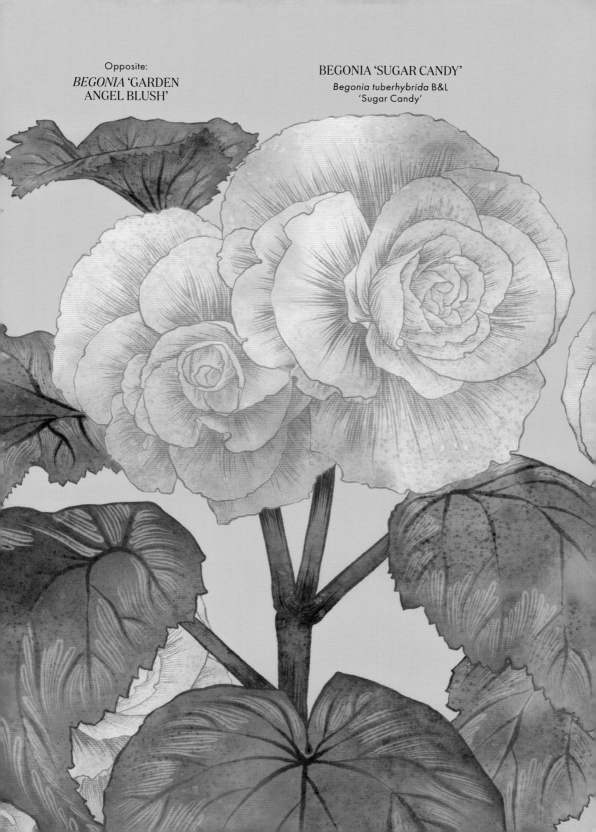

Opposite:
*BEGONIA* 'GARDEN
ANGEL BLUSH'

BEGONIA 'SUGAR CANDY'
*Begonia tuberhybrida* B&L
'Sugar Candy'

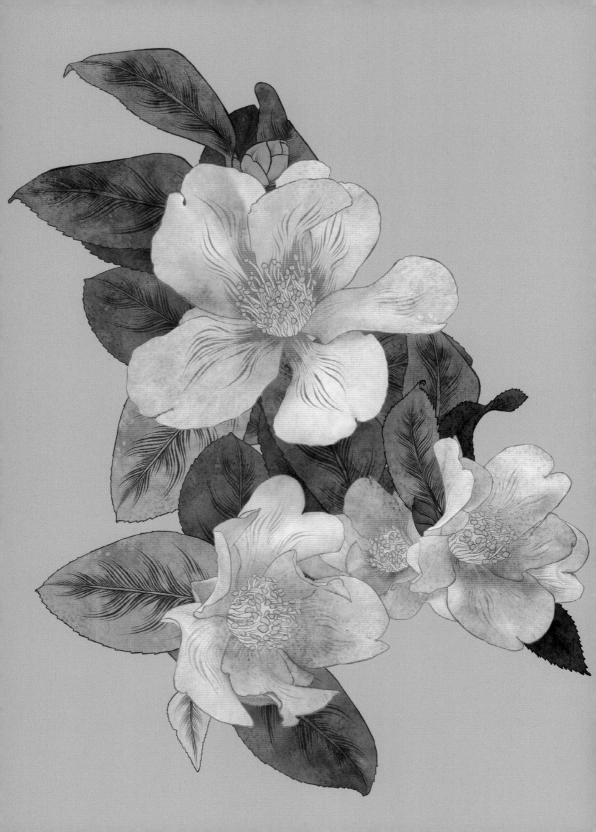

# CAMELLIA

THEACEAE

Camellias are the glamazons of the Theaceae group, a cool-climate bunch of showy, shady ladies clad in glossy, evergreen finery.

Growing wild on the low-altitude peaks of the Asian Himalaya, camellia is a giving tree, its leaves used for tea, its seeds for oil, its flowers for beauty. Cultivated for centuries in China and Japan, it is prized for its conspicuous, ornamental blooms hued pink, red and white – some stripy, some speckled, some double – and was introduced to Europe and America in the eighteenth century.

Ancient Chinese emperors included *cháhuā* in their secret gardens, and Japanese planted *tsubaki* near temples and places of worship, believing Shinto gods inhabited their blooms when they visited earth. But Japanese legend warns: never give samurai a tsubaki bloom. These ancient rebels feared how the flower aged, falling to the ground with a thud, symbolising a head severed by a sword, left to wither and decompose.

**IN HARPER LEE'S *TO KILL A MOCKINGBIRD*, THE WHITE CAMELLIA IS A SYMBOL FOR UNDERSTANDING AND COMPASSION.**

Extracting camellia oil by cold-pressing the seeds of *Camellia japonica* and *Camellia oleifera* is another centuries-old Japanese tradition, with the oil used by warriors to maintain their weaponry, by sumo wrestlers to keep their hair neat and slicked back, and touted as a beauty secret of geishas who used it to remove their heavy make-up and moisturise their skin. Packed with vitamins and minerals, camellia oil is also edible, its high smoking point making it excellent for frying tempura, its delicate flavour adding sweetness to salad dressing.

Wood ash from camellia trees has been used for millennia when brewing sake, Japan's famous alcoholic wine made from fermented rice. *Tane-koji*, which means 'bloom of mould', is the backbone of the process, its fungal spores inoculated onto rice mixed with wood ash, activating yeast cells to begin fermentation.

Camellia's symmetrical blooms are often represented in art, painted on Chinese wallpapers and porcelain, and found in the highest houses of haute couture. Iconic fashion designer Coco Chanel was renowned for pinning a silk camellia bud to her lapels, hats and hair, and camellias have been featured in Chanel's designs since the 1920s.

But perhaps camellia's greatest gift to the world is the magnificently simple pleasure of a cup of tea. The Chinese invented the trick of steeping the leaves of the tea plant (*Camellia sinensis*) in hot water, creating a stimulating yet soothing beverage. In the seventeenth century, China introduced the art of tea to Korea and Japan and, later, to England, where it was known as 'the cup that cheers but does not inebriate', forever becoming the cornerstone of British domesticity for the posh and the poor alike.

Previous:

*CAMELLIA* × 'YUME'

New Zealand adopted the white camellia as a symbol for women's
right to vote, and it appears on the country's ten-dollar note.

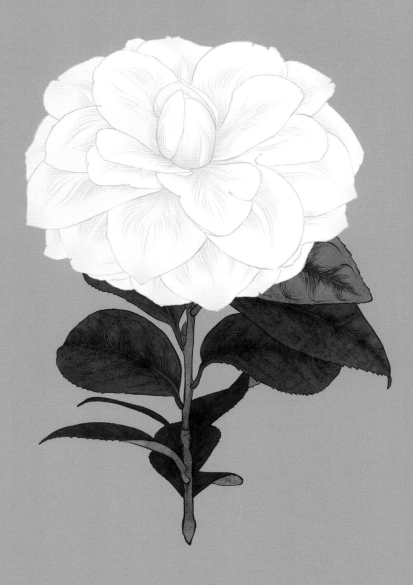

*CAMELLIA JAPONICA*
'DAHLONEGA'

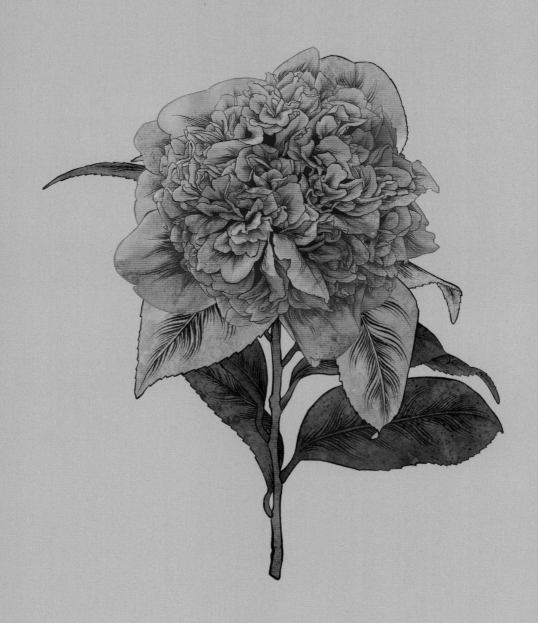

*CAMELLIA JAPONICA*
'DONA HERZILIA DE FREITAS MAGALHÃES'

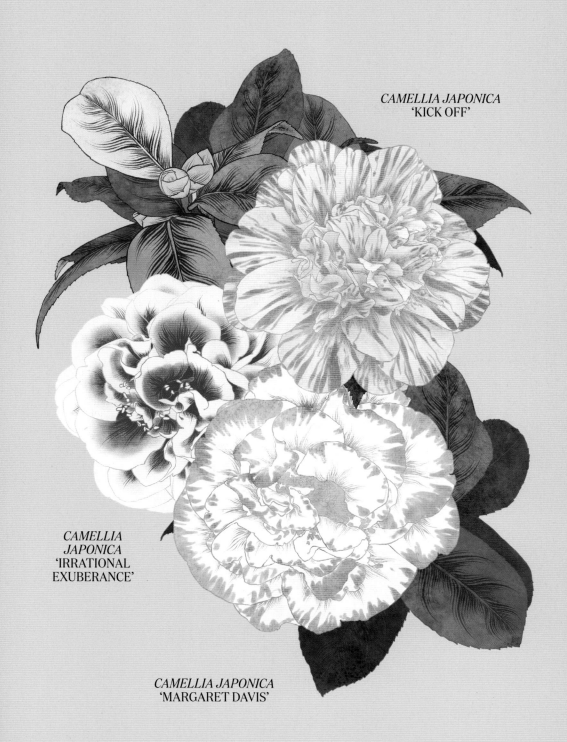

CAMELLIA JAPONICA
'KICK OFF'

CAMELLIA
JAPONICA
'IRRATIONAL
EXUBERANCE'

CAMELLIA JAPONICA
'MARGARET DAVIS'

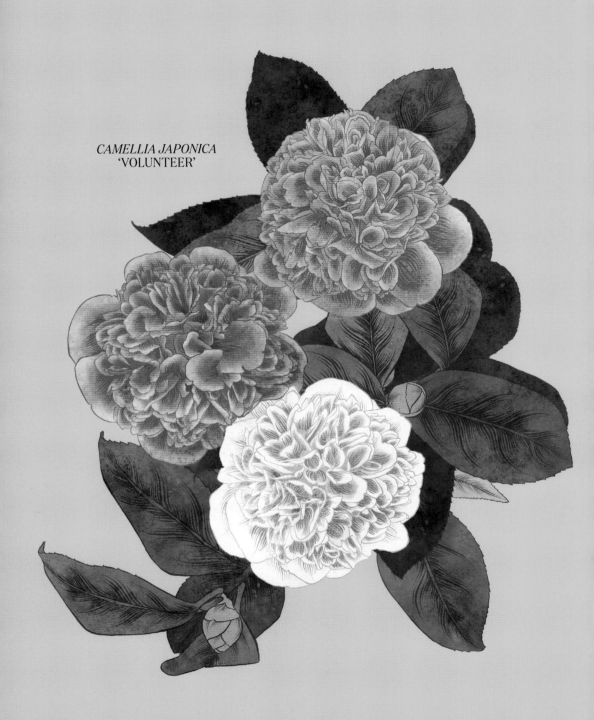

CAMELLIA JAPONICA
'VOLUNTEER'

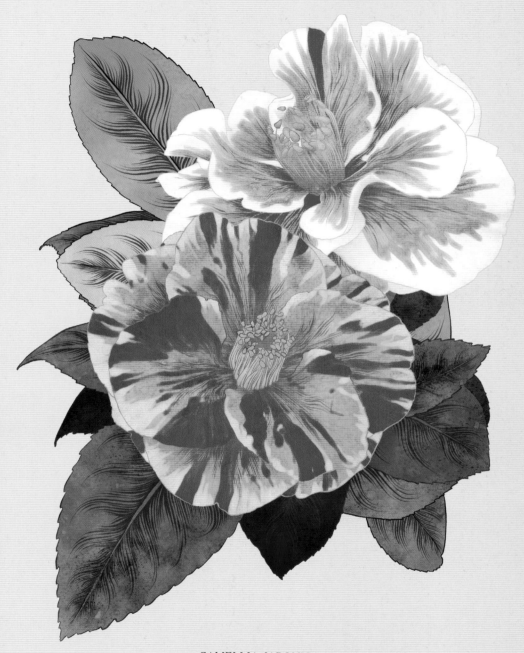

*CAMELLIA JAPONICA*
'LADY VANSITTART'

Camellia is often dubbed the 'Japanese rose' or the 'Chinese rose of winter' for its flowers that bloom in the year's coldest season.

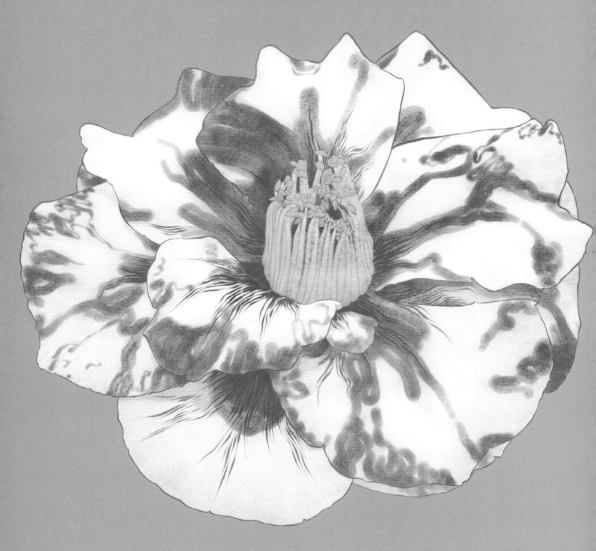

*CAMELLIA JAPONICA*
'VILLE DE NANTES'

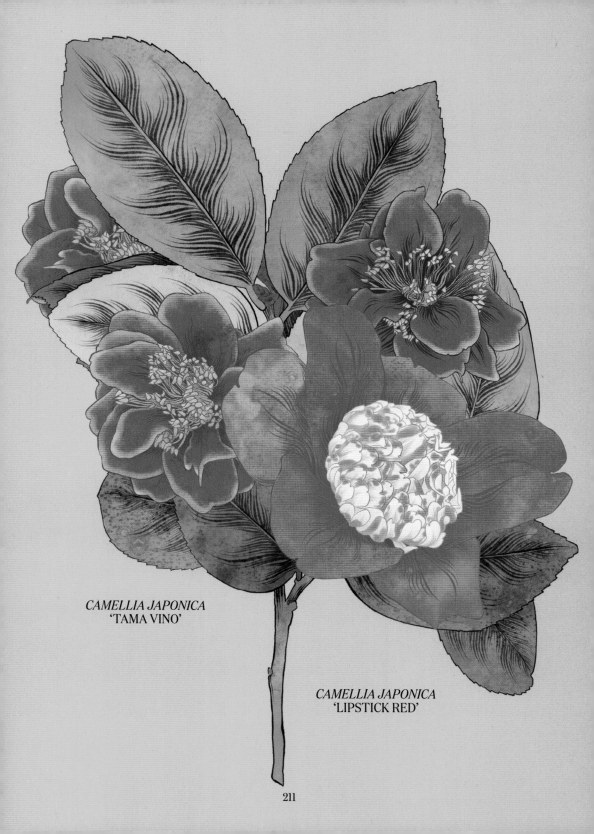

CAMELLIA JAPONICA
'TAMA VINO'

CAMELLIA JAPONICA
'LIPSTICK RED'

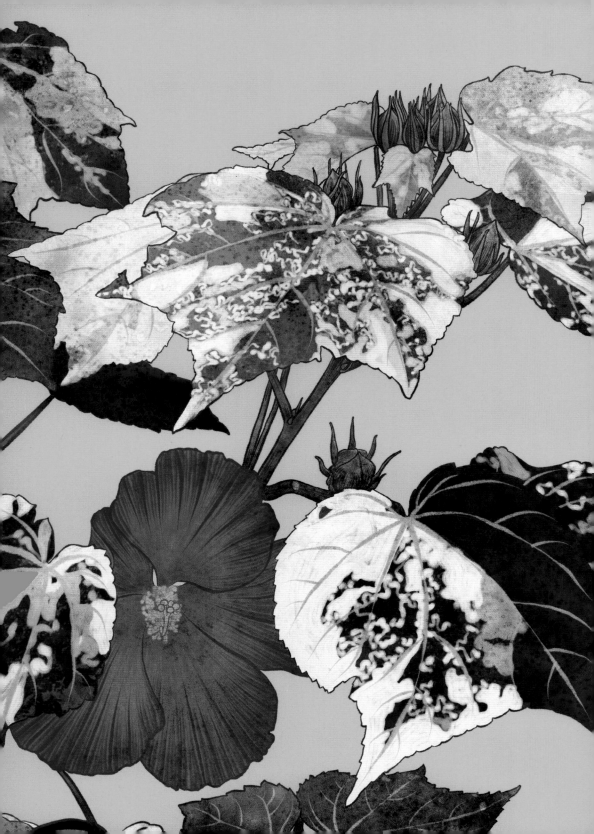

# MALLOW

MALVACEAE

Some families are odd, a collection of disparate relatives with seemingly no common connection. Crazily diverse Malvaceae is one such clan, with okra, cotton, durian, marshmallow, hollyhock, Illawarra flame tree and the voluptuous tropical beauties of hibiscus all part of the same gang.

Their commonality? Malvaceae is a family of medicos united by mucilage, the far-from-sexy slimy substance revered for its medicinal properties. Wonder weeds red-flowered mallow (*Modiola caroliniana*) and marshmallow (*Malva parviflora*) are used to heal burns, reduce inflammation and soothe sore throats and dry coughs. Tangy, ruby-red tea, packed with antioxidants and vitamin C, is made from the mucilage-rich leaves of Chinese hibiscus (*Hibiscus rosa-sinensis*). Sometimes called 'the rose of China', it is one of the world's most hybridised flowers.

During the refined Victorian era heirloom hollyhocks (*Alcea*) were known as 'outhouse flowers', a common sight in cottage gardens. They grew tall and bright, with spires of pinks and magenta, high enough to shield the outside bathroom. It was a floral signal, so ladies of polite society didn't have to ask about the unmentionable. Hollyhock 'black' (*Alcea rosea var nigra*) is an heirloom variety, a black stunner, which may have also graced the outhouse exterior.

Flamboyant hibiscus is the most famous Malvaceae, hailing from the valleys of China and the picturesque South Pacific, with many endemic to the fertile, volcanic Hawaiian islands, adding bold colour to wet rainforests and marshy lowlands. Primary-yellow Hawaiian hibiscus (*Hibiscus brackenridgei*) is the state flower, traditionally seen tucked behind the ears of islander women (left ear if spoken for, right ear if single, according to lore).

## HINDUS BELIEVE DIVINE ENERGY IS EMBODIED IN HIBISCUS, AND SCARLET CHINESE HIBISCUS IS GIVEN AS AN OFFERING TO GODDESS KALI AND LORD GANESHA.

Hibiscus's magic trick is the ability to change the colour of its flowers, such as white kauai rosemallow (*Hibiscus waimeae*), which grows wild in the craggy gorges of Waimea Canyon, Hawaii's geologic wonderland characterised by weathered basalt and waterfalls. Its bright orange-red stamen thrusts from the flower, which starts the day white and turns pink by late afternoon. Why? Because colour pigments (carotenoids and flavonoids) in hibiscus's petals react with its environment. Hot-coloured carotenoids (reds, oranges, yellows) love the heat, so the higher the temperature, the brighter they bloom, whereas blue-purple and yellow-white colours tend towards pastel in the heat. Like hydrangeas, hibiscuses are also affected by the alkalinity or acidity of the soil pH.

Then there are the hard-working members of the family. Durian (*Durio zibethinus*), with its thorny rind, is banned on public transport in Asia, its smell rank to some, but inspiring delicious anticipation of its bittersweet, custardy flesh in others. Okra (*Abelmoschus esculentus*) has stunning, almost translucent, creamy-yellow petals, and its edible fruit is excellent for thickening curries and stews. And upland cotton (*Gossypium hirsutum*) was first woven into fabric 3000 years ago.

Odd or not, Malvaceae is a family of great beauty, its sun-loving showstopper blooms generously unfurling, and its fruits providing sustenance.

Previous:

### 'GOLD SPLASH' HIBISCUS

*Hibiscus mutabilis*

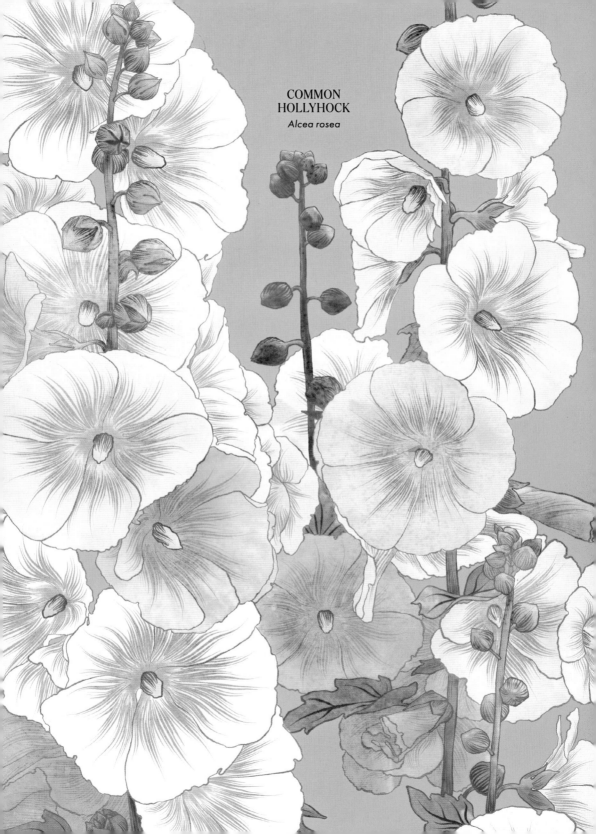

COMMON
HOLLYHOCK
*Alcea rosea*

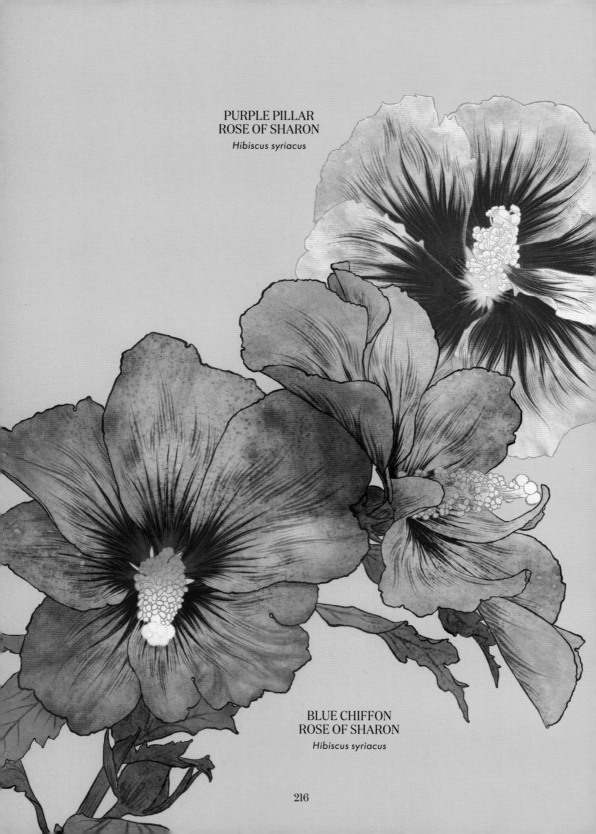

PURPLE PILLAR
ROSE OF SHARON

*Hibiscus syriacus*

BLUE CHIFFON
ROSE OF SHARON

*Hibiscus syriacus*

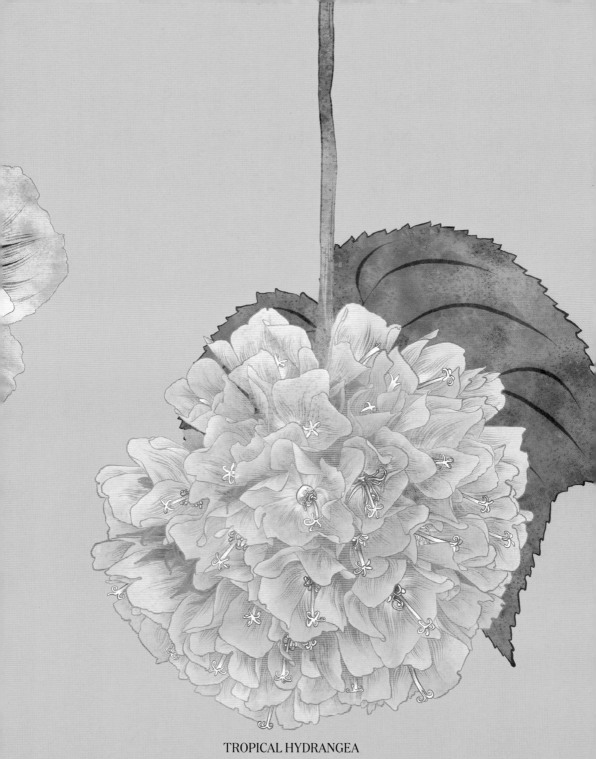

TROPICAL HYDRANGEA

*Dombeya wallichii*

217

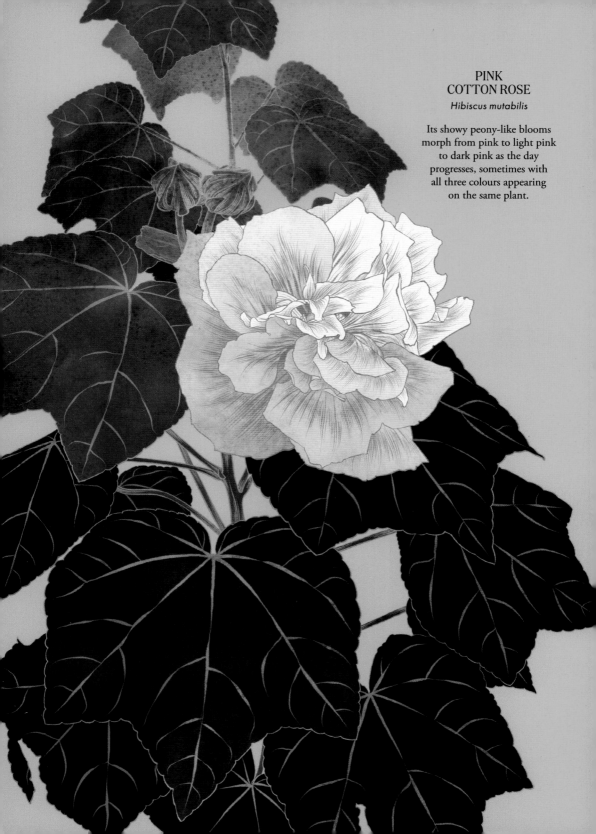

PINK
COTTON ROSE
*Hibiscus mutabilis*

Its showy peony-like blooms
morph from pink to light pink
to dark pink as the day
progresses, sometimes with
all three colours appearing
on the same plant.

Hummingbirds love hibiscus, foraging
in the nectar-rich blooms.

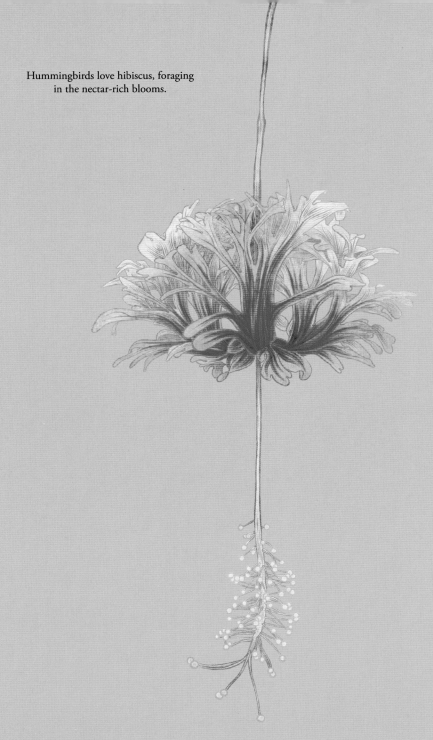

**SPIDER HIBISCUS**
*Hibiscus schizopetalus*

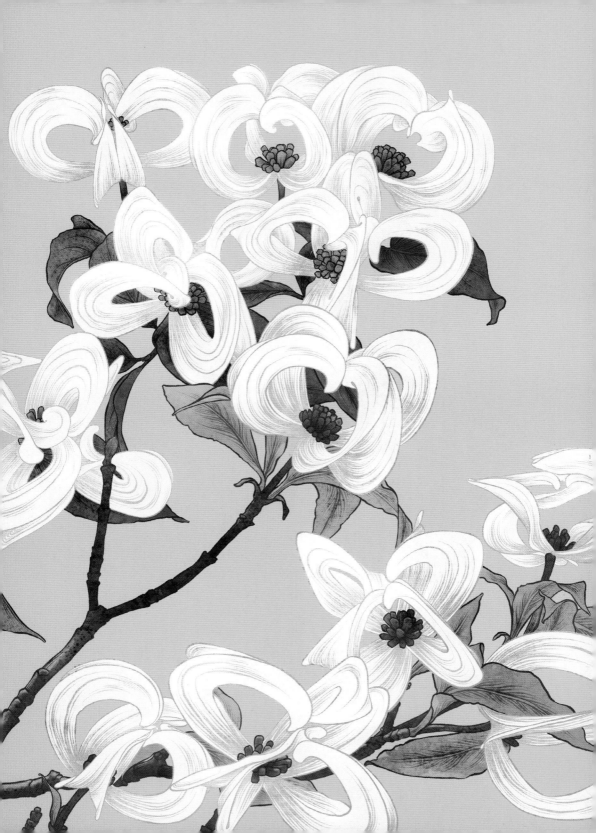

# DOGWOOD

CORNACEAE

S uch a handsome spectacle, dogwood is a tree for all seasons. The Cornaceae family's flowering hero is an unmistakable part of the scenery in its native Eurasia and America – especially in the American south, where flowering dogwood (*Cornus florida*) is the proud emblem of Virginia and North Carolina. Flowering dogwood once hugged America's east coast, from Maine to Mexico, thriving in Florida and west to the Mississippi River. In spring, it's covered with distinctive white blooms; in summer, its branches bear round, red berries adored by birds. It rolls into autumn with a magnificent show of reds and purples, then adds winter garden interest with its mottled, decorative bark. Dogwoods are wildlife attractors; in America, the flowers and bracts attract blue jays, robins and cardinals.

## NOT JUST FOR SHOW, THE EDIBLE FRUIT OF THE EUROPEAN CORNELIAN CHERRY (*CORNUS MAS*) CAN BE MADE INTO PRESERVES.

Dogwood's petals are deceptive; its true flower is a tiny, button-like cluster surrounded by four large ornamental bracts – or specialised leaves. The bracts start off green but, as they grow and expand, they morph into white, the palest lime, or deep pinks and reds. The spring-flowering kousa dogwood (*Cornus kousa*), native to Korea, Japan and China, has an arresting display of white blooms fading to pink as the season progresses, and the blooms of *Cornus k.* 'Satomi' are an amazing deep pink, adding pops of glorious spring colour. *Cornus canadensis* is a creeping white-flowering dogwood from North America, sprawling along forest floors.

During the Middle Ages, the bark of flowering dogwood was boiled and the liquid used to bathe mangy dogs, an (ineffective) attempt to treat their symptoms. But exactly why a tree is named after a canine is unclear. In the mid-sixteenth century, *Cornus* was known as 'dog-tree' before being called 'hound's tree' and 'dogwood' in the early seventeenth century. Likely its name comes from Old English references to 'dagwood', the trees' hard, fine-grained timber highly prized for strength and used to make daggers. The white wood was also crafted into arrowheads, skewers, golf clubs (woods) and wheels for roller skates, its twigs woven into sturdy baskets – anything where strength was required.

Christian folklore tells of towering dogwoods, the tallest trees in the forests near ancient Jerusalem. Legend has it the hard timber was used to craft the cross for Jesus's crucifixion, the tree enduring a terrible sadness at being involved with his death. Supposedly, a compassionate Jesus transformed the lofty tree into today's gnarlier, more shrub-like form so it could never again be used for crucifixions. When Jesus rose on the third day, dogwoods growing in the Israeli forests burst into full bloom, celebrating the resurrection. Adding further to the tale are the rusty marks on the bracts' tips, representing the four corners of the cross, or the bloody nail holes. The origin of the legend is unknown, but for many Christian Americans, Easter-flowering dogwoods have special religious significance.

Previous:

MEXICAN DOGWOOD

*Cornus florida var urbiniana*

Opposite:

CHINESE DOGWOOD 'ROSEA'

*Cornus kousa 'Rosea'*

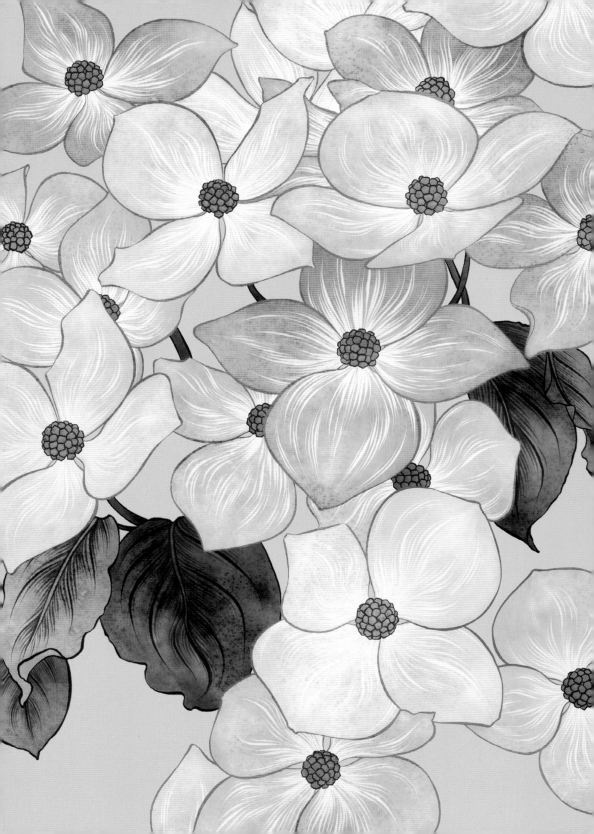

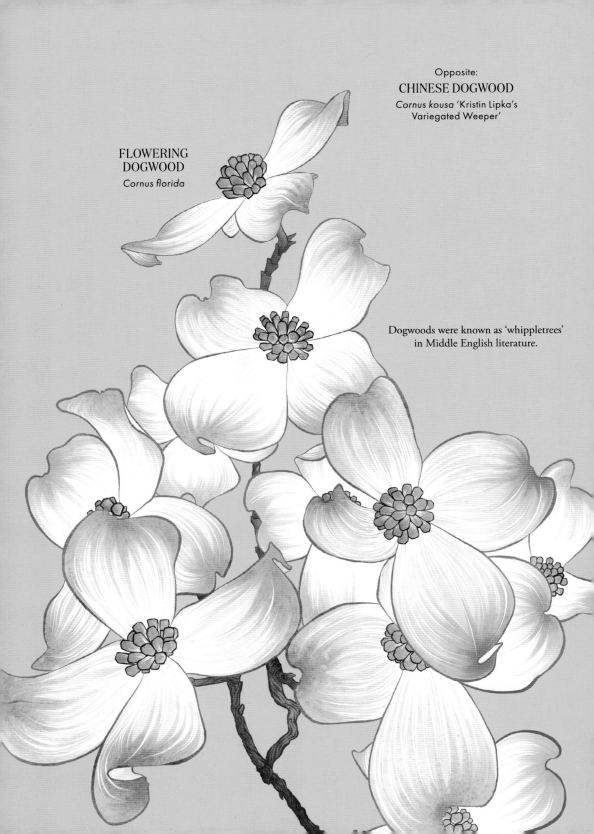

Opposite:
**CHINESE DOGWOOD**
*Cornus kousa* 'Kristin Lipka's Variegated Weeper'

**FLOWERING DOGWOOD**
*Cornus florida*

Dogwoods were known as 'whippletrees' in Middle English literature.

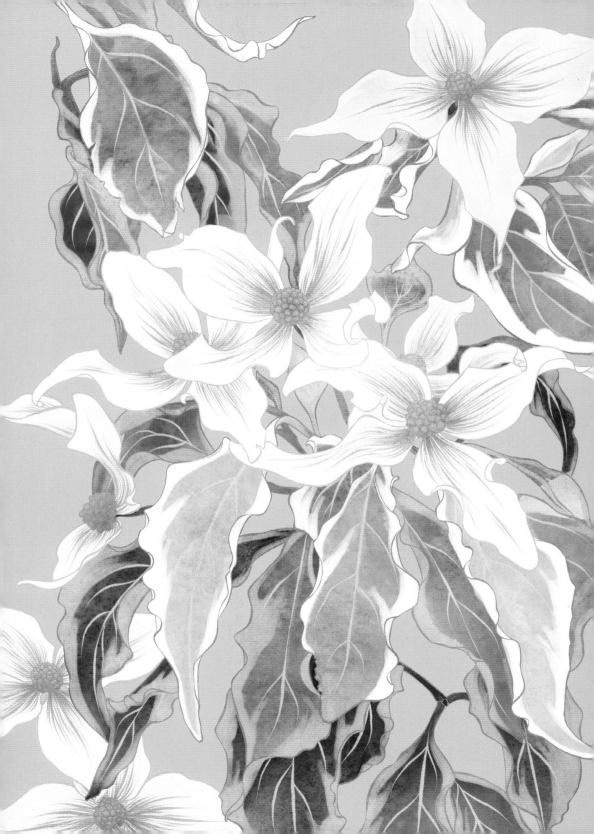

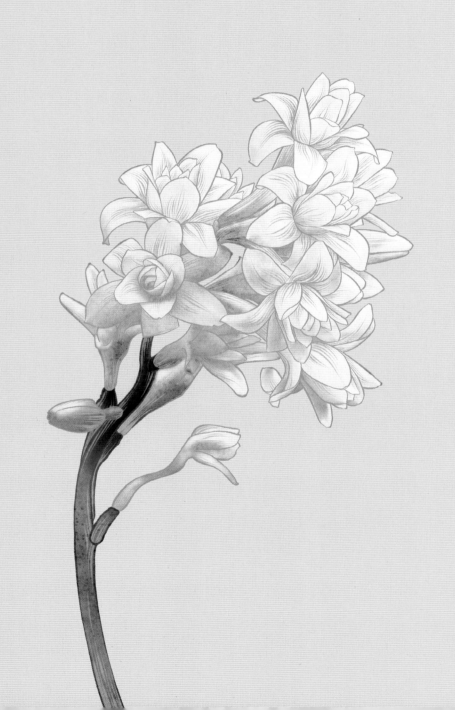

# ASPARAGUS

ASPARAGACEAE

A deeply evocative family, Asparagaceae stirs the olfactory senses with its intoxicating blooms. Its sweet floral notes are adored by perfumers, while the lusty spears are the food of legend.

Garden-variety asparagus (*Asparagus officinalis*) is a saucy minx, long valued as an aphrodisiac, medicine and a form of sustenance. The Mediterranean native has small, nodding, bell-shaped blossoms, and its stiff spears thrusting from the earth certainly give it a phallic vibe. This erotic edible appeared in the fifteenth-century Arabic sex manual *The Perfumed Garden of Sensual Delight* by Nefzawi. He suggests eating a daily dose of boiled then fried asparagus with egg yolk so men can 'grow very strong for the coitus and find it a stimulant for his amorous desires'. Boiling asparagus and drinking the water is another way to imbibe, and the vegetable is packed with vitamins and folate, which can stimulate sex hormones in men and women, as well as giving valuable nutrition.

**ASPARAGUS WAS A REGULAR IN THE MEDICINAL PLOTS OF OLD FRENCH MONASTERIES.**

But that's not all. Asparagus was also part of a publishing project put together by one enterprising woman in the eighteenth century. It was one of a series of drawings by Scottish illustrator Elizabeth Blackwell, one of the first botanical artists to draw, etch and engrave, and hand colour her work. Her husband's dodgy business practices landed him in debtor's prison after he was unable to pay his fines, and it was Blackwell's art that saved him. She spent six years creating *A Curious Herbal*, a mammoth medical project of 500 illustrations, generating income to secure her husband's release.

In France, King Louis XIV championed asparagus, with plantings in the garden of Versailles, and his mistress, Madame de Pompadour, relished its 'love tips' as a delicacy, swooning over the umami taste of the fresh young spears. Louis XIV also ordered mass plantings of tuberose (*Polianthes tuberosa*) at Versailles, a Mexican stunner with spikes of richly fragrant white flowers. He adored the sweet, almost cloying scent, which filled the air at the height of summer, and its petals have been used for centuries to make perfume (to which Queen Marie Antoinette was partial).

Another fragrant Asparagaceae is the romantic but deadly lily of the valley (*Convallaria majalis*), a toxic woodland plant with hanging bell-shaped flowers that blooms during spring in its native northern hemisphere. It is also known as Mary's tears: Christian folklore has it the fragrant blooms grew from her tears as she wept over Jesus's death, and the flowers represent humility in religious paintings. In France it's tradition to sell lily of the valley without any sales tax on Labour Day, 1 May. French couturier Christian Dior loved them, and in the 1950s the company crafted the signature perfume Diorissimo with notes of freshly picked lily of the valley.

Across the way in South Africa, the succulent corkscrew albuca (*Albuca spiralis*) has green-and-yellow blooms that release a sweet scent of vanilla, its wacky leaves curling into spirals, like a tree growing on the pages of a Dr Seuss storybook.

Previous:

## TUBEROSE

*Polianthes tuberosa*

The fragrance of tuberose is especially strong as dusk falls, and French legend warns young women to be safely home before they can smell its aroma.

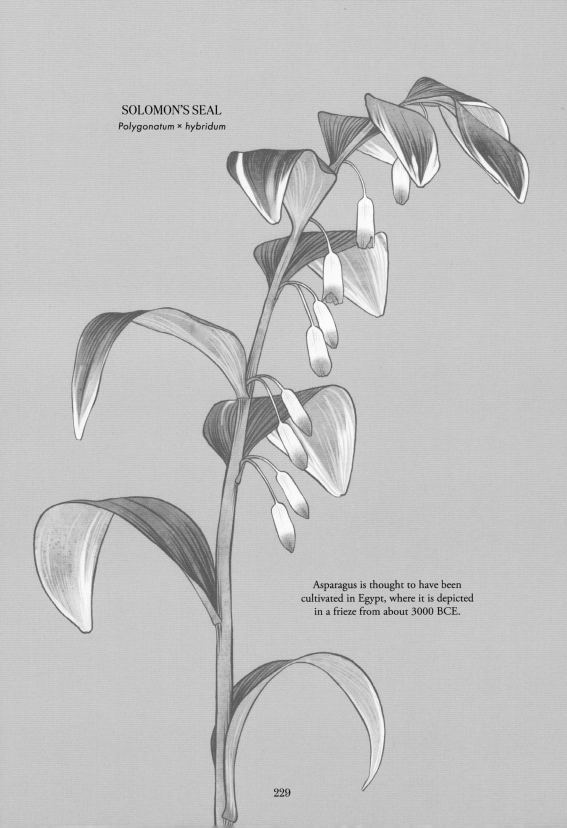

SOLOMON'S SEAL
*Polygonatum × hybridum*

Asparagus is thought to have been
cultivated in Egypt, where it is depicted
in a frieze from about 3000 BCE.

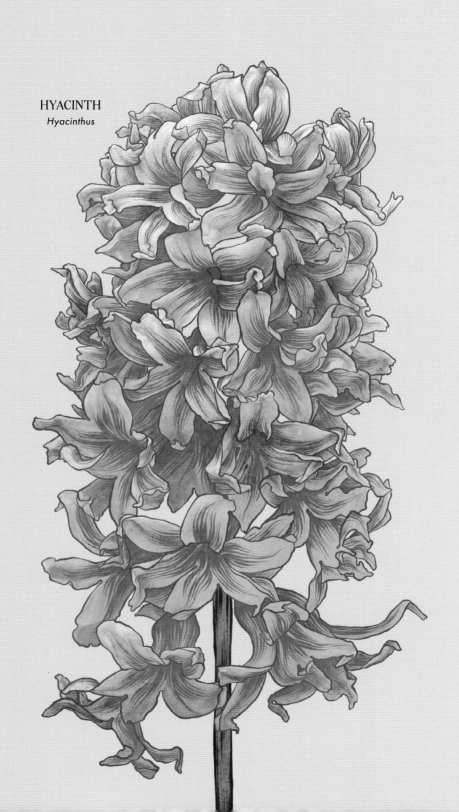

HYACINTH
*Hyacinthus*

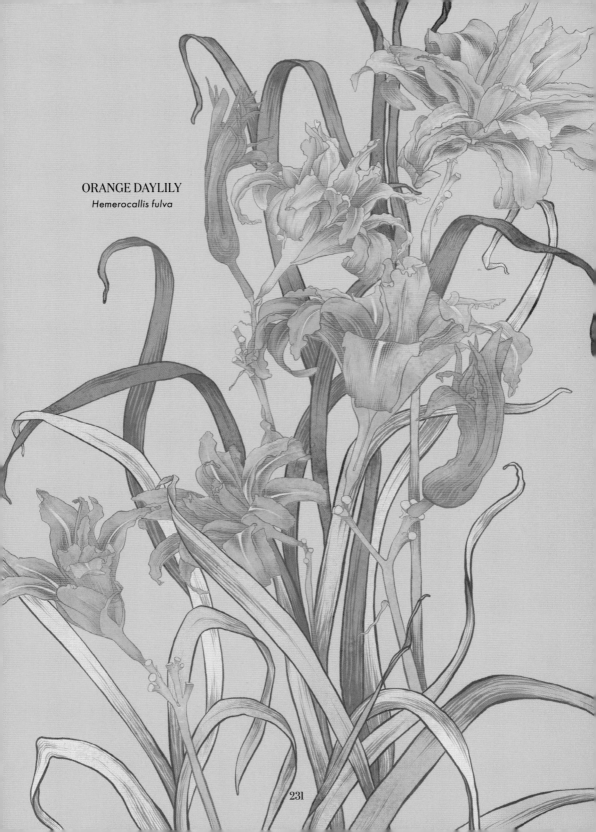

ORANGE DAYLILY

*Hemerocallis fulva*

# PRIMROSE

PRIMULACEAE

P rimula is the pretty, painterly star of this family, with its velvety foliage and delicate symmetrical flowers busting out at the first sniff of spring.

Native to the northern hemisphere, Primulaceae colours temperate woodlands and open prairies with swathes of pink, lilac, yellow and crimson, and blooms in the crevices and crannies of the European Alps and Asian Himalaya. Auricula (*Primula auricula*) loves the alkaline soils of Italy's Dolomites; drumstick primula (*Primula denticulata*), with its rounded lilac-blue flower, grips the sheer cliffs near Bhutan's famous seventeenth-century Tiger's Nest Monastery; and the erect clusters of candelabra primula (*Primula pulverulenta*), one of the few of the family that doesn't mind wet feet, can be collected near a bubbling stream.

## THE RARE DUKE OF BURGUNDY BUTTERFLY LAYS ITS EGGS UNDER PRIMROSE AND COWSLIP.

Poker primula (*Primula vialii*), a rocket-shaped bloom with a shock of red and violet, was first discovered by Scottish plant hunter George Forrest. The intrepid Forrest made multiple expeditions to the Himalaya in China and Tibet, escaping from rebel lamas who tortured and murdered the rest of his group, enduring starvation, and battling the harsh mountain landscape with primitive equipment. He collected more than 30,000 specimens during his travels, 50 of which were primula.

Primrose (*Primula vulgaris*) has long been cherished by the ancient Celtic druids, the sacred blooms thought to possess magical powers of protection, their petals embodiments of heaven. Flowers were placed near the front door, a sign of welcome for faerie folk, used to make potion, and rubbed on cows' udders to promote milk production at the start of butter-making season in May. They used the fragrant primrose oil for cleansing and purification during religious rites, and white-robed druids still visit Primrose Hill in London to mark the autumn equinox, a harvest ceremony dating from the eighteenth century.

But it was the seventeenth-century Flemish Huguenot silk weavers credited as the first people to cultivate the flower, later introducing it to England. Primulas' popularity peaked during the florilegium craze of nineteenth-century Europe where they were displayed in 'theatres', the pots arranged like rows of seats, complete with curtains to keep out the rain.

Apothecaries of the Middle Ages prized cowslip (*Primula veris*), used to treat paralysis, spasms, cramps, gout and rheumatism. Others ate the leaves in salads and used the flowers to flavour wine or make crystallised cake decorations.

Pollination of the family is mainly done by insects. Shooting star (*Dodecatheon meadia*), dubbed 'flower of the twelve Gods' by the Greeks, is fertilised by buzz pollination. Solitary bees grab the long stamen with their mouth, rapidly contracting their flight muscles to shake the pollen loose from the tube. In other Primulaceae, skinny ants scuttle right to the bottom of the flower's long tube for the nectar mother lode, covering themselves in pollen before heading to the next flower.

In Latin, primrose references *primus* (first) and in Italian it's *primavera* (spring), both fitting names given it's one of the season's first bloomers, its petals unfurling after the snow has melted away. Britain's Queen Victoria sent a yellow primrose wreath when Prime Minister Benjamin Disraeli died, and Primrose Day was created on 19 April in his honour. In the language of flowers, the primrose symbolises eternal love.

Previous:

## FLORIST'S CYCLAMEN

*Cyclamen persicum hybrid*

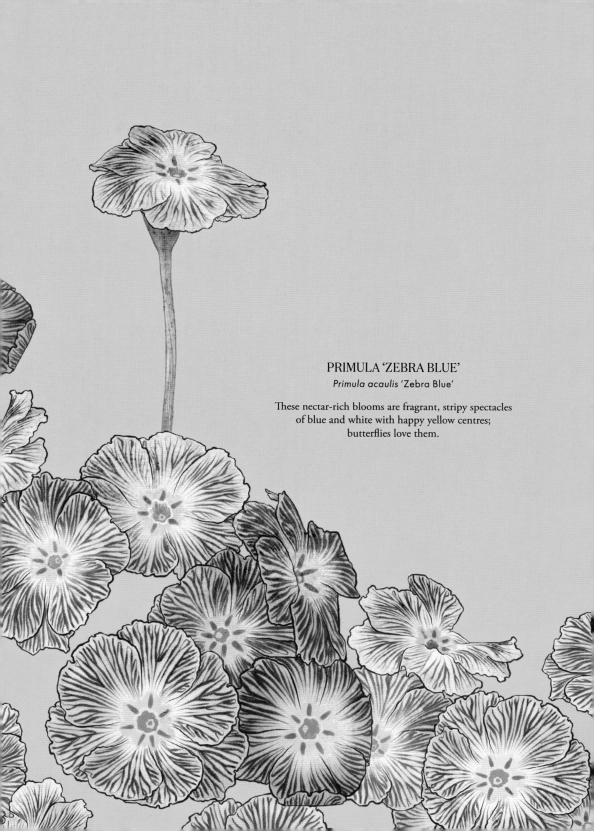

PRIMULA 'ZEBRA BLUE'

*Primula acaulis 'Zebra Blue'*

These nectar-rich blooms are fragrant, stripy spectacles
of blue and white with happy yellow centres;
butterflies love them.

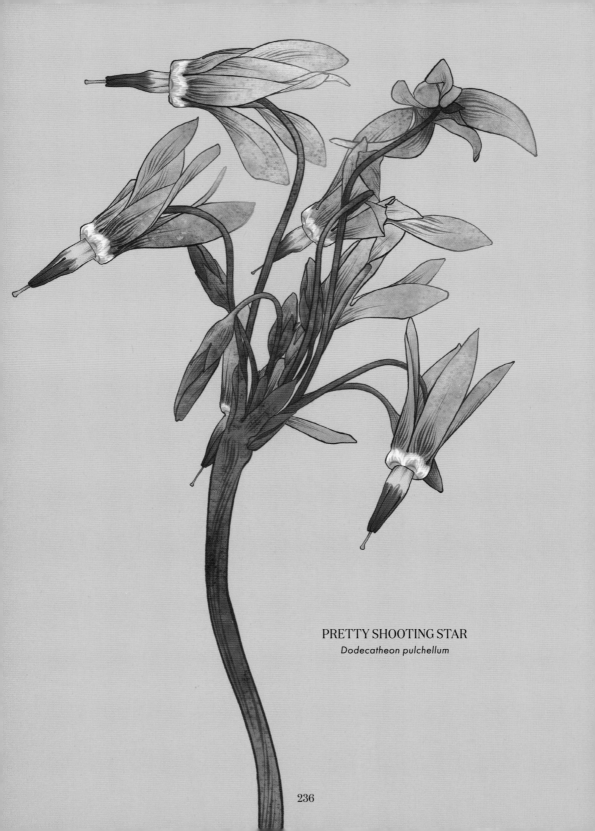

PRETTY SHOOTING STAR
*Dodecatheon pulchellum*

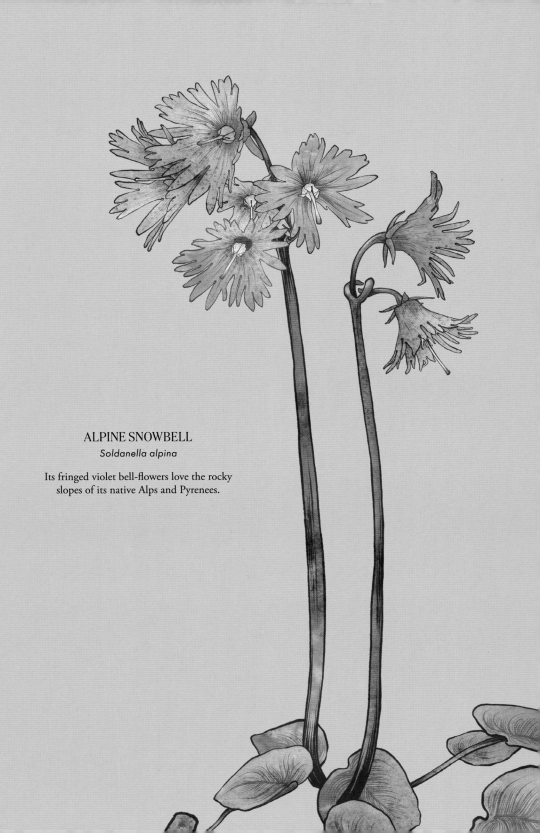

ALPINE SNOWBELL

*Soldanella alpina*

Its fringed violet bell-flowers love the rocky
slopes of its native Alps and Pyrenees.

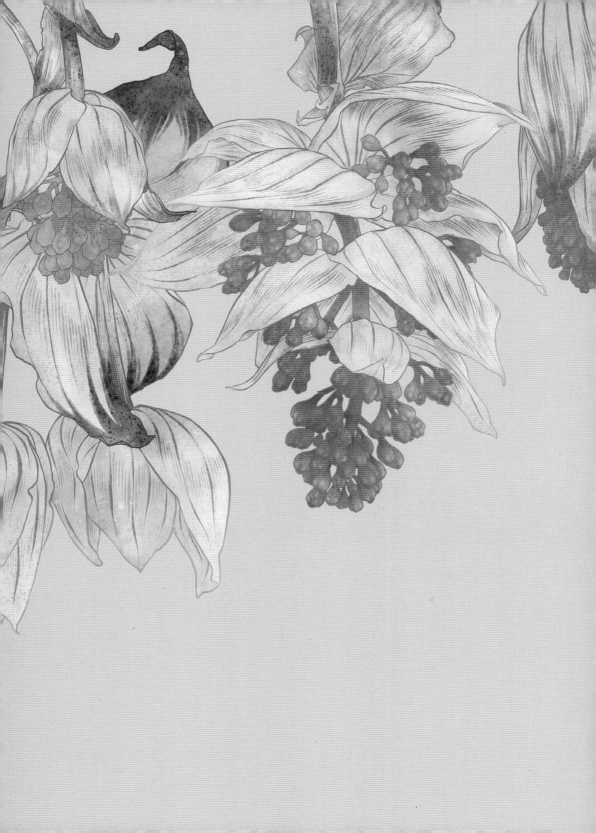

# UNUSUAL
# SPECIMENS

This chapter spotlights the bizarre, the oddball, the terrifying, with kooky specimens and rare novelties that give plant nerds that special thrill.

In the forests and deserts of Mexico, the majestic queen of the night (*Selenicereus grandiflorus*) flowers from dusk till dawn for a single evening each year; so impressive is its performance, communities plan parties to coincide with its flowering. Pollinated by the hawk moth, night-feeding insects and bats, this epiphytic cactus produces a big, white, glowing bloom – often aligning with a full moon – its petals taking two to three hours to fully unfurl. As morning breaks, the trumpet-shaped blossom wilts and fades, an intoxicating, pheromone-rich perfume lingering in its wake – until next year.

In another part of the world, across the oceans and seas in Central Asia, lives the white bat flower (*Tacca integrifolia*), its bizarre flower face resembling a whiskery bat with white bracts for ears and purply-red petals for a face. Its spindly 'whiskers' are long bracts, which can trail half a metre (about one and a half feet), and it's an impressive sight in full bloom. Pollinated by flies, which are lured by its musky scent, white bat flower grows in the dank, leaf-littered understorey of the humid rainforests of Sri Lanka, Malaysia and Bhutan.

**QUEEN OF THE NIGHT ONLY STARTS PRODUCING ITS BRILLIANT BLOOMS ONCE IT REACHES FOUR OR FIVE YEARS OF AGE.**

Nearby, in the Philippines and Malay Peninsula, the epiphytic pink lantern plant (*Medinilla magnifica*) is an absolute stunner, growing in the crooks of forest trees. Its flowers are blushing pendulous bracts, like clusters of tiny pink grapes, with succulent green foliage.

Fragrant wax plant (*Hoya carnosa*), an evergreen epiphytic creeper that climbs and twines, also hails from Asia, as well as tropical Australia. Its flowers comprise two layers of five-pointed stars that form a disco ball–style cluster, their waxiness giving it a surreal appearance, like a ceramic art installation. Its scented flowers drip with sweet nectar and its colours span the artist's palette, from green to red to almost-black.

In the rainforests of the Americas, beware the tremendous cannonball tree (*Couroupita guianensis*), with its heavy fruit like rusty cannonballs that fall to earth, loudly exploding on impact – there are usually warning signs near cannonball trees to caution people. It's a member of the Lecythidaceae family, which includes the Brazil nut (*Bertholletia excelsa*). The cannonball tree is renowned for its medicinal properties, its leaf extracts used to treat rashes and soothe toothache. The tree's bright flowers grow on long stalks directly from the trunk – big, zygomorphic beauties, which are heavily fragrant in the morning and at night, enticing its bee and bat pollinators. Indians have cultivated this tree for nearly 3000 years and it's of great religious significance in parts of Asia, often planted near Shiva and Buddhist temples.

These horticultural oddballs are some of the wackier wonders of the plant kingdom, ones to add to the plant bucket list.

Previous:
SHOWY MEDINILLA
*Medinilla magnifica*

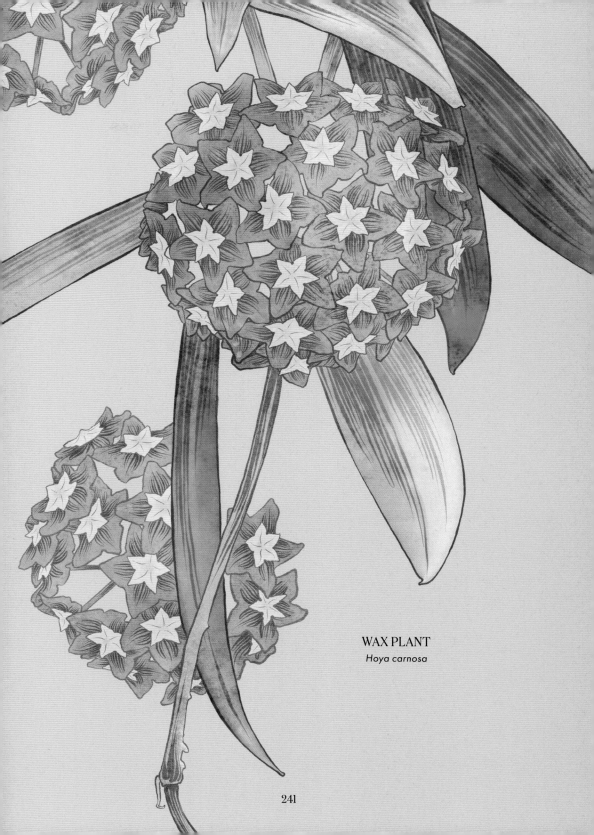

WAX PLANT

*Hoya carnosa*

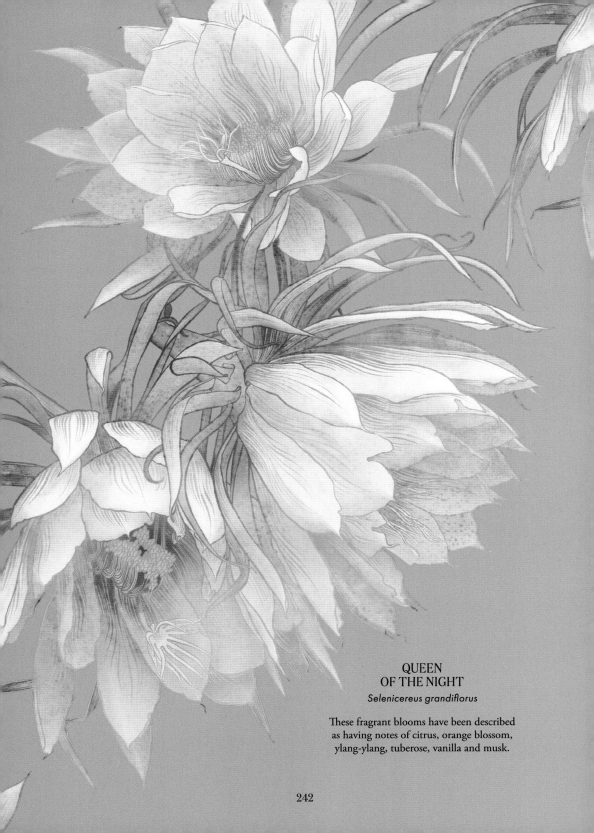

## QUEEN
## OF THE NIGHT
*Selenicereus grandiflorus*

These fragrant blooms have been described
as having notes of citrus, orange blossom,
ylang-ylang, tuberose, vanilla and musk.

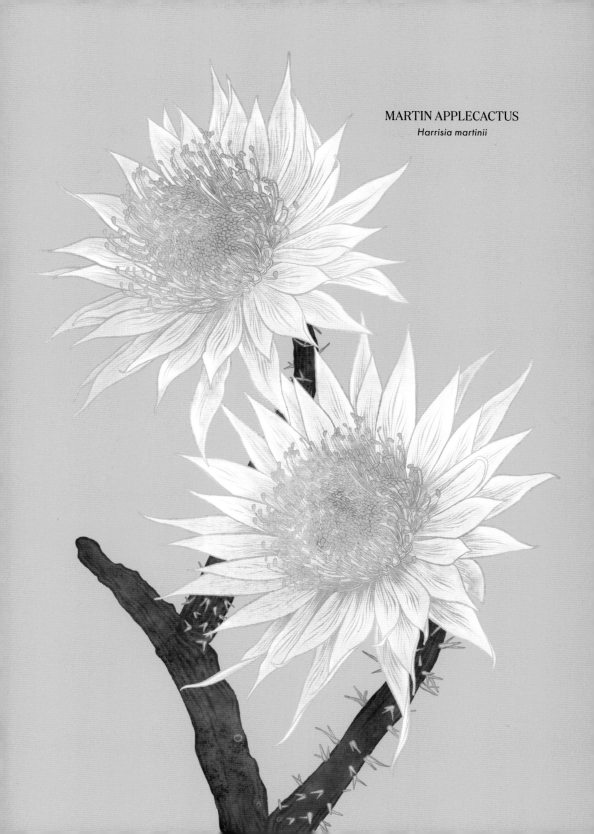

MARTIN APPLECACTUS
*Harrisia martinii*

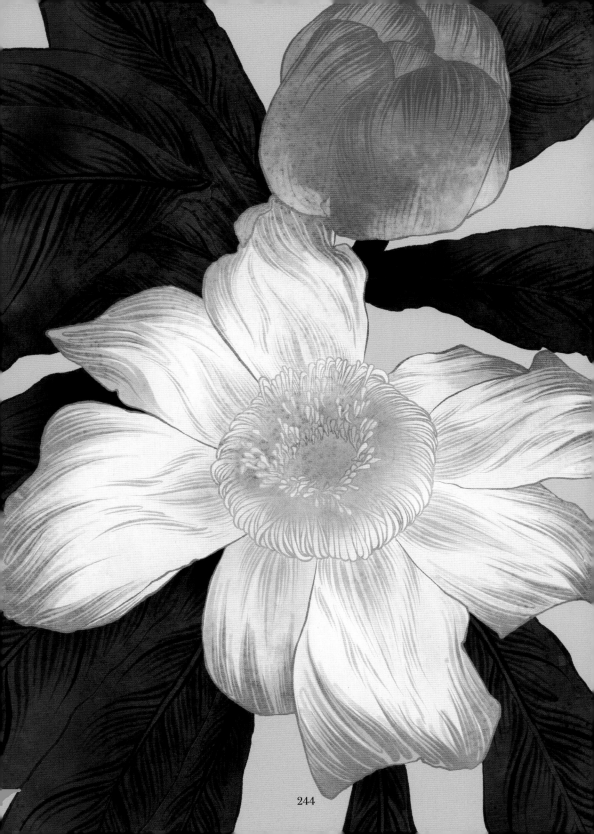

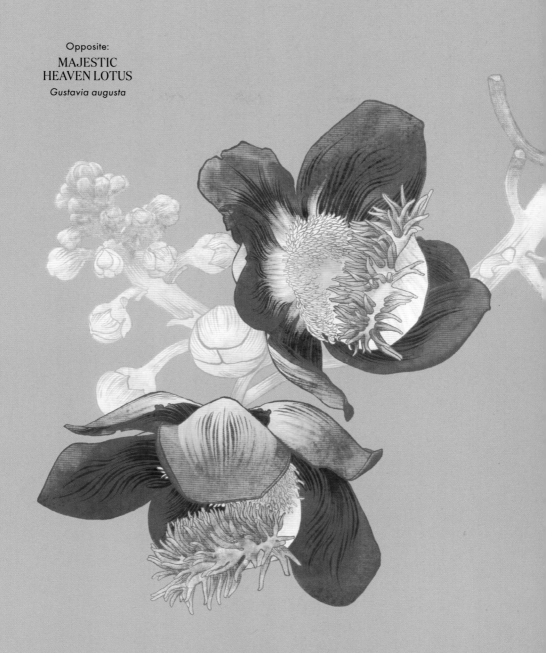

Opposite:
**MAJESTIC
HEAVEN LOTUS**
*Gustavia augusta*

CANNONBALL TREE
*Couroupita guianensis*

# FRINGED PINK

*Dianthus superbus*

The delicate and frilly pinwheel flowers have a rich,
heady perfume that can be sniffed night and day.

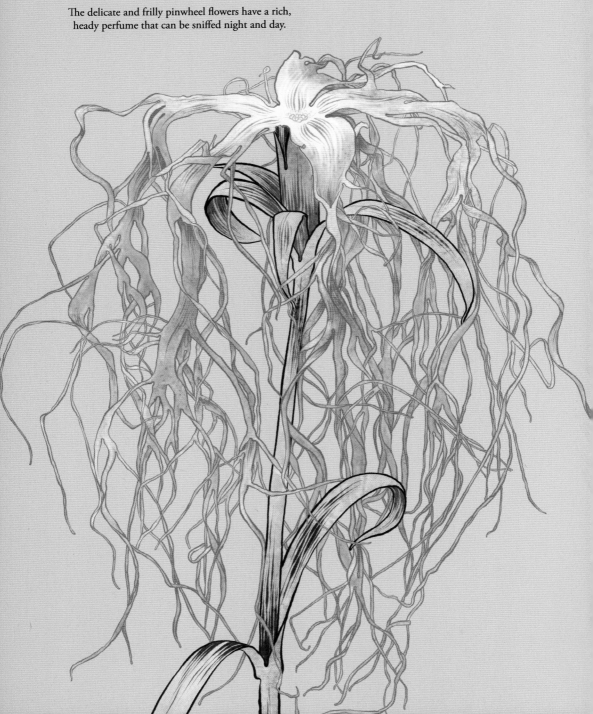

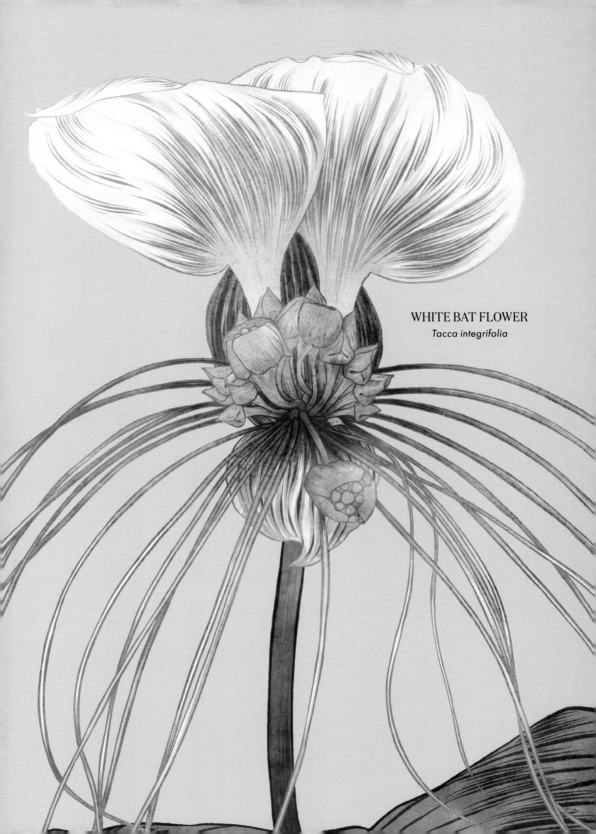

WHITE BAT FLOWER
*Tacca integrifolia*

# ACKNOWLEDGEMENTS

Firstly, thank you to Hardie Grant. I feel incredibly honoured to have the support of such an engaged team. To Jane Willson, Emily Hart, Kate Daniel, Jessica Lowe, Hannah Schubert and Todd Rechner for their tireless work.

A special thank you to Nina Rousseau for her sparkling words, and to Daniel New for his incredible design eye.

I must also thank Fran Berry for her early belief in my abilities.

To my family, who encourage me through my creative endeavours with constant love and humour, especially my parents Bryan and Sally Picker, brother Andrew, and my aunt and uncle Margo and Geoff Coltheart. My wonderful cousin James Coltheart and his wife Virginia have so graciously sustained me throughout the process of making this work. For my mother, I've included a rose on page 21 with her maiden name, Holmes. It's a rose that grows in her garden, as well as my aunt's, and will forever be in my heart.

To my very dear friend and talented artist Gemma O'Brien for generously taking the time to write the foreword for this book, and committing my illegal flower foraging activities to print.

Of all the people that I have encountered that share my passion for plants, Rebecca Castle trumps them all for enthusiasm and knowledge. Many of the flowers here are drawn from reference photos taken in her beautiful Southern Highlands garden and are a testament to our wonderful friendship.

I am blessed to be surrounded by an incredible network of friends. Alice Kimberley, Matthew Swieboda, Nikki To, Silvana Azzi Heras, Anna Westcott, Daniel Gonzalez, Rachael Fung and, on this particular occasion, my high-school sweetheart Emma Gonzalez: thanks for bolstering me in so many ways, large and small.

And finally, thank you to everyone who has supported my illustration career to this point. I feel incredibly lucky that my curiosity for nature and colour resonates with you.

# ABOUT THE AUTHOR

Adriana Picker is an Australian-born illustrator who lives in Sydney, Australia. At the heart of her work is a lifelong passion for flowers, which she manages to find wherever she goes.

As an illustrator, artist and designer, her work encompasses the diverse fields of publishing, fine arts, film and advertising.

This is Adriana's fourth book, having previously illustrated *The Cocktail Garden*, *Where the Wildflowers Grow* and *The Garden of Earthly Delights*.

# REFERENCES

*The Book of Orchids: A Life-Size Guide to Six Hundred Species* by Maarten Christenhusz and Mark Chase

*Daffodil: Biography of a Flower* by Helen O'Neill

*Encyclopaedia of Superstitions, Folklore, and the Occult Sciences of the World* edited by Corra Linn Daniels and CM Stevans

*Fifty Plants that Changed the Course of History* by Bill Laws

*Flowerpaedia: 1000 Flowers and Their Meanings* by Cheralyn Darcey

*A Gardener's Latin: The Language of Plants Explained* by Richard Bird

*Herbal Tea Remedies: Tisanes, Cordials and Tonics for Health and Healing* by Jessica Houdret

*A History of Ornamental-Foliaged Pelargoniums: With Practical Hints for Their Production, Propagation and Cultivation* by Peter Grieve

*Lily* by Marcia Reiss

*Mad Enchantment: Claude Monet and the Painting of the Water Lilies* by Ross King

*Peonies: Beautiful Varieties for Home and Garden* by Jane Eastoe

*Seven Flowers: And How They Shaped Our World* by Jennifer Potter

*Tales of the Rose Tree: Ravishing Rhododendrons and Their Travels Around the World* by Jane Brown

*The Untamed Garden: A Revealing Look at Our Love Affair with Plants* by Sonia Day

*The Wondrous World of Weeds: Understanding Nature's Little Workers* by Pat Collins

Opposite:

## GERANIUM

*Pelargonium* × *hortorum*

This flower is being used as a biological control for the pest Japanese beetle, which becomes paralysed after feasting on its leaves.

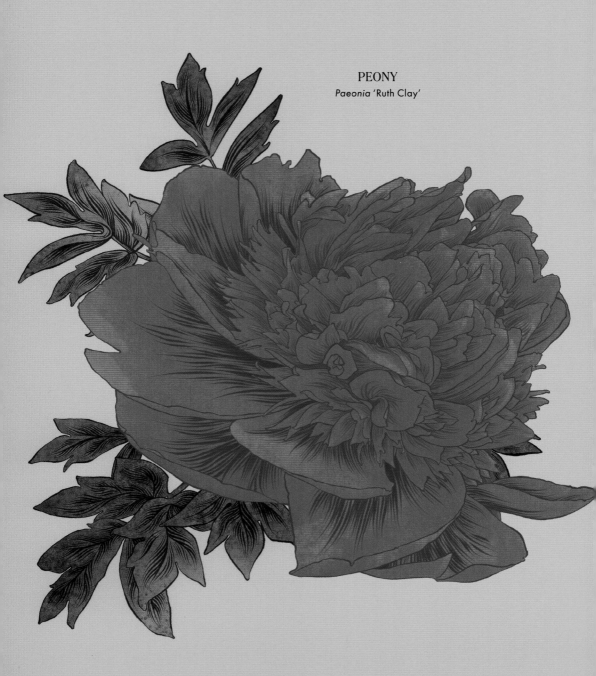

PEONY
*Paeonia 'Ruth Clay'*

# INDEX OF FLOWERS

This edition published in 2023.
First published in 2020 by Hardie Grant Books,
an imprint of Hardie Grant Publishing

Hardie Grant Books (Melbourne)
Building 1, 658 Church Street
Richmond, Victoria 3121

Hardie Grant Books (London)
5th & 6th Floors
52–54 Southwark Street
London SE1 1UN

hardiegrant.com/books

Hardie Grant acknowledges the Traditional Owners of the Country on which
we work, the Wurundjeri People of the Kulin Nation and the Gadigal People
of the Eora Nation, and recognises their continuing connection to the land,
waters and culture. We pay our respects to their Elders past and present.

A catalogue record for this
book is available from the
National Library of Australia

Petal
ISBN 978 1 74379 984 0

10 9 8 7 6 5 4 3 2 1

Publishing Director: Jane Willson
Project Editor: Emily Hart
Writer: Nina Rousseau
Editor: Kate Daniel
Design Manager: Jessica Lowe
Designer: Daniel New
Typesetter: Hannah Schubert

Production Manager: Todd Rechner
Production Coordinator: Mietta Yans

Colour reproduction by
Splitting Image Colour Studio
Printed in China by
Leo Paper Products LTD.